American Realists

American Realists

HOMER TO HOPPER BY MAHONRI SHARP YOUNG

WATSON-GUPTILL PUBLICATIONS/NEW YORK

First published 1977 in the United States and Canada by Watson-Guptill Publications
a division of Billboard Publications, Inc.
1515 Broadway, New York, N.Y. 10036

Library of Congress Cataloging in Publication Data

Young, Mahonri Sharp, 1911–
 American realists, Homer to Hopper.
 Bibliography: p.
 Includes index.
 1. Painting, American. 2. Realism in art–United
States. 3. Painting, Modern–19th century–United
States. 4. Painting, Modern–20th century–United
States. 5.Painters–United States–Biography.
I. Title.
ND210.5.R4Y68 759.13 [B] 77-5416
ISBN 0-8230-0215-2

Manufactured in Japan

First Printing, 1977

Edited by Bonnie Silverstein
Designed by Bob Fillie
Set in 12-point Goudy Old Style by Gerard Associates/Phototypesetting, Inc.
Color printed in Japan by Toppan Printing Company
Printed and bound in Japan by Toppan Printing Company

Contents

Color Plates

Black and White Plates

American Realists

Introduction

Realism has had a long tradition in American art, and while it's not the only way to paint, it has undeniable force.

There were realistic pictures before Homer and after Hopper, but all the artists in this book painted what they saw, not what they felt. It may not be the ultimate reality, but it's all we can be sure of. They took for granted that what was outside was really there, and we still see with their eyes.

It's easy to despise real things, as mystics do, but the world is no better for their dreams. The reality these men painted isn't a sublime vision, but it's where we live. It's fashionable to wish away reality, but even fanatics and philosophers live in the real world. It's no help to say that realism is only one way of seeing, since it's the only way for us. Realism may be short-sighted, but these artists were not thinkers; they painted the life around them. We have far more painters than we have poets. This is the way we see the world, and this is the way most American painters painted it.

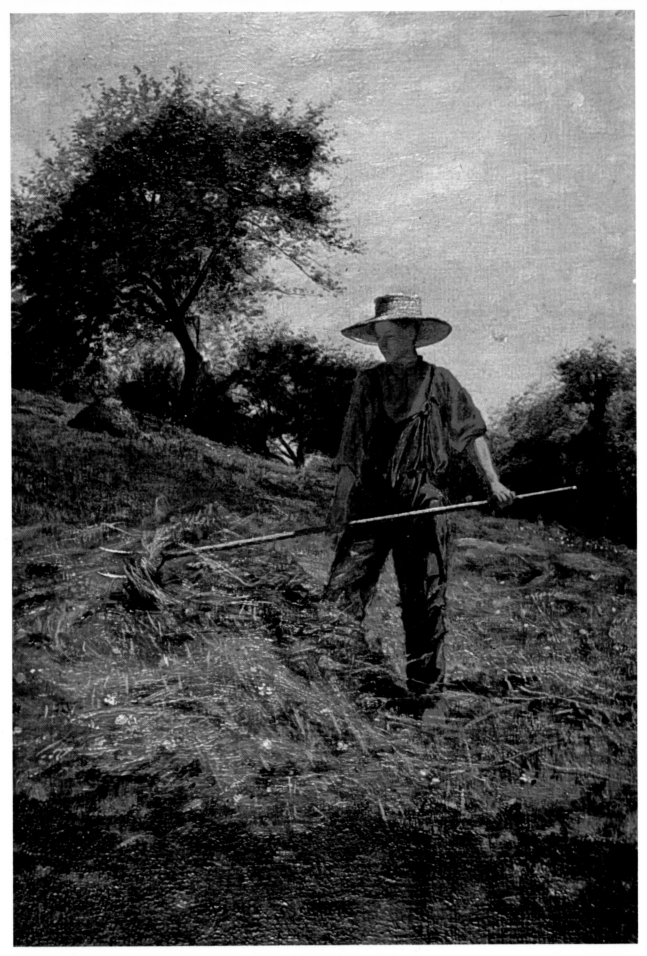

Haymaking *by Winslow Homer, 1864. Oil on canvas, 16" x 11" (40.6 x 27.9 cm).*
The Columbus Gallery of Fine Arts, Columbus, Ohio. Howald Fund Purchase.

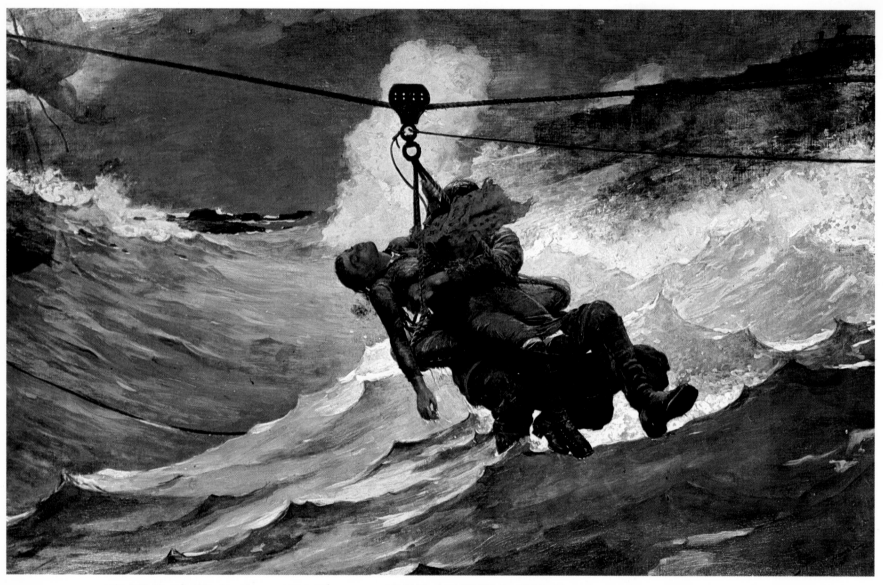

The Life Line by *Winslow Homer, 1884. Oil on canvas, 28 3/4" x 44 5/8" (73.6 x 113.3 cm). Philadelphia Museum of Art, Philadelphia, Pennsylvania. The George W. Elkins Collection.*

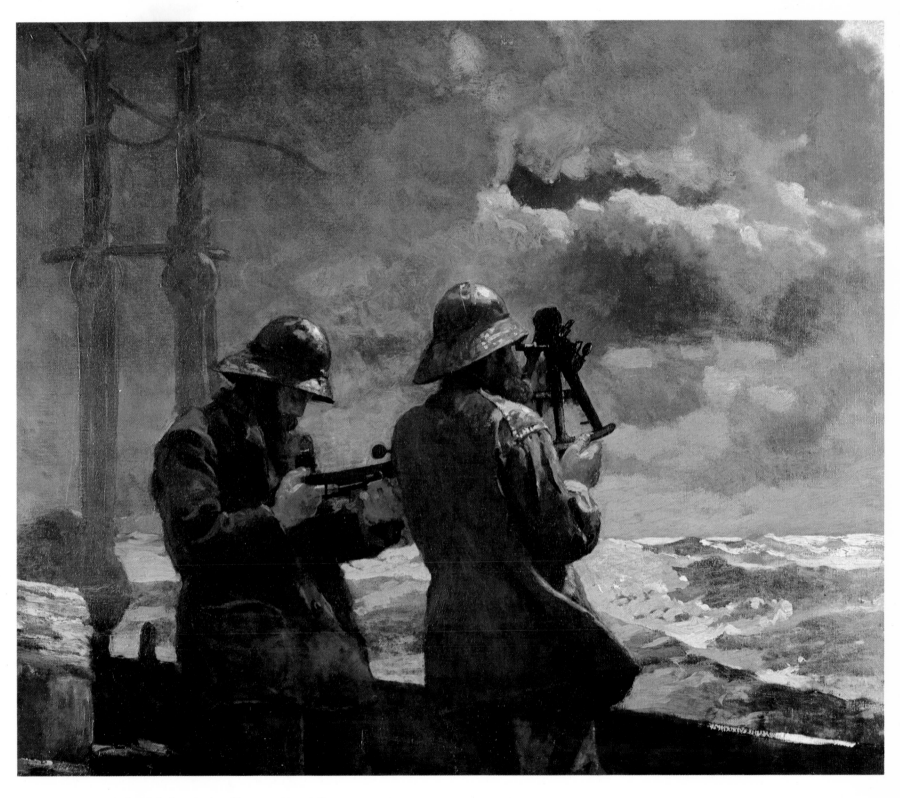

Eight Bells *by Winslow Homer, 1886. Oil on canvas, 25″ x 30″ (63.5 x 76.2 cm).*
Addison Gallery of American Art, Phillips Academy, Andover, Massachusetts.

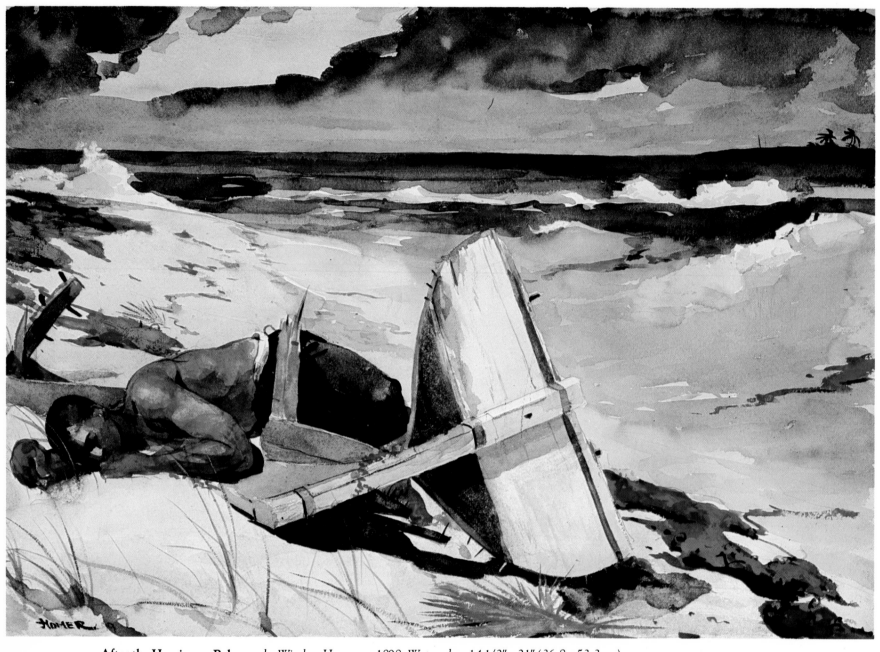

After the Hurricane, Bahamas *by Winslow Homer, c. 1898. Watercolor, 14 1/2" x 21" (36.8 x 53.3 cm).*
The Art Institute of Chicago, Chicago, Illinois. Dr. and Mrs. Martin A. Ryerson Collection.

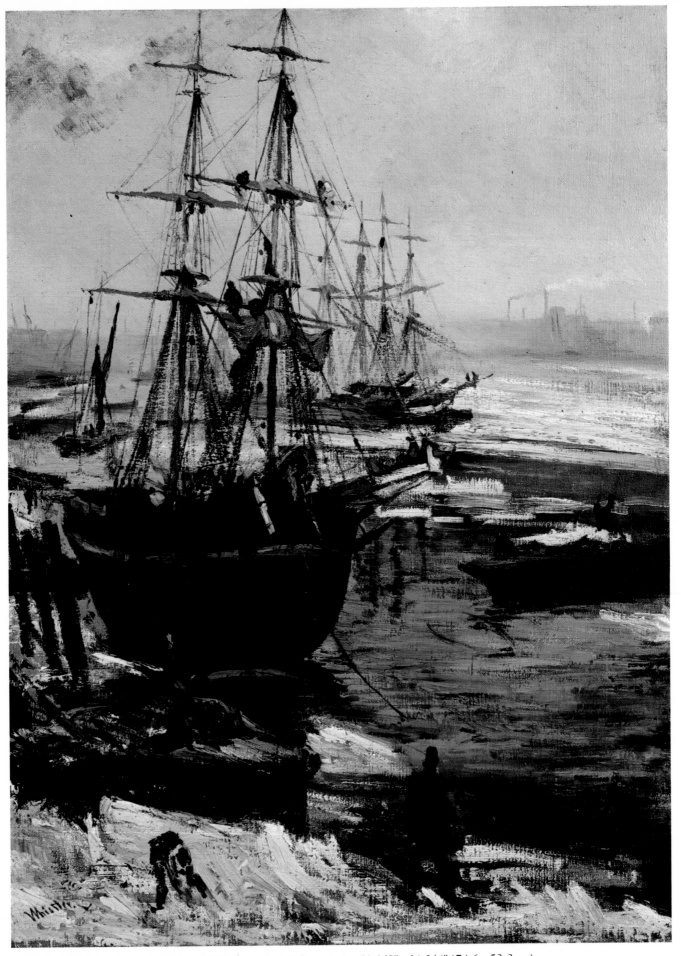

The Thames in Ice by James McNeill Whistler, 1860. Oil on canvas, 29 3/8" x 21 3/4" (74.6 x 53.3 cm).
Freer Gallery of Art, The Smithsonian Institution, Washington, D.C.

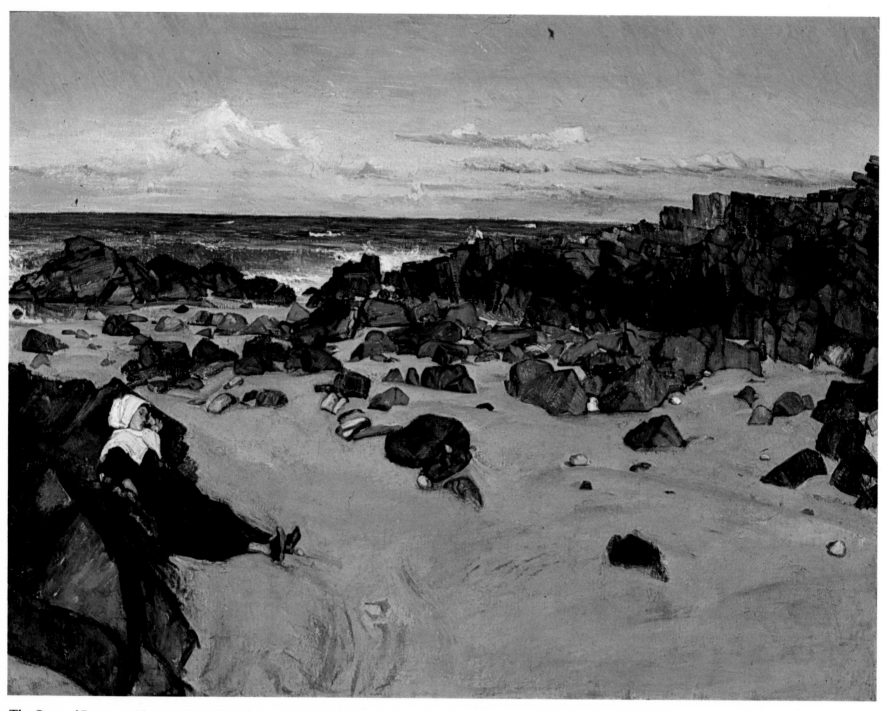

The Coast of Brittany (Alone with the Tide) *by James McNeill Whistler, 1861. Oil on canvas, 34 3/8″ x 46″ (87.2 x 116.8 cm).*
Wadsworth Atheneum, Hartford, Connecticut.

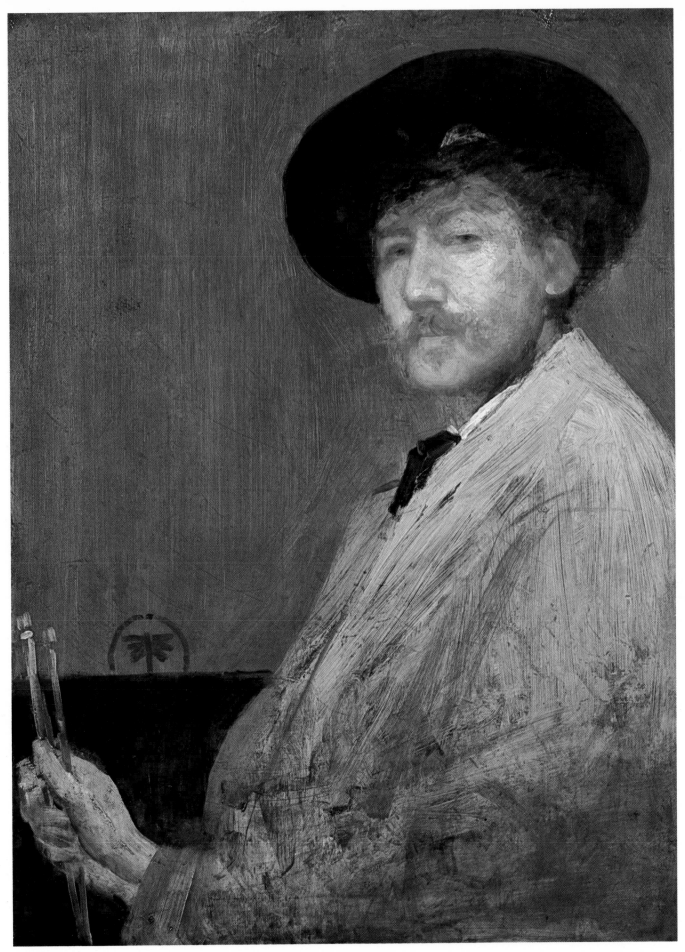

Arrangement in Gray: Self-Portrait *by James McNeill Whistler, 1871– 73. Oil on canvas, 29 1/2″ x 21″ (74.9 x 53.3 cm).*
The Detroit Institute of Arts, Detroit, Michigan. Bequest of Henry G. Stevens.

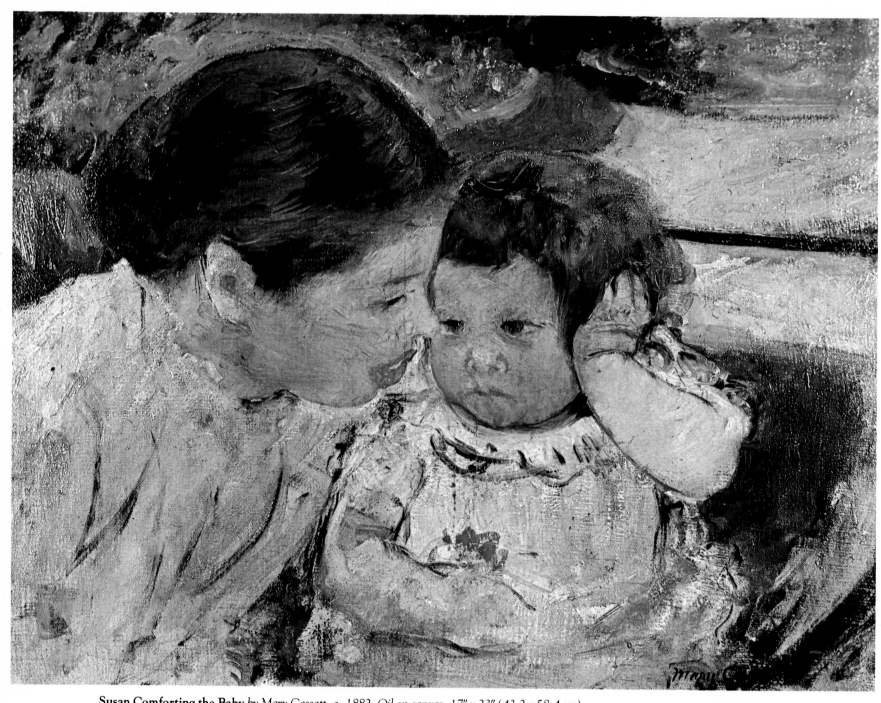

Susan Comforting the Baby *by Mary Cassatt, c. 1882. Oil on canvas, 17" x 23" (43.2 x 58.4 cm).*
The Columbus Gallery of Fine Arts, Columbus, Ohio. Bequest of Frederick W. Schumacher.

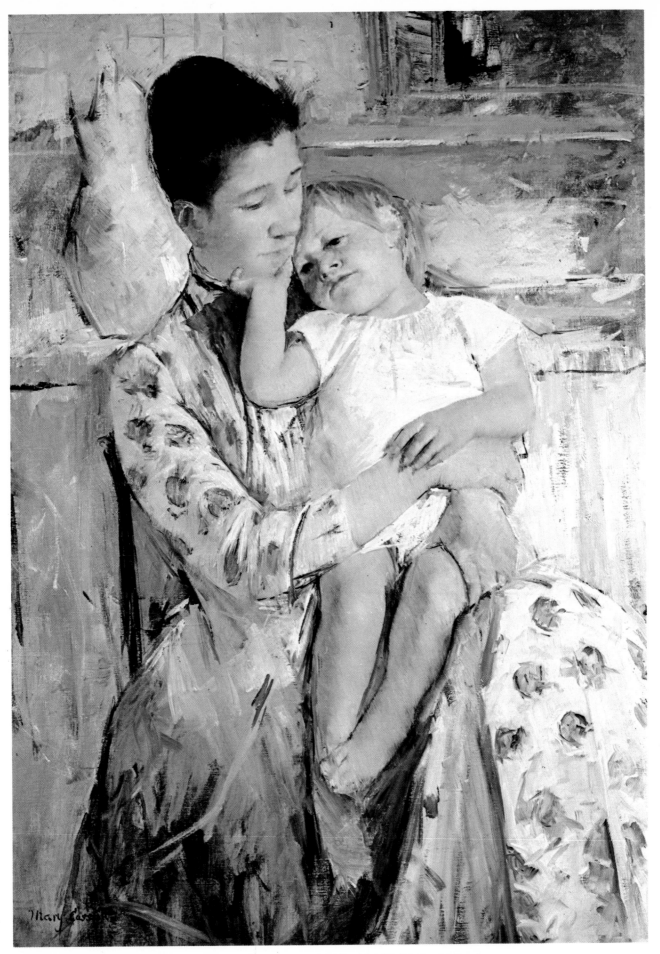

Mother and Child by Mary Cassatt, 1890. Oil on canvas, 35 3/8" x 25 3/8" (89.9 x 64.5 cm). *Wichita Art Museum, Wichita, Kansas.*

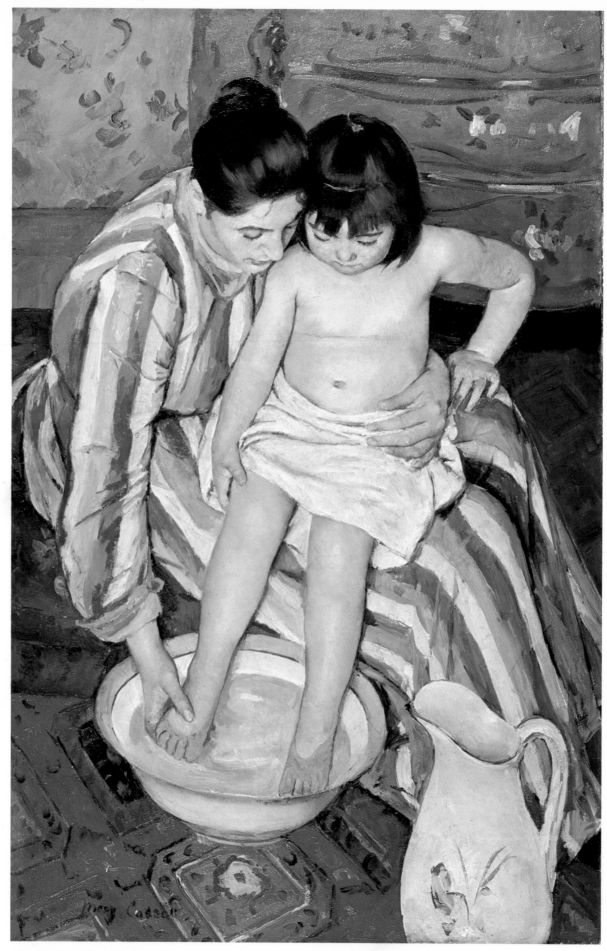

The Bath *by Mary Cassatt, 1891 – 92. Oil on canvas, 39" x 26" (99 x 66 cm).*
The Art Institute of Chicago, Chicago, Illinois.

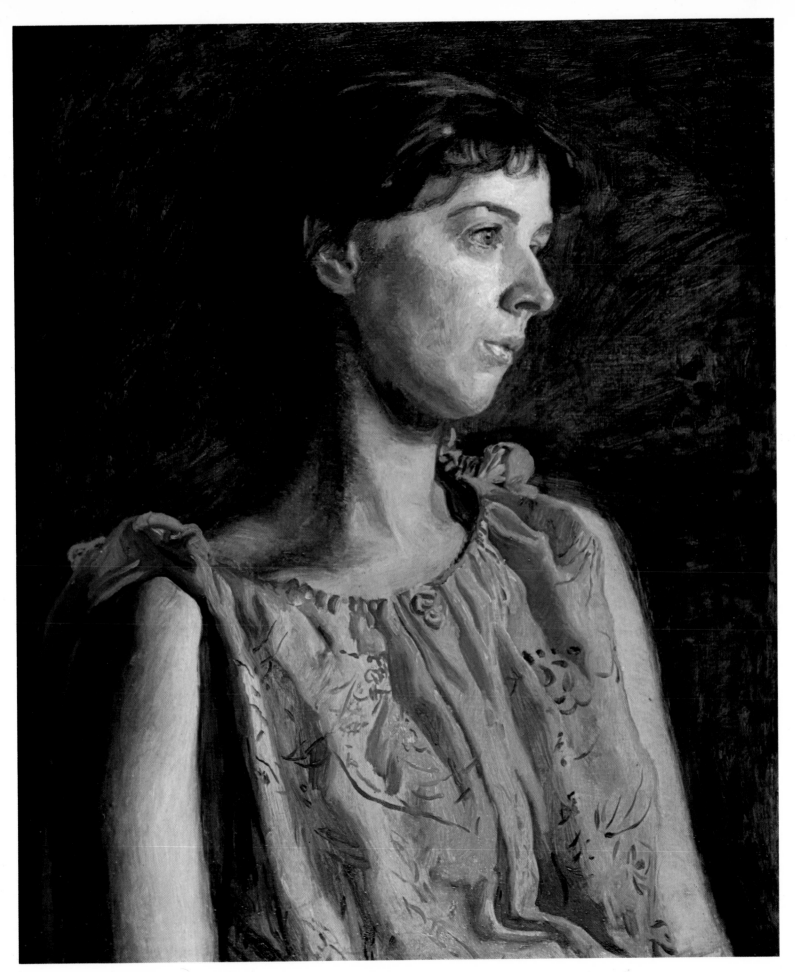

Weda Cook by Thomas Eakins, 1895. Oil on canvas, 24" x 20" (61 x 50.8 cm).
The Columbus Gallery of Fine Arts, Columbus, Ohio. Howald Fund Purchase.

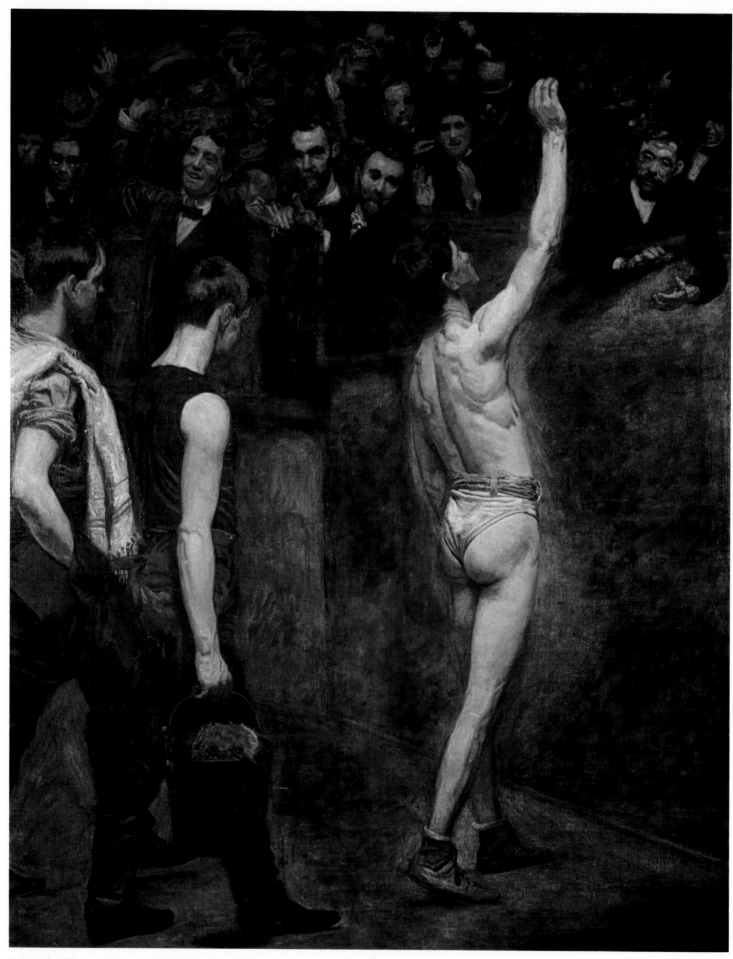

Salutat *by Thomas Eakins, 1898. Oil on canvas, 49 1/2" x 39 1/2" (125.7 x 100.3 cm).*
Addison Gallery of American Art, Phillips Academy, Andover, Massachusetts.

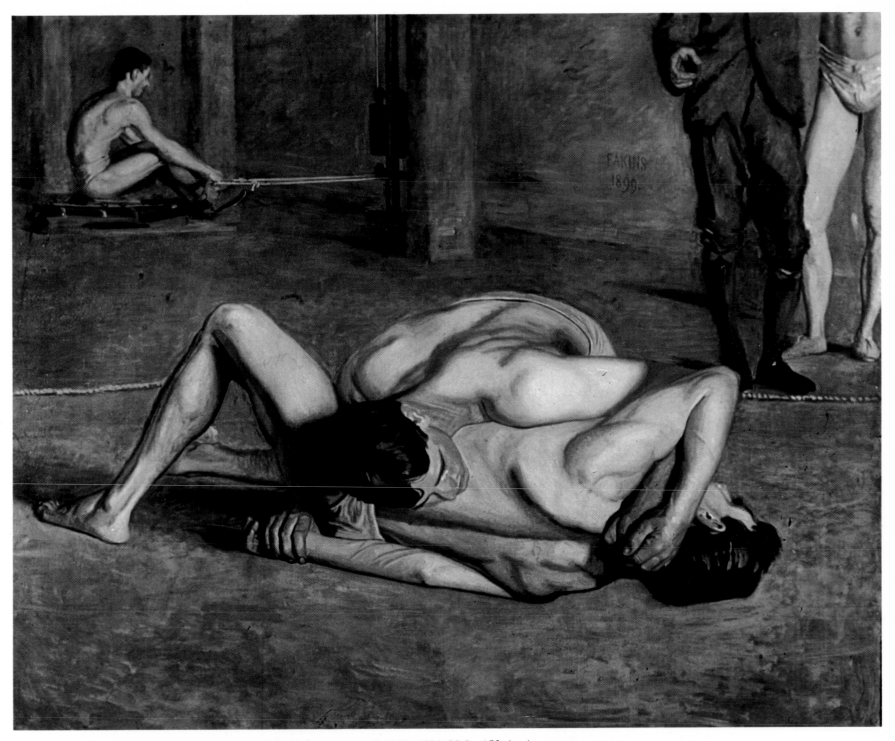

Wrestlers by Thomas Eakins, 1899. Oil on canvas, 48 3/4" x 60" (123.9 x 152.4 cm).
The Columbus Gallery of Fine Arts, Columbus, Ohio. Derby Fund Purchase.

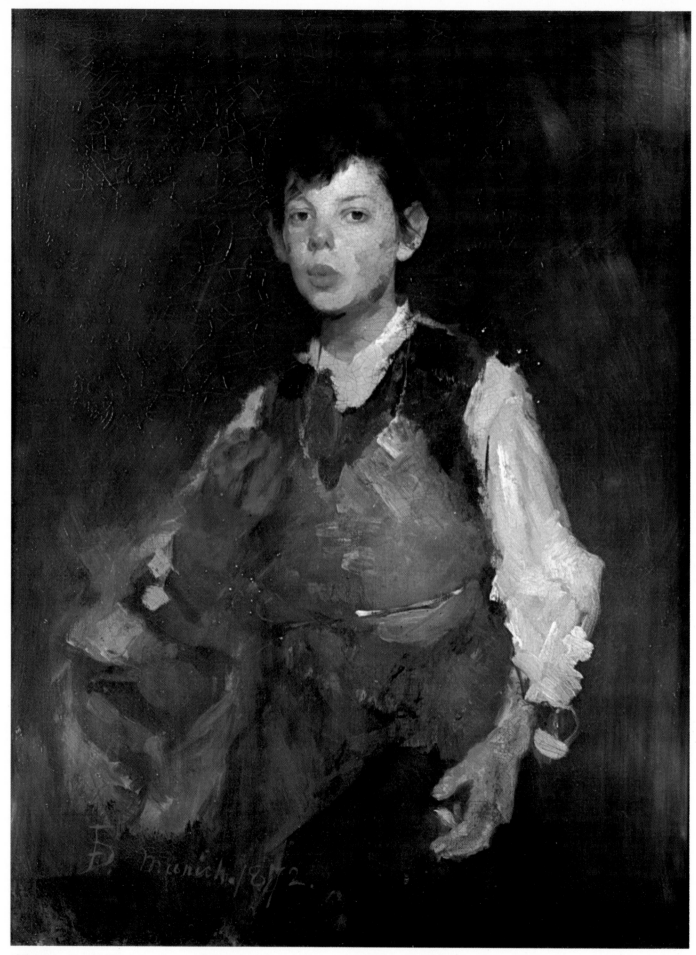

Whistling Boy *by Frank Duveneck, 1872. Oil on canvas, 28″ x 21 1/2″ (71.1 x 54.6 cm).*
Cincinnati Art Museum, Cincinnati, Ohio. Gift of the artist.

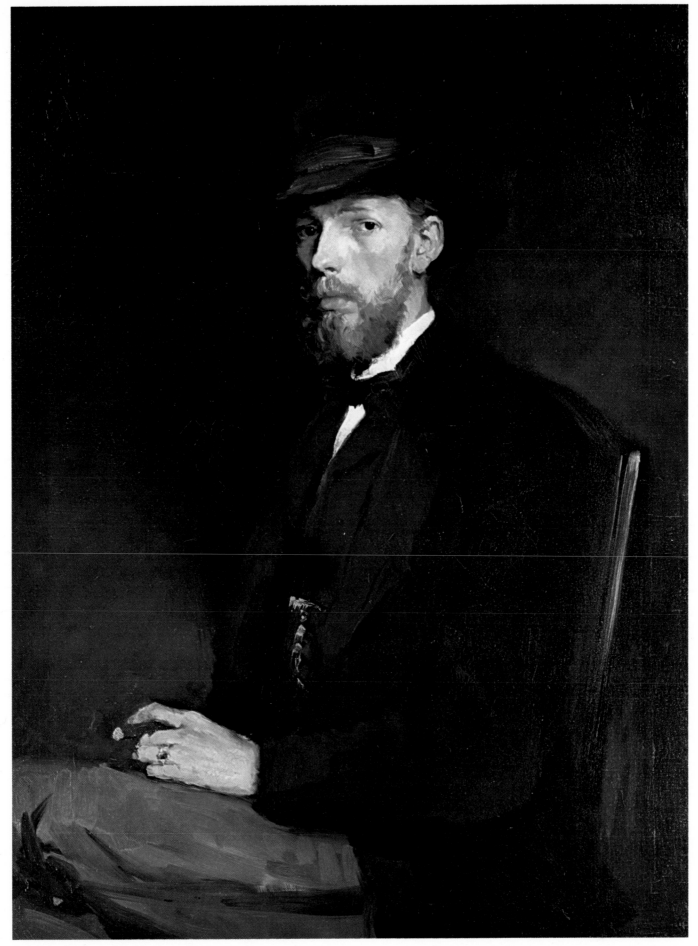

Portrait of Professor Ludwig Loefftz *by Frank Duveneck, c. 1873. Oil on canvas, 38 1/8" x 28 1/4" (96.9 x 71.8 cm). Cincinnati Art Museum, Cincinnati, Ohio. The J. J. Emery Fund.*

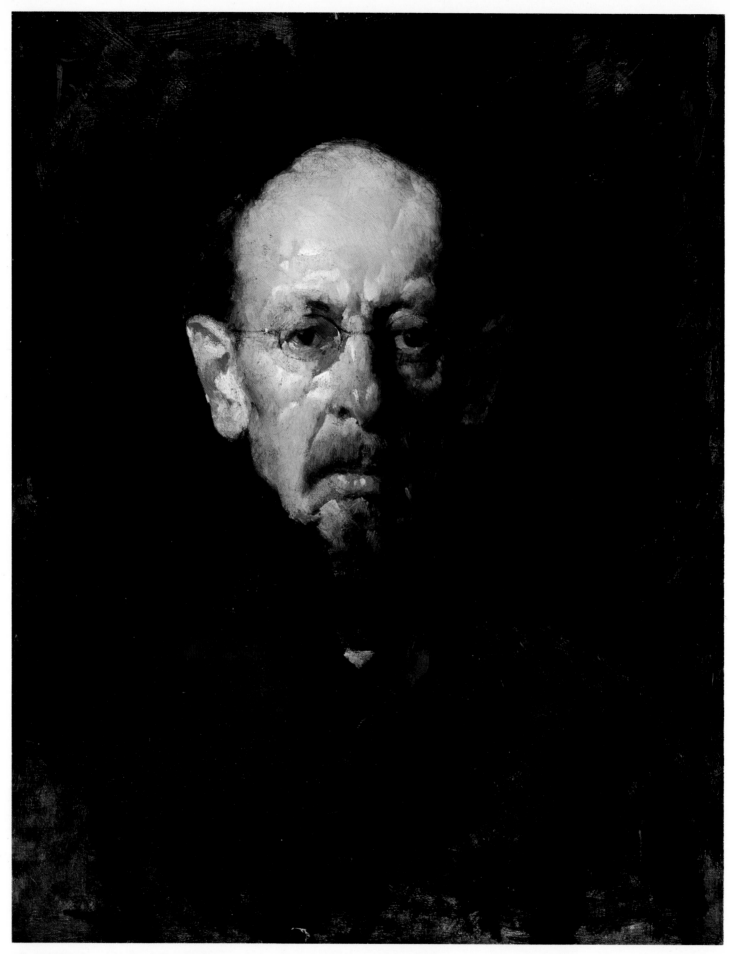

The Old Professor *by Frank Duveneck, 1911. Oil on canvas, 24" x 19 1/4" (61 x 48.9 cm).*
Museum of Fine Arts, Boston, Massachusetts. Gift of Martha B. Angell.

Winslow Homer

1836-1910

Winslow Homer's nature is what city people flee to. He didn't paint the New England mills or the New York slums. Cambridge, where he grew up, was a suburb of Boston, rather than a country village. Homer was a comfortable jump away from the farm, a jump that makes all the difference: he fished for fun, and his Adirondacks were a sportsman's preserve.

He was great on painting the West Indies, where rich people go for the winter. The Bahamas look exactly the way Winslow Homer painted them. The sky is bright blue; the fish are the brightest colors in the world; the palms bend and twist; the water is so blue you can't believe it; and the people are astonishingly black. Homer liked the little pink coral houses and the dry dust of the island roads. In Homer's day, you could see shoals of turtles in the shallows and giant rays. Homer loved the sound of water slapping against the side of the boat. The Out Islands had lots of conch and crayfish, and the red sunsets were splendid.

Van Gogh, who had made an enormous collection of magazine clippings, prized English and American illustrators far more than French Impressionists. He said that the enormously popular and now forgotten Edwin Austin Abbey was the finest of the lot, and proof that not all Americans are bad. Homer too was an illustrator. He got his training in a Boston lithography shop, but quit at twenty-one to draw for the illustrated magazines, then at their peak. Homer's magazine training shows in his work (page 18). He studied briefly at the National Academy in New York before covering the Civil War for *Harper's Weekly*, which was like being a combat photographer for *Life* (page 35). Most of his drawings are camp scenes of men lying around and playing cards. He exhibited his first two paintings in New York in 1863 and became a full member of the National Academy in 1865, at the exceptionally early age of twenty-nine.

After the Civil War, Homer spent a year in Paris, where friends said he didn't work very hard, but where he learned a lot about art. He kept his subject matter American, painting *Snap the Whip* (page 38) and *Long Branch, New Jersey* (page 37) in Paris. When his Civil War pictures were shown at the great Paris World's Fair in 1867, the *London Art Journal* said that Homer was painting what he had seen and known, and his *Prisoners from the Front* made a hit with the French critics.

Back in New York, Homer lived a good bachelor life with painting trips in the summer and a glass in his hand in the winter, his studio full of pictures and the pungent smell of turpentine. One friend said he had the usual number of love affairs. When asked for material for a biography, Homer said it would probably kill him to have such a thing appear, and that the most interesting part of his life was of no concern to the public. In the Tile Club, which included the leading painters and illustrators of the day, he was known as the Obtuse Bard. But nobody kidded Homer very much. He was always a man's man, a bit stand-offish, and with a strong sense of his own worth.

In 1885, when he was forty-eight, Homer left New York and went to live full time on the rocky shore at Prout's Neck in Maine. Here he was as close to the sea as he could get. In bad weather, which he loved, he could actually taste the spray (page 40). His feeling for the sea was probably the deepest love of his life. Homer never got very far from water. His last name was just right for a man who loved the sea. At Prout's Neck and elsewhere, he worked when he wanted to, in a manner which Henry James called "perfect realism" — awkward, lumpy, and only too true to life — which James did not mean as a compliment. Homer loved the woods, storms, the water in the bottom of the boat, and taking fish off the hook; he and Henry James were not exactly made to understand each other. Homer liked guns and duck blinds,

where the whiskey tastes wonderful straight out of the bottle.

Occasionally Homer visited his brother in Massachusetts, and in the spring and fall he fished and hunted in the Adirondacks. He painted the great storms on the coast, the deer and the dogs in the lake, and the ducks falling right and left (page 41). He said that the life he had chosen gave him very full hours of enjoyment for the rest of his life, and that the sun did not rise or set without his notice and thanks. When someone complained about the tragedy in one of his pictures, he said he regretted very much that he had painted a picture that required any description. His paintings say what he meant; Homer was not a wordy man. His paintings do not require explanation. You see what he saw, which is what he meant you to see.

Homer thought birds were more admirable than men, and fish more remarkable. He found the beauty of dawn and sunset a lot more inspiring than people. Homer didn't admire many people, but there were some he did. English fishing girls certainly, the Gloucester fishermen because their lives were dangerous and close to the sea (page 40). He saw the Bahamians as part of nature (page 20). And he admired Maine guides because of their skills.

Homer was a realist, all right. If there was a tre-mendous amount of poetry in his realism, why, what do you think people go fishing for? It's the poetry of the land that draws people to the outdoors. Homer was the most romantic of our realists; but that's no contradiction. The Realist painters came straight out of the romantic movement — in France, anyway, where Courbet tried to paint like Delacroix. The romantics discovered nature, and Winslow Homer was a nature painter. He would have denied this, of course, but Homer denied everything. He simply painted what he loved.

Though Homer became a kind of hermit, he didn't retire from the world until after he'd learned all he needed to know about painting. He was a professional painter all his life. The American Impressionists were his friends, and he took from them just what he needed: the momentary flash of light and the whiteness of some of his watercolors, though that may have had English sources. Along with the Impressionists, he left out the dingy side of life, the mean streets back of town. When Homer got enough money, he went to live in a spectacular spot with surf all around and the gulls screaming. He could rise in the morning when the sun woke him and paint when he pleased. That was the world he loved. He thought his pictures were good because they said exactly what he wanted and looked exactly like what he saw.

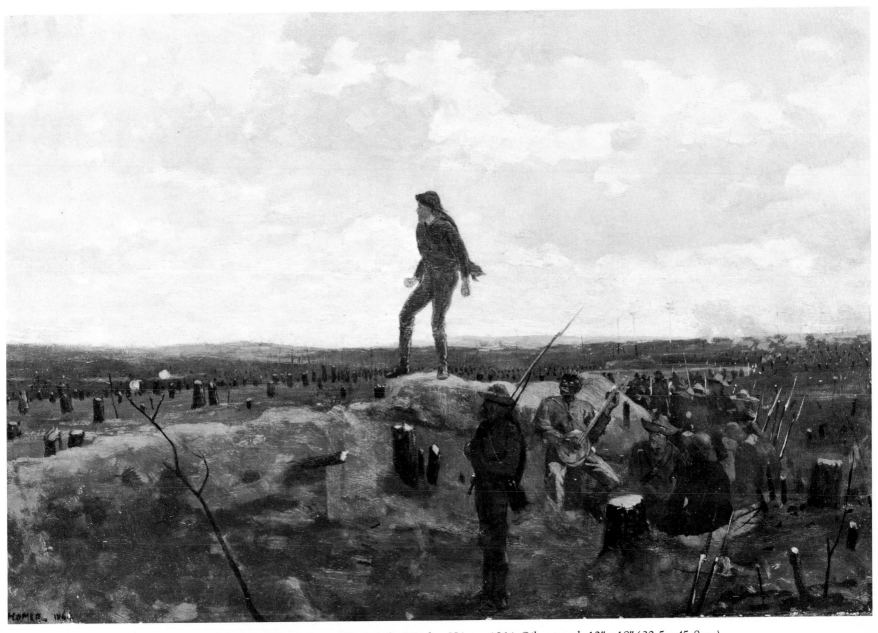

Defiance, Inviting a Shot Before Petersburg, Virginia *by Winslow Homer, 1864. Oil on panel, 12″ x 18″ (30.5 x 45.8 cm).*
The Detroit Institute of Arts, Detroit, Michigan. Gift of Dexter M. Ferry, Jr.

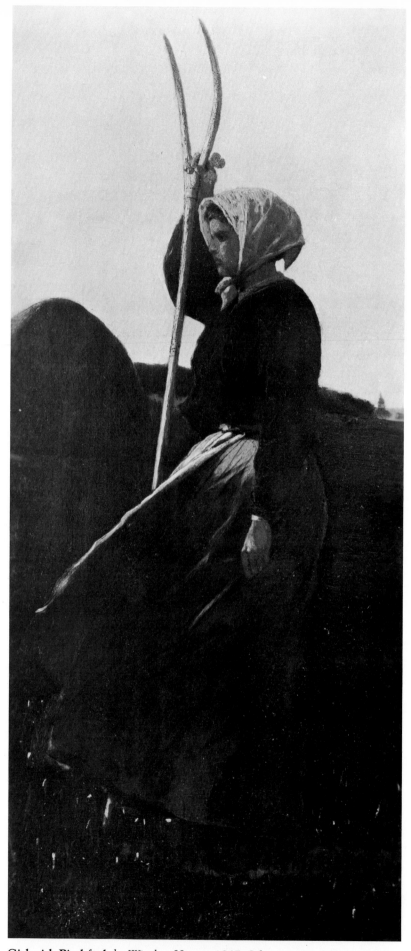

Girl with Pitchfork *by Winslow Homer, 1867. Oil on canvas, 24" x 10 1/2" (61 x 26.7 cm). The Phillips Collection, Washington, D.C.*

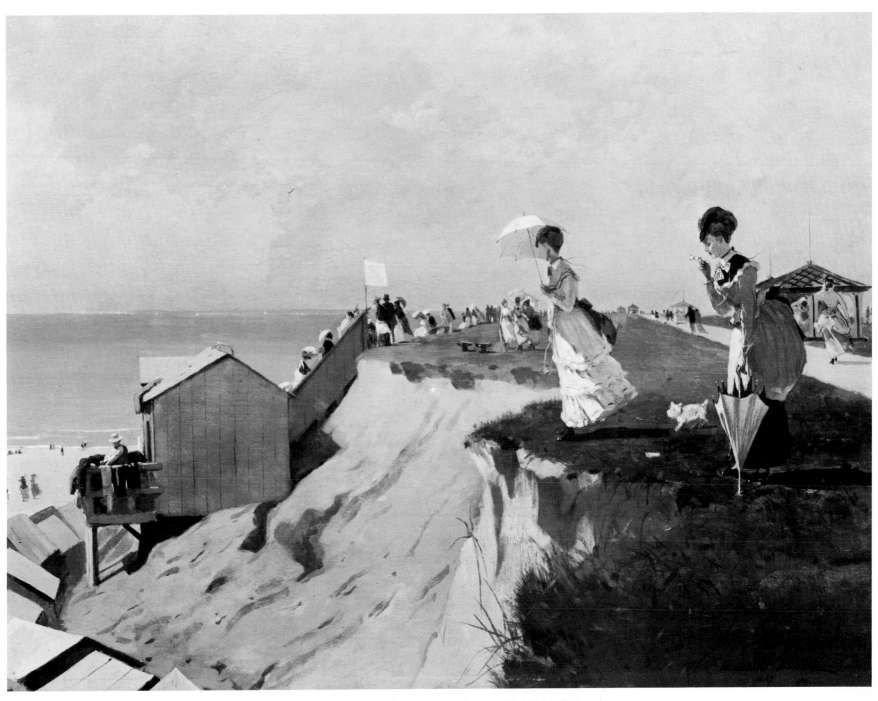

Long Branch, New Jersey *by Winslow Homer, 1869. Oil on canvas, 16" x 21 3/4" (40.6 x 55.2 cm).*
Museum of Fine Arts, Boston, Massachusetts. Charles Henry Hayden Fund.

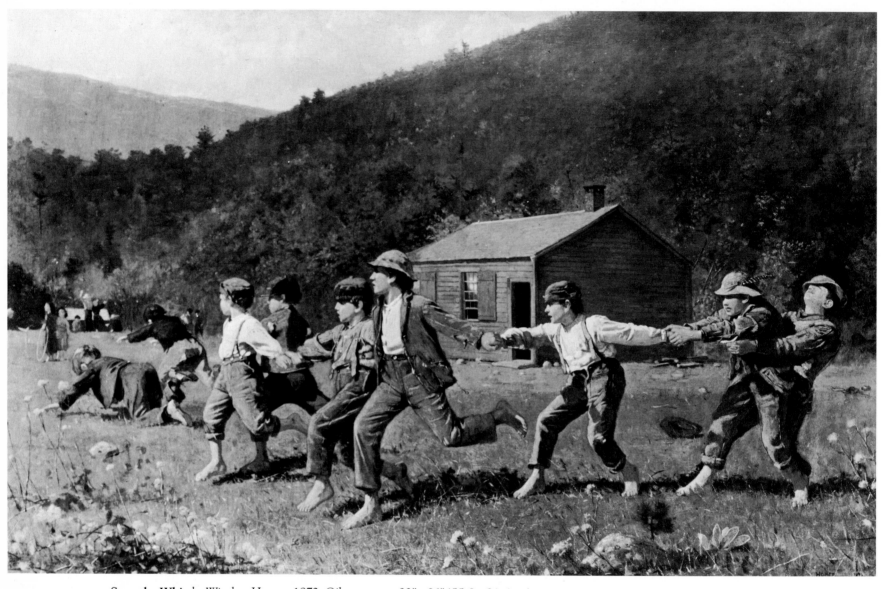

Snap the Whip *by Winslow Homer, 1872. Oil on canvas, 22" x 36" (55.9 x 91.4 cm).*
The Butler Institute of American Art, Youngstown, Ohio.

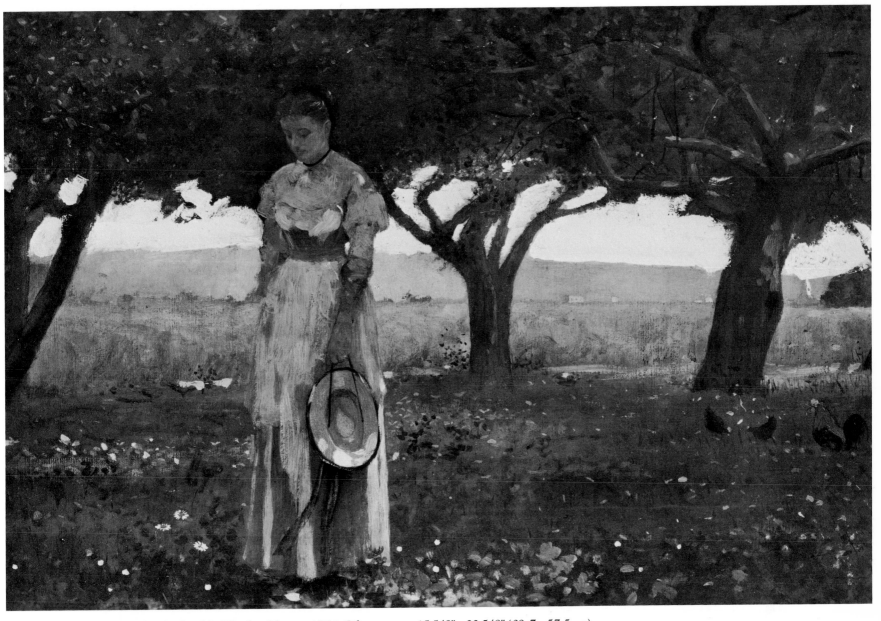

Girl in the Orchard *by Winslow Homer, 1874. Oil on canvas, 15 5/8" x 22 5/8" (39.7 x 57.5 cm).*
The Columbus Gallery of Fine Arts, Columbus, Ohio. Howald Fund Purchase.

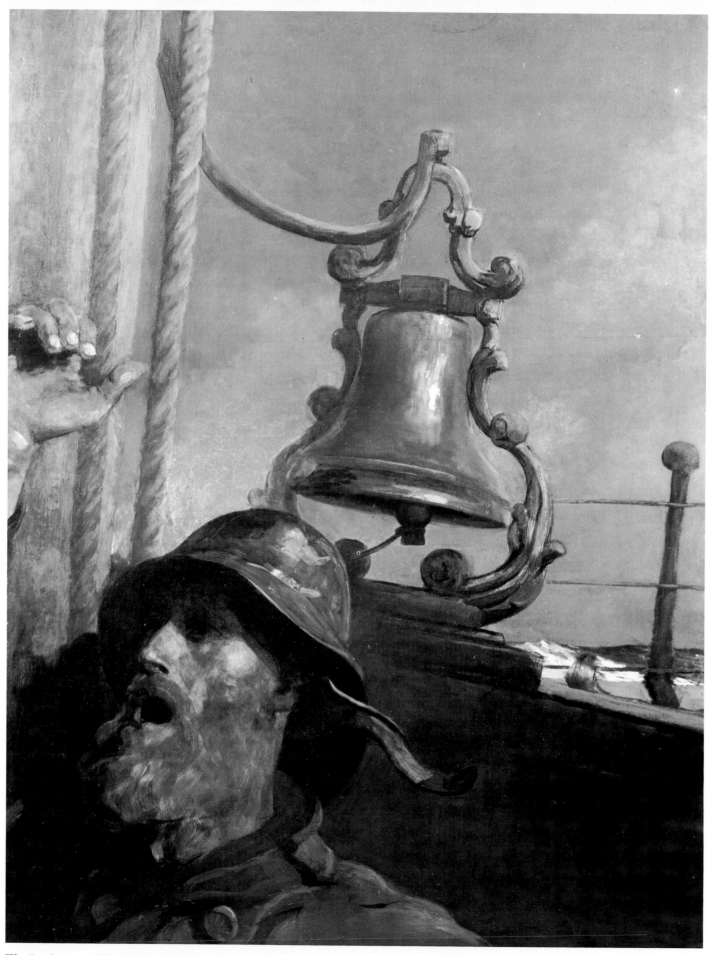

The Lookout — All's Well *by Winslow Homer, 1896. Oil on canvas, 40″ x 30 1/4″ (101.6 x 76.8 cm). Museum of Fine Arts, Boston, Massachusetts. William Wilkins Warren Fund.*

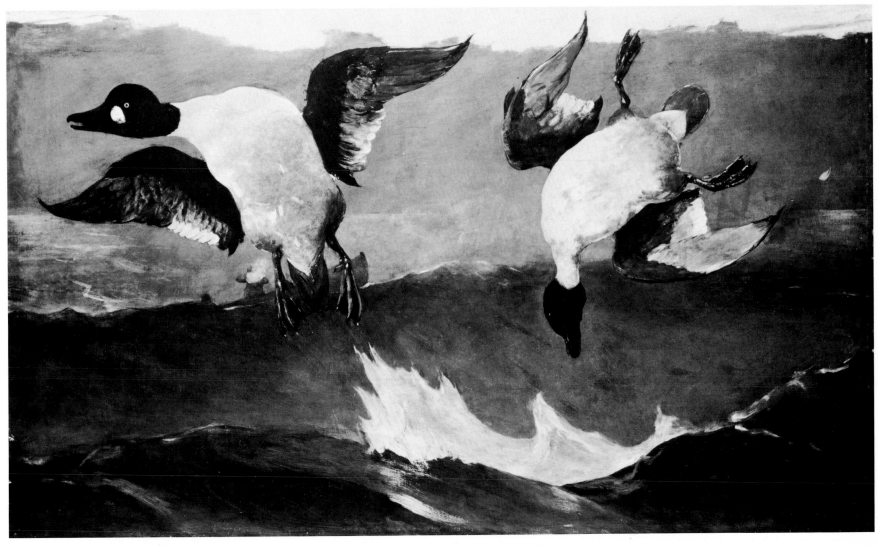

Right and Left *by Winslow Homer, 1909. Oil on canvas, 28 1/4" x 48 3/8" (71.8 x 123 cm).*
National Gallery of Art, Washington, D.C. Gift of the Avalon Foundation.

James McNeill Whistler

1834-1903

To the outside world, Whistler is our most important painter. Although the French never heard of most of our artists, they accept Whistler because of his personal connections with Courbet and Degas. And since he made his career in England, and was very much a part of the local scene, the English think of him as their own. Except for a few portraits, his subject matter is European. For Whistler, Titian and Tintoretto were great swells, Canaletto and Guardi great masters, and he felt that he was in that class. He did not consider himself in competition with his American contemporaries. There's very little that is American about his art. Perhaps we should nationalize his great gifts, as the Poles did Chopin's.

This refined, even remote painter began as a realist and even the vaguest of his later paintings are an intense and precise response to nature. For all his pose and pretense, (and his occasional cruelty), Whistler had a strong feeling for what went on in the mist of a London evening, or in the bright north light of the studio with the model posing — all his models were enchanting. Whistler did not invent Venice from a distance, or the long stretch of London's Thames river (page 21); he saw them. He was impatient with people who could *not* see. He took his work directly from his surroundings. He never painted a picture he hadn't seen. His problem was that he found it astonishingly difficult to catch his own best vision on canvas.

Born in the States and brought up abroad, Whistler went back to Paris as an art student and never saw America again. In a famous appearance in court, Whistler gave his birthplace as St. Petersburg because he refused to be born in Lowell, Massachusetts, and because he had spent some time as a boy in St. Petersburg, where his father, an army engineer, built the railroad to Moscow. In Turgenev's Russia, the Whistlers maintained an American home with American food and American friends, although

Whistler learned French and went to the Imperial Academy of Fine Arts. According to his story, the Czar suggested that he go to page school, but his formidable mother dragged him back to America after his father's death, where he flunked out of West Point. Chemistry was his nemesis: he liked to say that had silicon been a gas, he would have been a major general.

When Whistler arrived in Paris in 1855, the young painters were throwing over romanticism for realism. He made friends all over the Latin Quarter by modeling himself on Murger, the picturesque author of the influential *Scenes de la Vie de Bohême,* and he was one of the models for Du Maurier's *Trilby.* Whistler was very conscious of the effect he produced and he enjoyed playing the art student's role just as he later enjoyed playing the role of the great master in black hat and black cape.

His early work looks very much like Courbet, the founder of French realism, who became a great friend (page 45). Though Whistler later regretted Courbet's influence, he started out as a realist. He was Courbet's most brilliant follower, but not for very long, for he was quicker and finer than Courbet. When they both painted Whistler's Irish mistress, Whistler produced masterpieces of charm and grace, while Courbet painted a Wagnerian creature with eyes like a cow.

Whistler's *At the Piano* (page 45), painted when he was twenty-five, is a completely original picture; you'd swear he'd never seen a Courbet. The subject is his half-sister, the wife of the etcher Seymour Haden, at the grand piano with her daughter Annie beside her, a "symphony in black and white" though he hadn't yet made up the phrase. Rejected by the Salon, *At the Piano* was accepted by the artists, and in London, Thackeray admired it beyond words. Millais called it "the finest picture of color that has been on the walls of the Royal Academy for years." Whis-

tler always had a very high reputation with other painters; no matter how infuriating they found him, they never questioned his ability.

Whistler liked to give the impression that he did things easily, tossing off an etching in a couple of hours, and while it's true that some of his best work was done quickly, most of the time he slogged along. He worked too much. He'd repaint a hundred times to make a painting look as though it just happened, and sometimes it never worked out.

In London, he lorded it over the local artists. Frenchmen like Degas would never have put up with that. But the English are far more indulgent to Americans than they are to each other. Whistler sold well, and he could have been a great financial success if he had been willing to suffer fools. But he wasn't a good manager and he had expensive tastes.

He found his great subject in London (pages 21, 47, and 49). The smoke and fog were just what he needed; for Whistler, poetry started in reality. He was afraid that Courbet would steal his London scenes, which Baddelaire called "a chaos of fog, chimneys and smoke, and the profound and complicated poetry of a vast capital."

Things went well for him in London, but Whistler was a very combative little man who got into fights with his best patrons, for he could not bear to be under obligation to anyone. The only one he didn't fight with was Charles Freer, the founder of the Freer Gallery in Washington and his best buyer in his later years. Whistler had a chip on his shoulder. The world didn't give him his due and he was impossible to get along with. If there had been duels in England, he would have fought them.

Though sometimes objectionable as a public figure, he was a great favorite with all kinds of people. His conversation was brilliant; he could hold forth by the hour. He talked circles around Oscar Wilde, or thought that he did, for Wilde was a very kindly man. But beyond his wit and charm, Whistler had a tender side, which he showed mostly to his wife and to close friends like Pennell, whose biography is the best book on an American artist.

Most people stayed out of Whistler's way, but John Ruskin, with his immense prestige as a critic, met him head on. "For Mr. Whistler's own sake, no less than for the protection of the purchaser," Ruskin said, "Sir Coutts ought not to have admitted works into the gallery in which the ill-educated conceit of the artist so nearly approached the aspect of willful imposture. I have seen, and heard much of cockney impudence before now, but never expected to hear a coxcomb ask two hundred guineas for flinging a pot of paint in the public's face." Whistler sued. He enjoyed showing off in the witness box, but the case literally bankrupted him.

After the Ruskin trial, Whistler went off to Venice as though nothing had happened and dashed off the finest etchings of his century. He worked as hard as ever, still seeking perfection. As he got older, he had trouble finishing his pictures, often overworked them, and some have darkened into black holes. He didn't know when to quit. No pictures are as good as Whistler *thought* his own should be. He had no great last phase, like Goya or Rembrandt, but his finest paintings are realistic masterpieces.

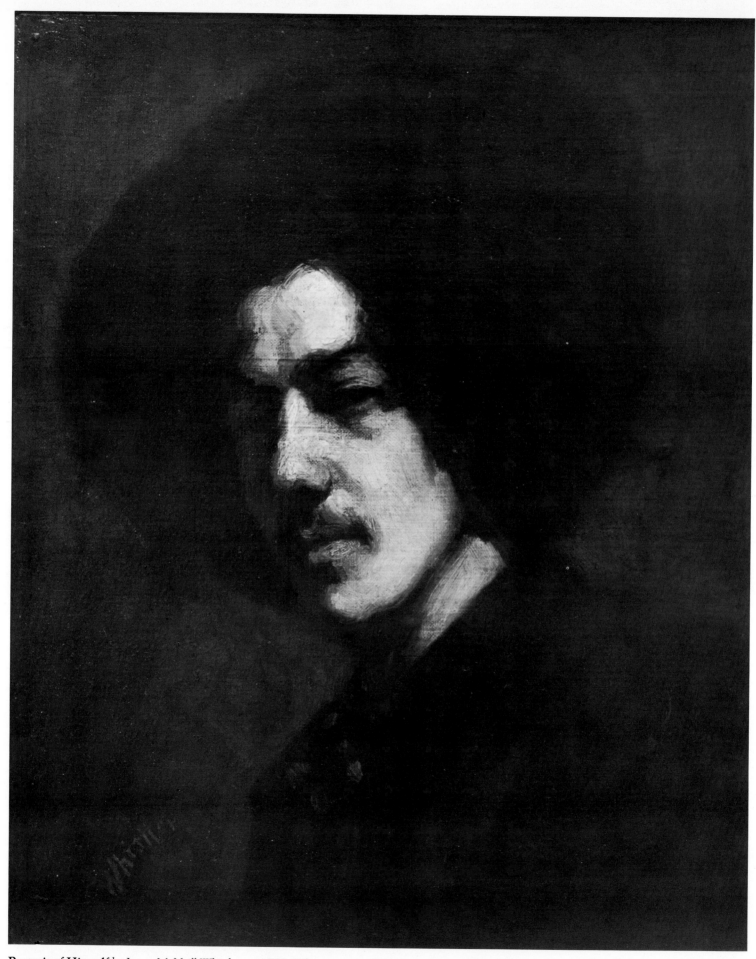

Portrait of Himself by *James McNeill Whistler, c. 1858. Oil on canvas, 18 1/4" x 15" (46. 4 x 38. 1 cm).*
Freer Gallery of Art, The Smithsonian Institution, Washington, D.C.

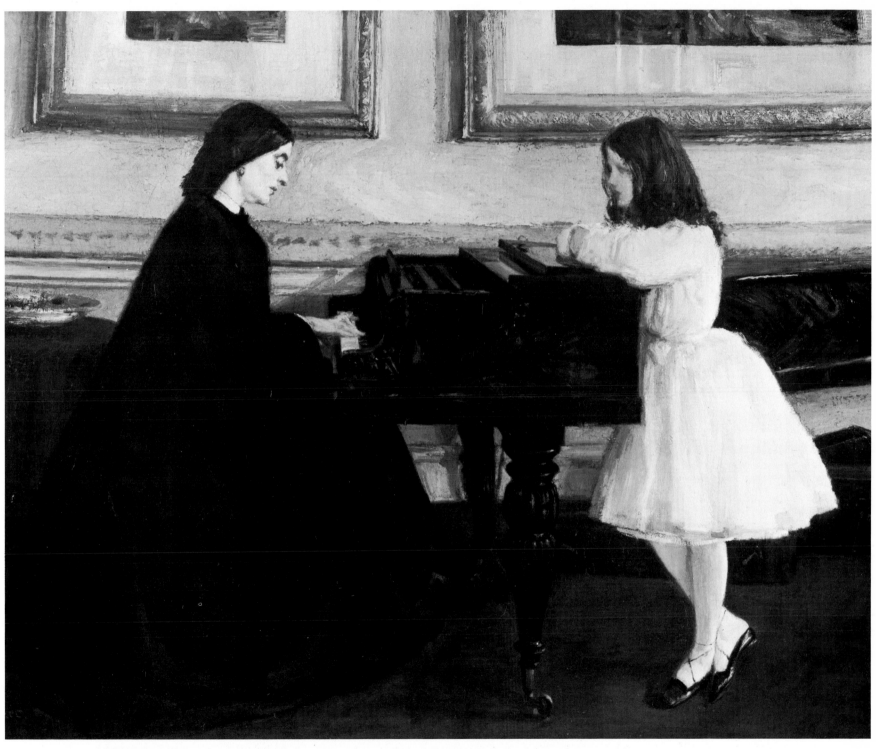

At the Piano *by James McNeill Whistler, 1859. Oil on canvas, 26 3/8″ x 36 1/16″ (67 x 91.6 cm).*
The Taft Museum, Cincinnati, Ohio. Louise Taft Semple Bequest.

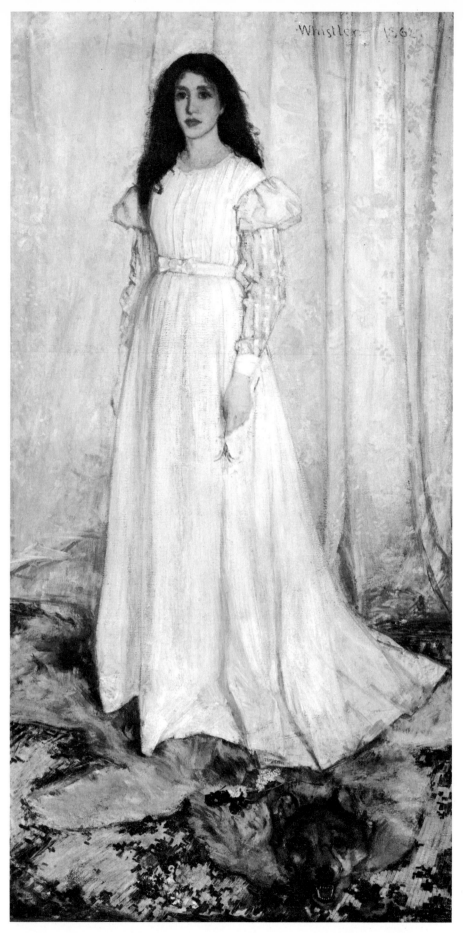

The White Girl: Symphony in White, No. 1 *by James McNeill Whistler, 1862.*
Oil on canvas, 84 1/2" x 42 1/2" (214.6 x 109 cm).
National Gallery of Art, Washington, D.C. Harris Whittemore Collection.

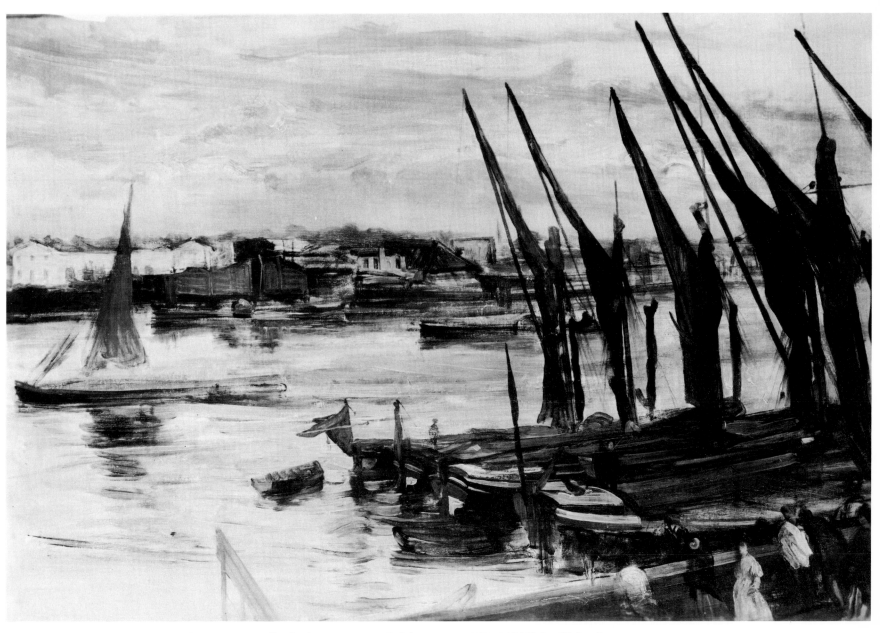

Battersea Reach by James McNeill Whistler, c. 1863– 65. Oil on canvas, 20″ x 30″ (50.8 x 76.2 cm).
The Corcoran Gallery of Art, Washington, D.C. Bequest of James Parmelee.

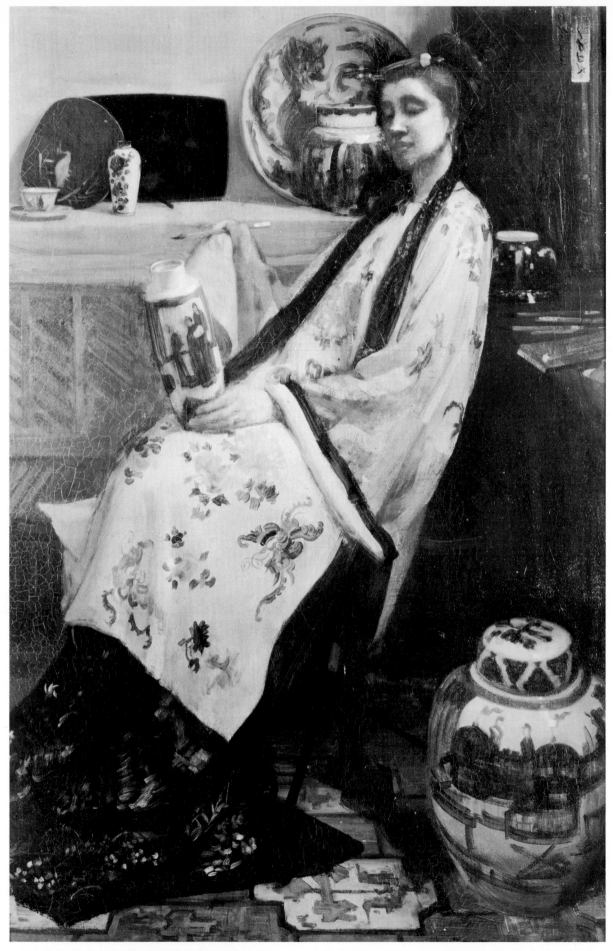

Lady of the Lange Lijzen *by James McNeill Whistler, 1864. Oil on canvas, 36 1/4" x 24 1/4" (92 x 61.6 cm). John G. Johnson Collection, Philadelphia, Pennsylvania.*

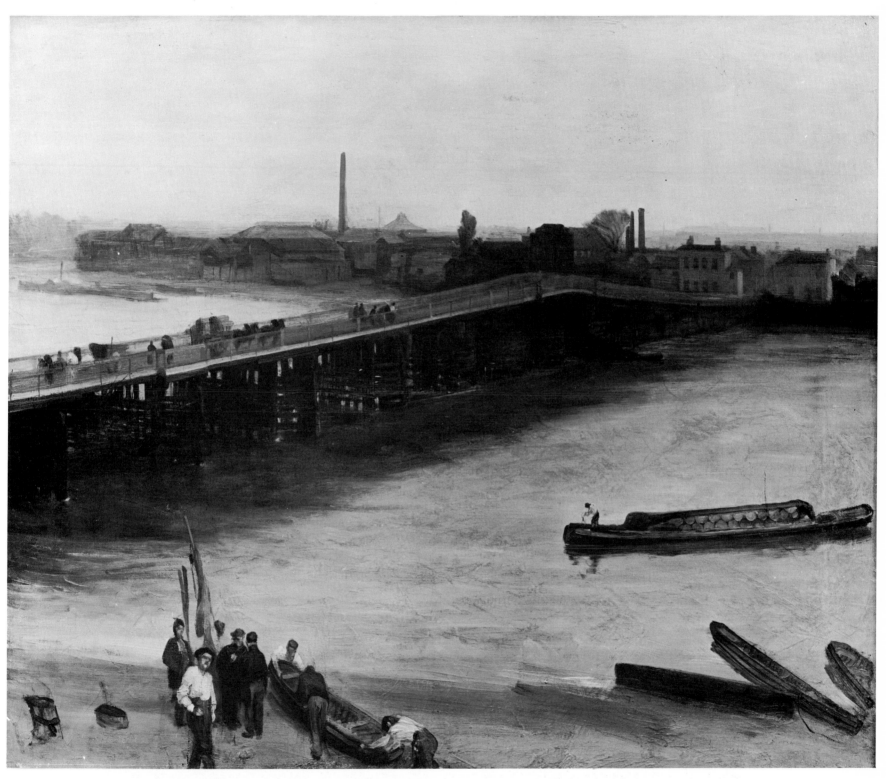

Brown and Silver: Old Battersea Bridge by James McNeill Whistler, c. 1865. Oil on canvas (remounted on Prestwood), 25" x 30" (63.5 x 76.2 cm). Addison Gallery of American Art, Phillips Academy, Andover, Massachusetts. Gift of Cornelius N. Bliss.

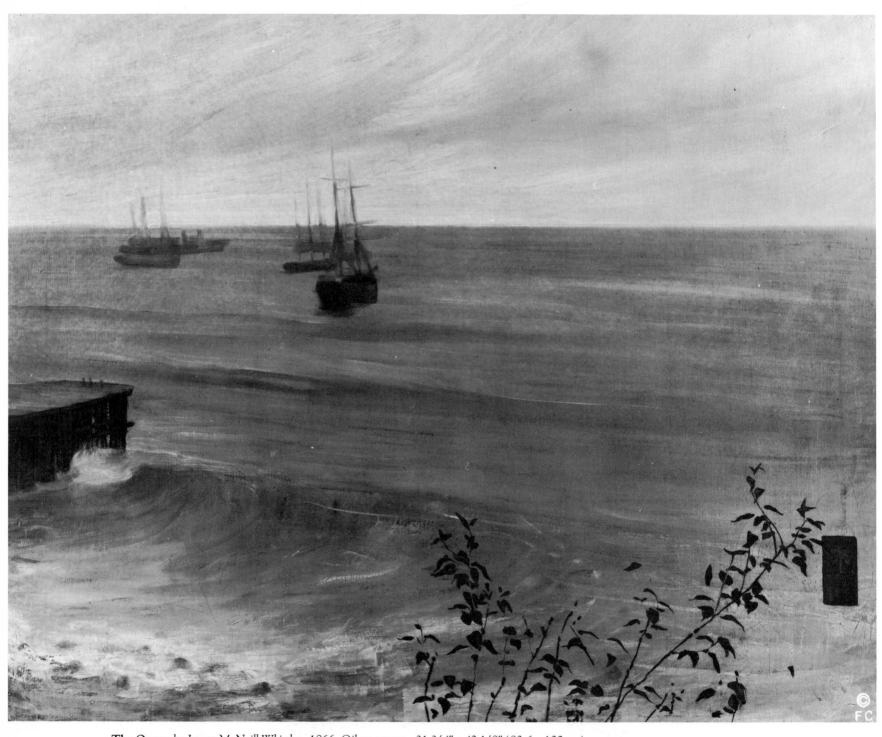

The Ocean *by James McNeill Whistler, 1866. Oil on canvas, 31 3/4″ x 40 1/8″ (80.6 x 102 cm).*
Copyright The Frick Collection, New York, New York.

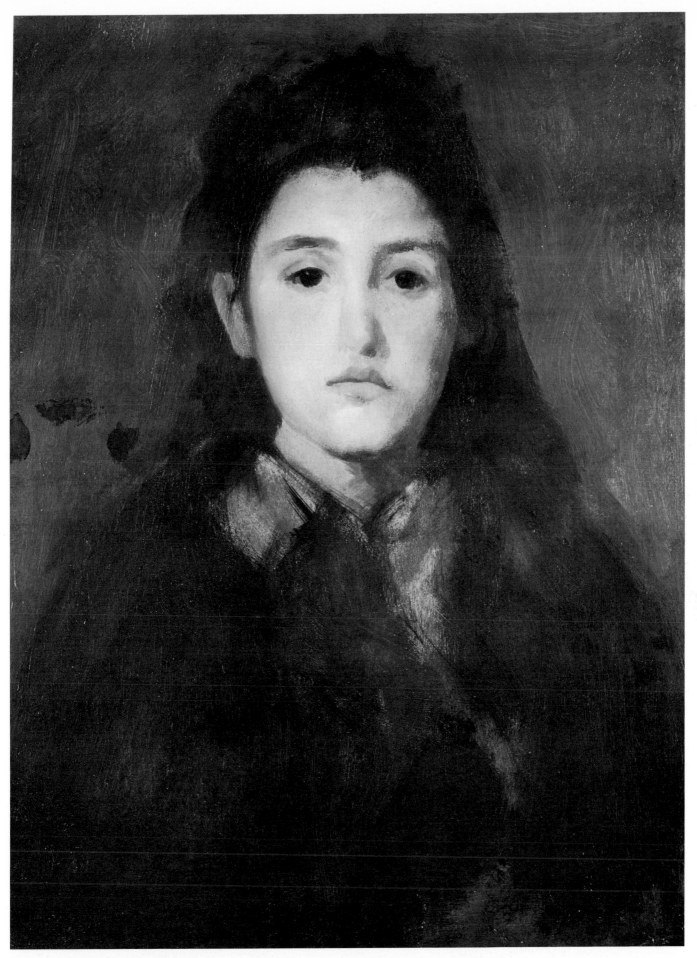

Head of a Girl *by James McNeill Whistler, c. 1883. Oil on canvas, 20 5/16" x 15" (51.6 x 38.1 cm).*
National Gallery of Art, Washington, D.C. Gift of Curt H. Reisinger.

Mary Cassatt

1845 - 1926

Although Mary Cassatt exhibited with the French Impressionists, she painted very few Impressionist pictures. Actually she was a realist like her mentor, Degas. In the history of European art, only Mary Cassatt and Whistler were accepted as colleagues by the French painters of the day. She was a figure painter; about all she borrowed from Impressionism was a light palette and a flash of light. She was a painter of women and children, who change far less than men. She never made up a picture in her life, always painting what was in front of her. Her subjects were her world, her heart's desire.

At an early age, she moved with her family to Europe, where Degas was the decisive event in her artistic life. A maiden lady and an obsessive aunt, she became the poet of the nursery (pages 24 to 26 and 61); her pictures are poems of the life she did not have. Though her paintings are very much her own, they look a good deal like the work of her French contemporaries Berthe Morisot and Eva Gonzales.

When her great friend Mrs. Horace Havemeyer began collecting, Mary Cassatt recommended the work of her friends in Paris, but she also had an eye for the old masters, and persuaded Mrs. Havemeyer to buy the finest El Grecos in the world. When her rich Cleveland friends, the Popes, had McKim, Meade, and White build a magnificent colonial mansion in Farmington, Connecticut, Cassatt filled it with Impressionist pictures. She put the young Philadelphia collector Carroll Tyson in touch with Faure, a star of the Paris Opera, who owned forty-three Manets. If American museums are now rich in Impressionist pictures, it is due, first of all, to Mary Cassatt.

James Stillman, chairman of the National City Bank, who collected women's dresses as well as pictures, was the only man besides Degas who meant a thing to her. Stillman admired her elegance and her clothes, and may have wanted to marry her. (When asked if she had had an affair with Degas, her reply was contempt.)

She spent her life painting at her château near Paris and her villa on the Riviera, convinced that mothers did not know how to hold their own children. In her country house, where her French neighbors considered her demented for putting in more bathrooms, she entertained people like Vernon Lee (page 112), a writer on odd Florentine themes and a wildcat behind those thick glasses, who had a most unexpected opinion of her hostess: "Miss Cassatt is very nice, simple, an odd mixture of self-recognizing artist, with passionate appreciation in literature." One American art student was closer to the mark when he called her a fiery and peppery lady, a very vivid, determined personality, positive in her opinions; he was scared to death of her.

She was an international figure all her life, but living abroad only accentuated her Americanism. She spoke French fluently — with an American accent which she didn't want to lose. George Biddle, the painter member of the famous Philadelphia family, said that, socially and emotionally, she remained the prim Philadelphia spinster of her generation (pages 54 and 56).

Eakins liked to say that his wife was the most important American woman painter, but nobody paid any attention to him; Mary Cassatt always had that position. She was head and shoulders above the competition, male or female, and the fact that she was a woman was immaterial.

She had no use for Sargent or Henry James or Edith Wharton, for she felt they fawned on society. When Mrs. Montgomery Sears, a Bostonian collector whom she advised on her collecting, took her to one of Gertrude Stein's parties on the Rue de Fleurus, Cassatt said that she had never in her life seen so many dreadful paintings in one place, nor had she seen so many dreadful people gathered together.

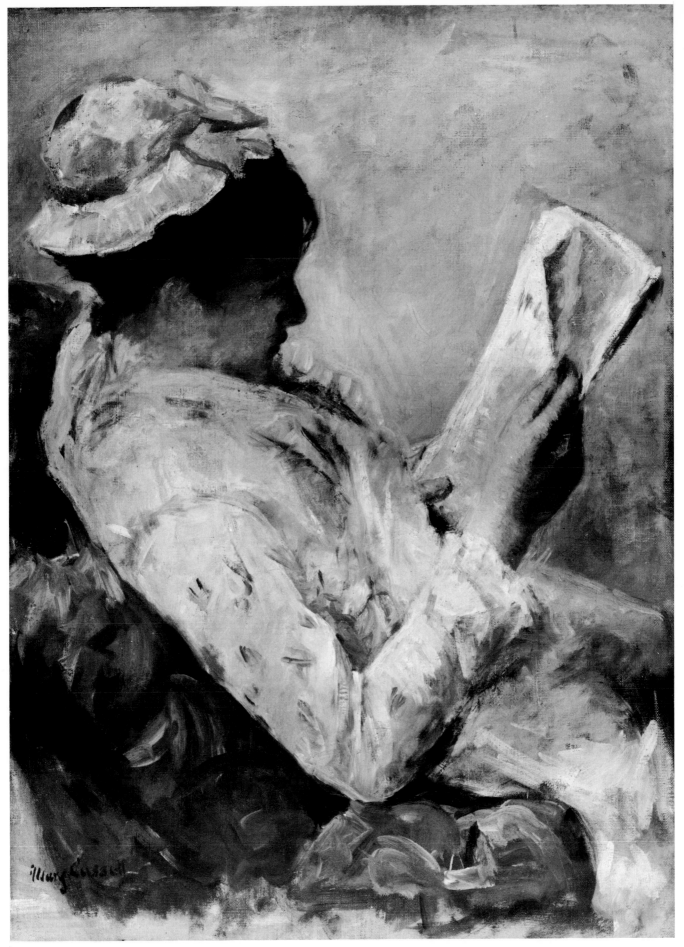

Portrait of Lydia Cassatt, The Artist's Sister *by Mary Cassatt, 1878. Oil on canvas, 23 1/2" x 32" (59.7 x 81.3 cm).*
Joslyn Art Museum, Omaha, Nebraska.

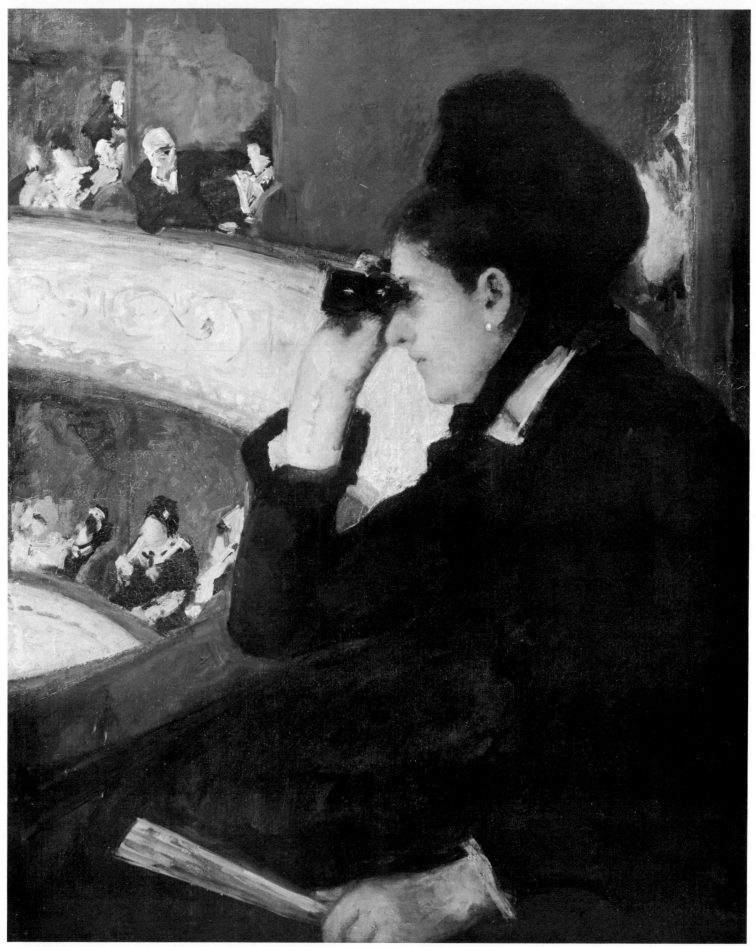

At the Opera by Mary Cassatt, 1879. Oil on canvas, 31 1/2" x 25 1/2" (80 x 64.7 cm).
Museum of Fine Arts, Boston, Massachusetts. Charles Henry Hayden Fund.

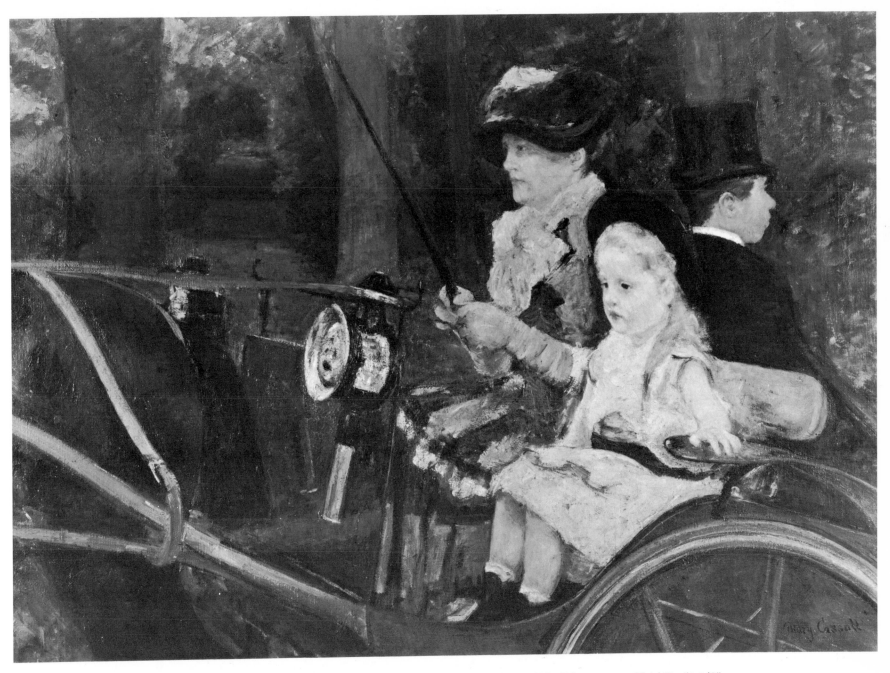

Woman and Child Driving (*Lydia Cassatt and a Niece of Degas'*) *by Mary Cassatt, 1879. Oil on canvas, 35 1/4" x 51 1/2" (89.5 x 130.8 cm). Philadelphia Museum of Art, Philadelphia, Pennsylvania. The W. P. Wilstach Collection.*

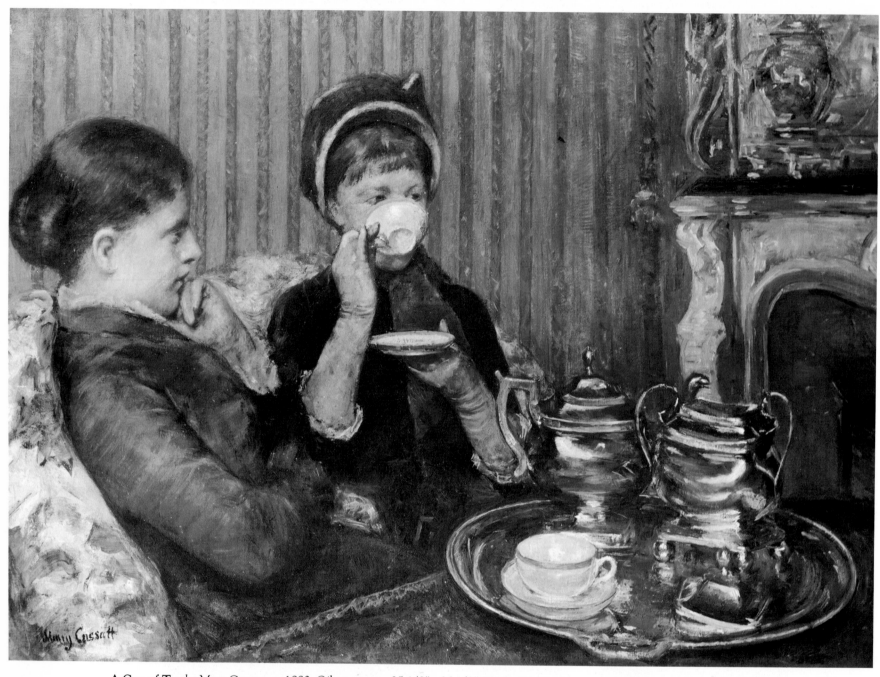

A Cup of Tea by Mary Cassatt, c. 1880. Oil on canvas, 25 1/2" x 36 1/2" (64.8 x 92.7 cm).
Museum of Fine Arts, Boston, Massachusetts. Maria Hopkins Fund.

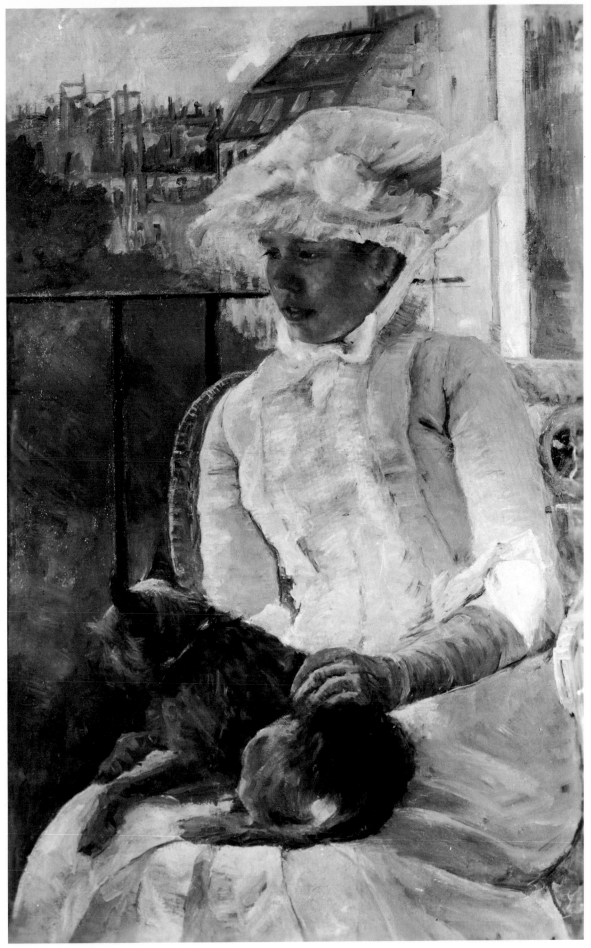

Woman with a Dog by *Mary Cassatt, c. 1880. Oil on canvas, 39 1/2" x 25 1/2" (100. 3 x 64. 8 cm).*
The Corcoran Gallery of Art, Washington, D.C.

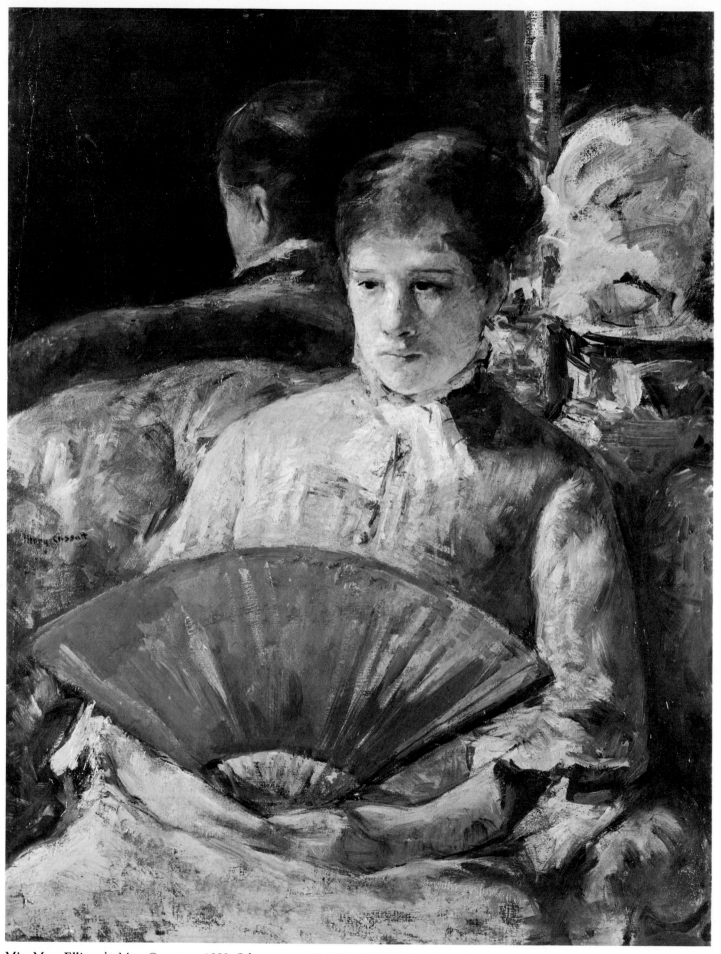

Miss Mary Ellison *by Mary Cassatt, c. 1880. Oil on canvas, 33 1/2″ x 25 3/4″ (85 x 65.4 cm).*
National Gallery of Art, Washington, D.C. Chester Dale Collection.

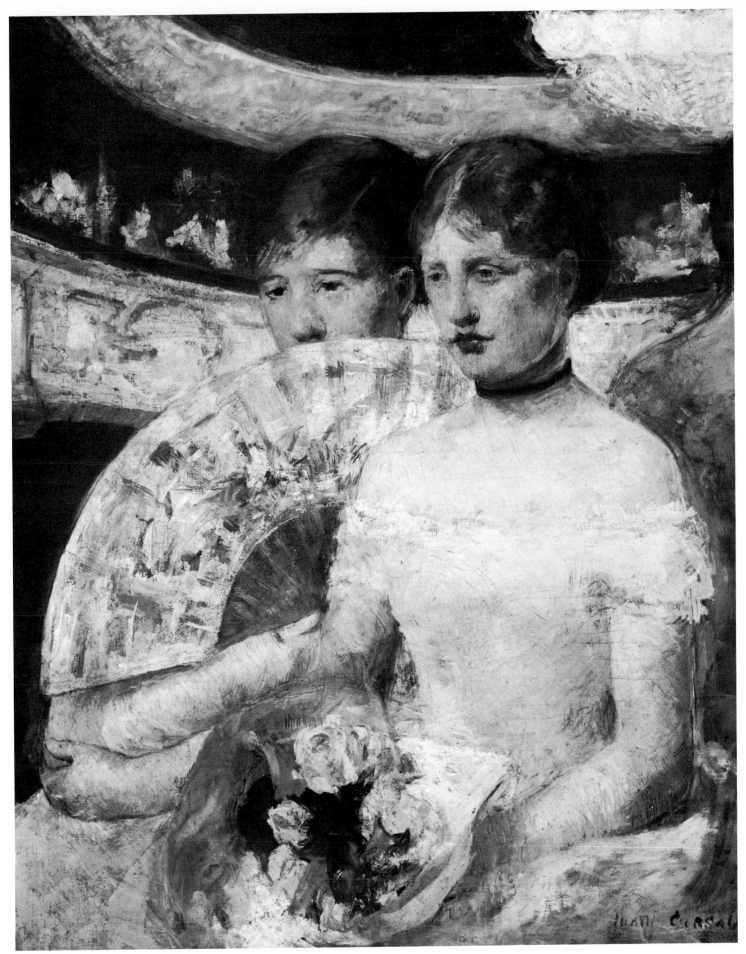

The Loge by Mary Cassatt, 1882. Oil on canvas, 31 1/2" x 25 1/8" (80 x 63.8 cm).
National Gallery of Art, Washington, D.C. Chester Dale Collection.

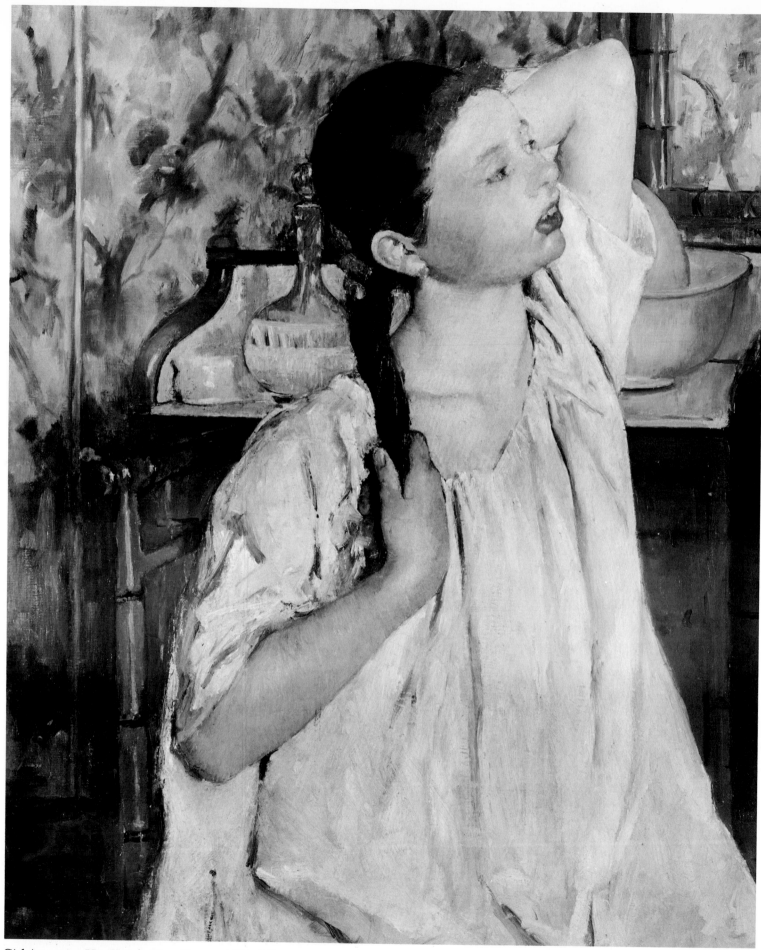

Girl Arranging Her Hair *by Mary Cassatt, 1886. Oil on canvas, 29 1/2" x 24 1/2" (74.9 x 62.2 cm). National Gallery of Art, Washington, D.C. Chester Dale Collection.*

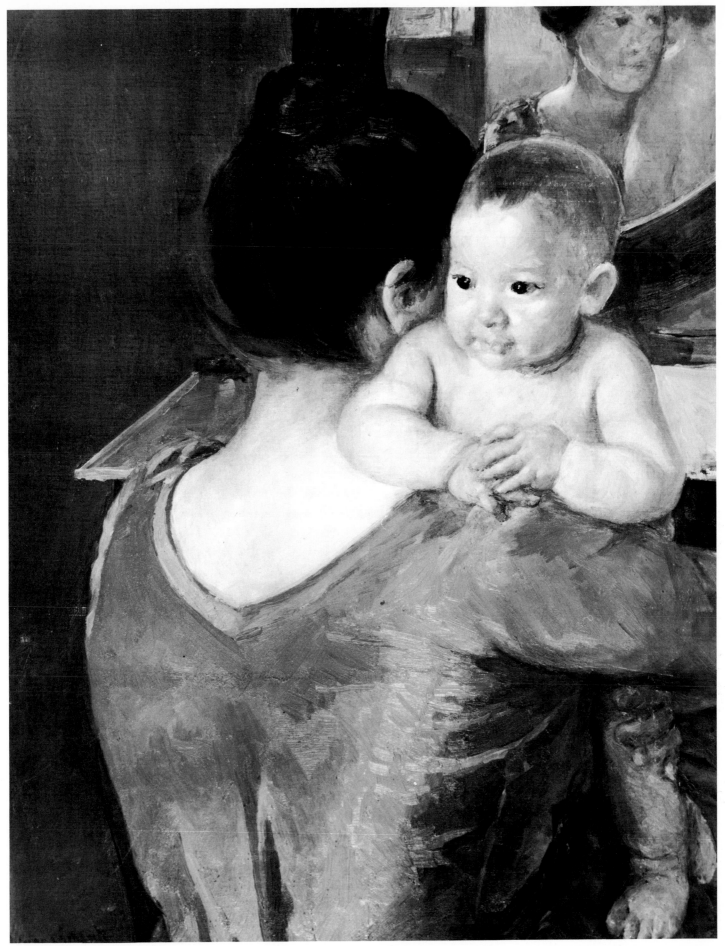

Mother and Child by Mary Cassatt, 1900. Oil on canvas, 27 3/4" x 20 7/8" (70.5 x 53 cm).
The Brooklyn Museum, Brooklyn, New York. Carll H. De Silver Fund.

Thomas Eakins

1844-1916

Thomas Eakins ground his way through four years of traditional art training at the École des Beaux-Arts in Paris without going to the Louvre. Manet and Courbet, whom he later admired, meant nothing to him in his student days. According to Eakins' sister, who came over to Paris on a visit, his hat was a great, big, gray steeple like a garbageman's, his coat a brown sack, and his best pants had the biggest grease spot you ever saw. Picturesque outside, he was conservative within; it had never occurred to him to question what he was taught. Eakins was a slow starter: he woke up at twenty-four, when many men have done their best work and closed their minds for the night. He hit his stride late and never changed it. When his vision came, it stayed with him the rest of his life. He was slow and stubborn, and once he saw things his own way, he kept them in focus.

When he got through the Beaux-Arts, Eakins knew everything about the mechanics of painting, but pictures didn't mean much to him until his graduation trip to Spain. He'd been too busy working. He was a good student, but it might just as well have been medicine. He had no specific talent; he went to class and turned in his work. Eakins was like an inarticulate character in a novel by Thomas Hardy: melancholy, harsh to others, quick to protect himself. Things may have been going on underneath, but they certainly didn't show.

Spain was the great artistic experience for Eakins: obviously he was ready for it. For Eakins and for many men of his time, Velasquez was the reality of life. They felt, and Eakins felt, that Velasquez conveyed everything that it is possible to paint — far more than it is possible to say. Painting begins where words fail; that's why people paint. During his winter in Seville, Eakins and his friends walked out into the country where every quarter of a mile there'd be little groups of men and women, parties, family affairs, with eating, drinking, and dancing. This was the world he learned from Velasquez. He started his first real picture in Seville, and he learned it all from Velasquez.

Soon after he got back to Philadelphia, the young firebrand from Paris was painting the realistic pictures we admire today. Though *The Pair-Oared Shell* (page 64) may have been inspired by an illustration in an English magazine, it was a brand new subject for painting. The oars make extraordinary angles, and Eakins caught the hesitating motion and the looming mass of the bridge. Soon he was a remarkably successful teacher at the Pennsylvania Academy. But with Eakins, things were never simple. When the Governing Board of the Pennsylvania Academy of Fine Arts objected to his posing a nude, he stomped out of the school in a fury, never suspecting that he might have had a bee in his bonnet.

Eakins felt the world was against him; he needed opposition, even if he had to make it up. Eakins knew he was right, and the rest of the world, the Philadelphia art world, was a bunch of stupid fools. Eakins needed to feel that he was persecuted. That's what gave him his peculiar insight into his sitters: his portraits are people bedeviled by life, by their own minds. This man who never looked in the mirror was painting himself all the time. Like all realists, he picked his own reality: he knew exactly what his sitters felt, because that's the way he felt himself. It's surprising that some people put up with Eakins' portraits; they must have agreed with what he saw.

Eakins was a harsh man, rough in his manners, capable of cruelty and rudeness, which he considered a mark of character. Things were never easy for him; he never let them be. Anything pleasant was unworthy of a serious man. He was fascinated by the painful side of sport, the crushing exhaustion. No cricket at Germantown for him, with those idiots in white flannels. He liked the slow agony of wrestling (page 29), the rancid sweat of the locker room. His boxers are never exultant; they're full of fear before

they start (pages 28 and 69). He was fascinated by the bloody side of nineteenth-century surgery: the gray cadavers, those tired surgeons, crushed with fatigue, were inspiring figures; so was Eakins. In the portraits of his friends, all the women have Mary Cassatt's frustrations, all the men have Eakins' fears. His blacks are careworn, his whites worried to death.

Eakins didn't have much influence as a painter, but he remained a great presence around the Pennsylvania Academy. Perhaps he wasn't as original as we think; the best Salon paintings aren't too far from his work. Rigidly conservative, this most American artist — who wrote to himself in French — said that Delacroix's pictures were abominable, that his men were monkeys. Eakins never went back to Europe, and modern art meant nothing to him. His opinion of his fellow artists was low.

In many ways, Eakins was an academic painter. He carried his Beaux-Arts training on his back; he believed in hard work, in anatomy, and in drawing from the model. That's the way he'd been brought up, and that's the way he taught. In his own day, he was old-fashioned enough to be understood. There were no innovations in his style to frighten people off; there was no language problem. But he told people things they didn't want to know, so it's no wonder that he wasn't wildly popular. The remarkable thing about this rigid man was that he said so much that people could understand.

He had his own work to do, and he did it. That's as much as you can say for any artist. A lonely and difficult man, only one thing gave him profound satisfaction: his work. If you'd have told Eakins he was happy, he'd have bitten your head off; but alone in the studio in the late afternoon, when it got too dark to paint, he felt the way he'd felt in Spain.

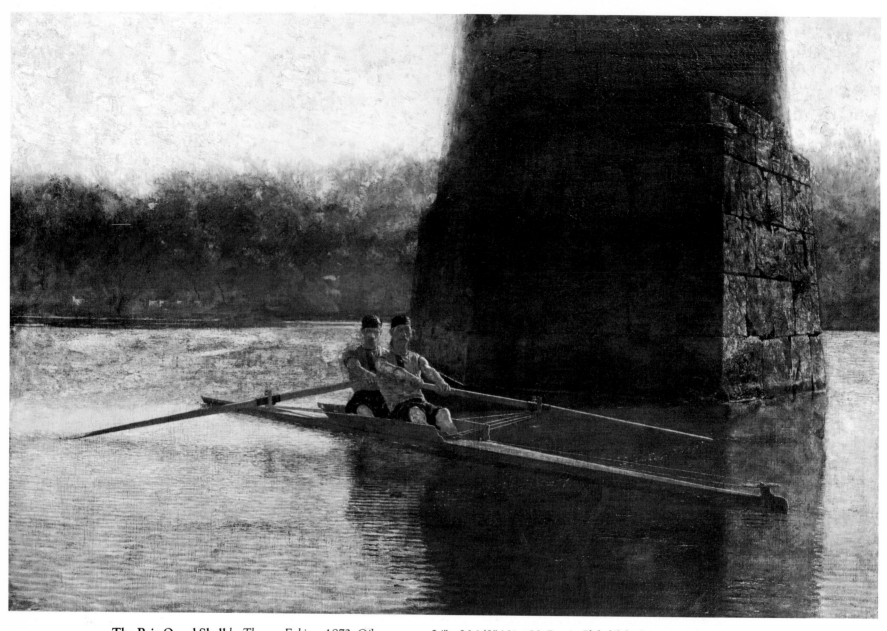

The Pair-Oared Shell *by Thomas Eakins, 1872. Oil on canvas, 24" x 36 1/2" (61 x 92.7 cm). Philadelphia Museum of Art, Philadelphia, Pennsylvania. Given by Mrs. Thomas Eakins and Miss Mary A. Williams.*

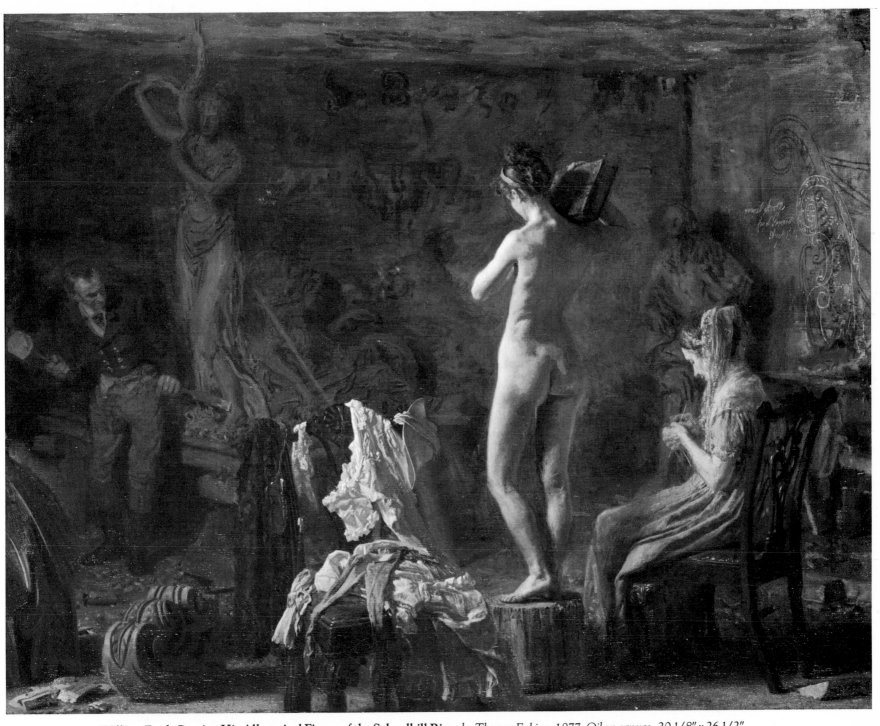

William Rush Carving His Allegorical Figure of the Schuylkill River *by Thomas Eakins, 1877. Oil on canvas, 20 1/8″ x 26 1/2″ (51.1 x 67.3 cm). Philadelphia Museum of Art, Philadelphia, Pennsylvania. Gift of Mrs. Thomas Eakins and Miss Mary A. Williams.*

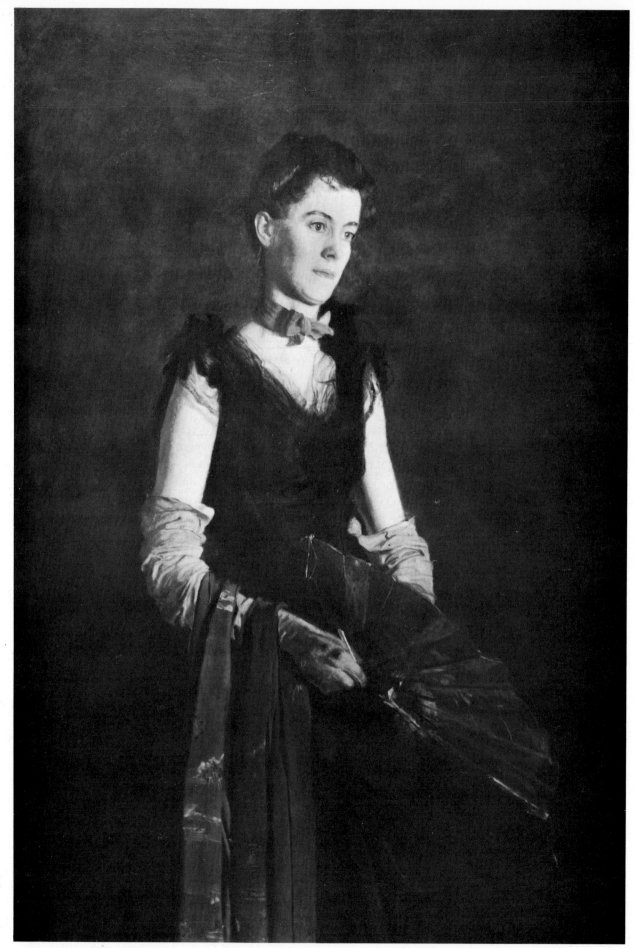

Letitia Wilson Jordan Bacon *by Thomas Eakins, 1888. Oil on canvas, 60″ x 40″ (152.4 x 101.6 cm).*
The Brooklyn Museum, Brooklyn, New York. Dick S. Ramsay Fund.

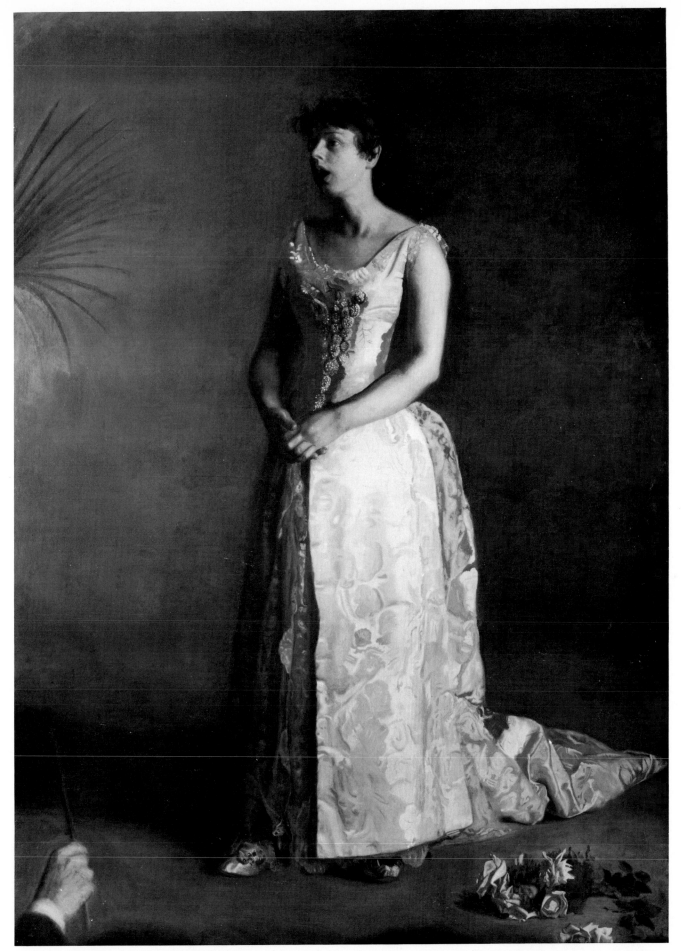

The Concert Singer, Portrait of Weda Cook by *Thomas Eakins, 1892. Oil on canvas, 75 3/8″ x 54 3/8″ (191.5 x 138.1 cm).*
Philadelphia Museum of Art, Philadelphia, Pennsylvania. Given by Mrs. Thomas Eakins and Miss Mary A. Williams.

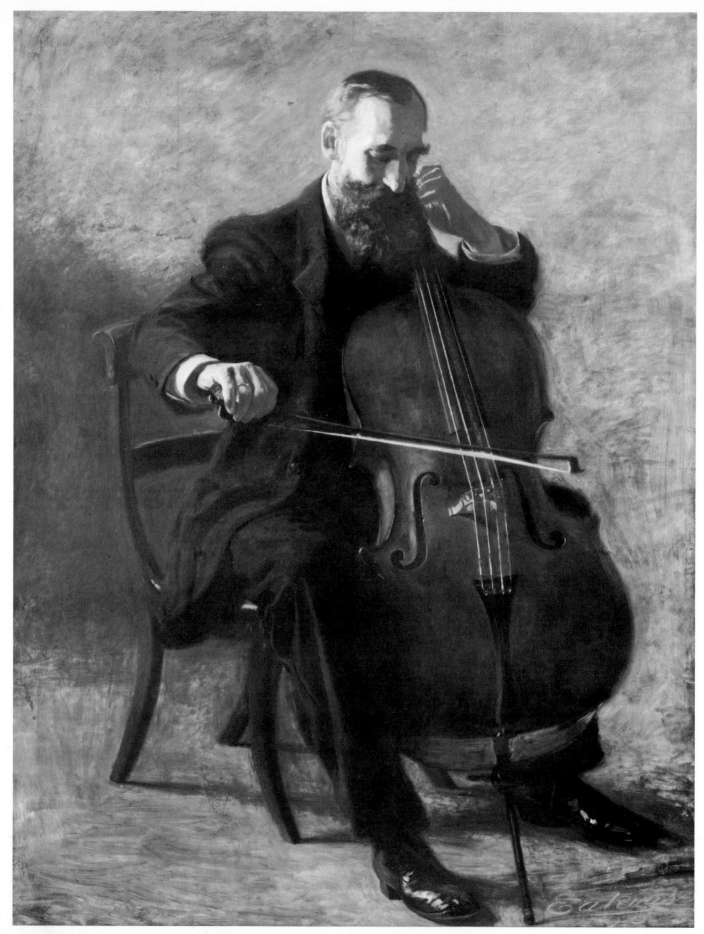

The Cello Player *by Thomas Eakins, 1896. Oil on canvas, 64 1/2" x 48 1/2" (163.8 x 123.2 cm).*
Pennsylvania Academy of the Fine Arts, Philadelphia, Pennsylvania. Temple Fund Purchase.

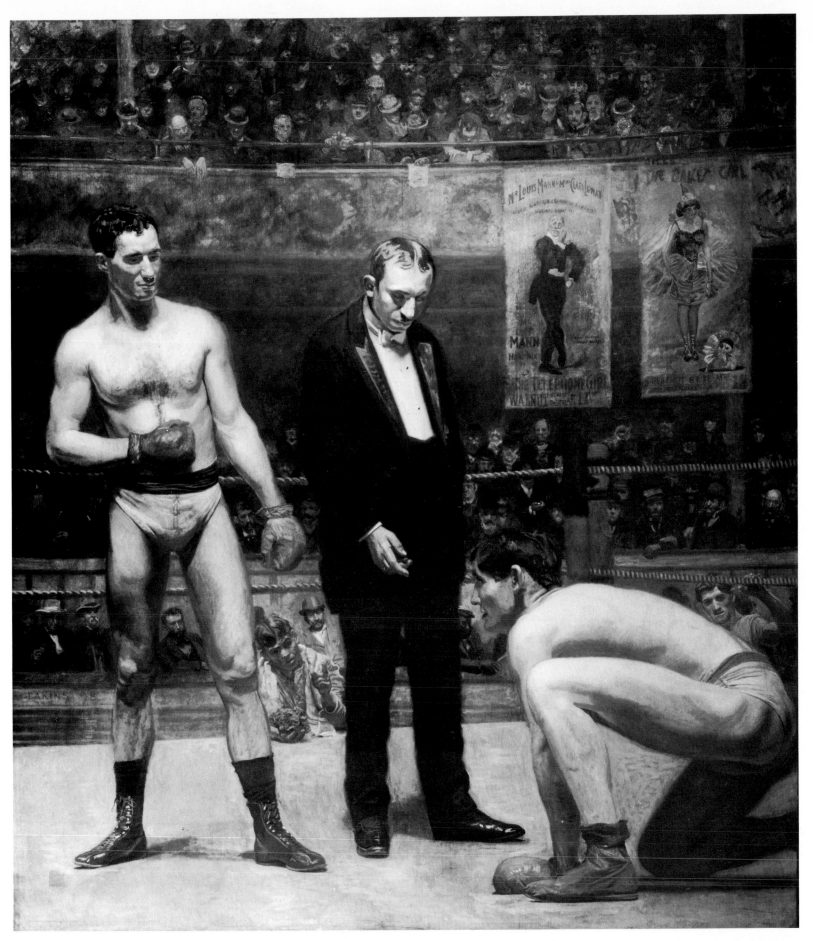

Taking the Count by *Thomas Eakins, 1898. Oil on canvas, 8 5/16" x 7 5/16"(21.11 x 18.6 cm).
Yale University Art Gallery, Whitney Collection of Sporting Art, New Haven, Connecticut.
Given in memory of Harry Payne Whitney and Payne Whitney by Francis P. Garvan.*

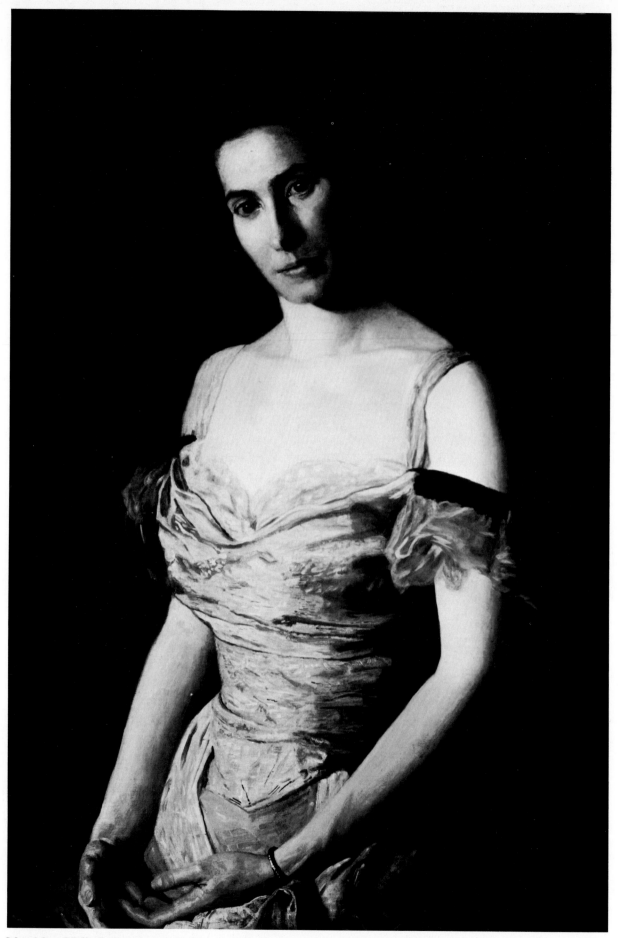

Mrs. Mary Hallock Greenewalt *by Thomas Eakins, 1903. Oil on canvas, 36″ x 24″ (91.4 x 61 cm).*
Wichita Art Museum, Wichita, Kansas. The Roland P. Murdock Collection.

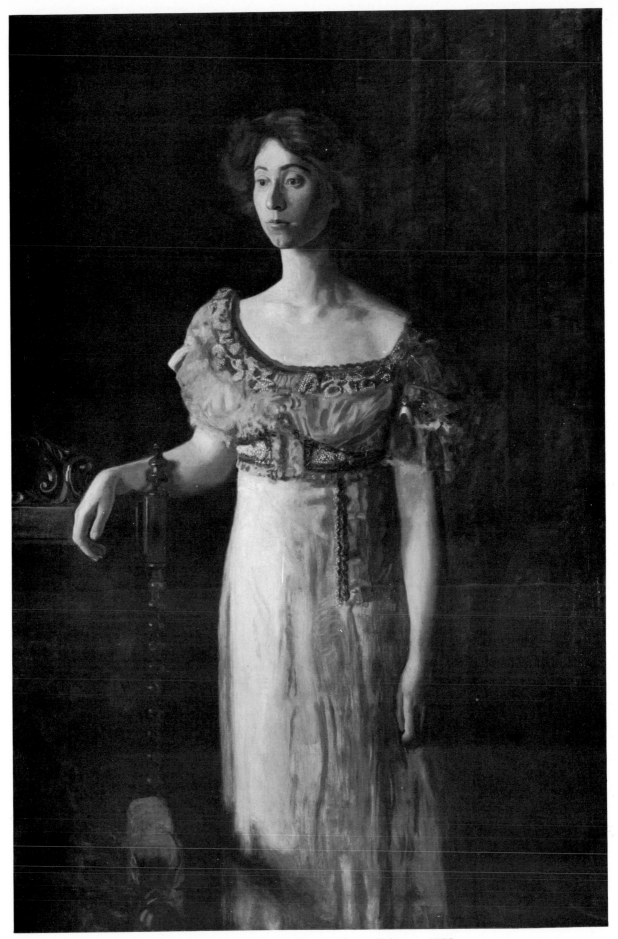

The Old-Fashioned Dress, Portrait of Miss Helen Parker *by Thomas Eakins, c. 1908.*
Oil on canvas, 60 3/8" x 40 1/4" (153.4 x 101.7 cm). Philadelphia Museum of Art, Philadelphia, Pennsylvania.
Given by Mrs. Thomas Eakins and Miss Mary A. Williams.

Frank Duveneck

1848-1919

When Duveneck landed in Munich in 1870, just after Courbet's visit, which brought realism to Germany, the city looked like heaven to this boy from Cincinnati who'd been apprenticed to a religious painter. After working in ugly Catholic churches from New Jersey to Quebec, he was overwhelmed by the Dutch pictures in the galleries, the dark beer, and the blonde girls. In no time flat, he was painting better than anybody except Leibl and leading the life of the gods. He caught the new realistic manner, mixed it with the bravura of Frans Hals, and started out as a genius.

In Germany, students were little lords, and Duveneck loved the student life. He went to the top immediately, among the foreign students anyway. It was impossible to drink too much dark beer, though Duveneck tried, and there was always room for one more girl. Life was wonderful and, as for painting, he couldn't miss, knocking off the best pictures of his life in a few hours — local characters, mostly (pages 30, 32, and 78). Duveneck was blasted with ecstacy. Things couldn't be this good, but they were: he could paint old studio props, the models everybody used, and they came out realistic masterpieces (pages 74 and 80). He had success when young, the time success is most needed. He could *show* you how to knock out a masterpiece; he would paint all over your canvas. Without any transition, his fellow students became his pupils. He made painting easy, just as it was easy for him. Do it, don't think about it! No wonder his pupils loved him.

When Duveneck went back to Cincinnati for a visit, swaggering around like a student prince, the Queen City seemed dreary indeed.

His exhibition in Boston made a great impression on Henry James. "We speak of realism," James said, "when we say that the half-dozen portraits have an extraordinary interest. They are all portraits of men — and of very ugly men: they have little grace, little finish, little elegance, none of the relatively superfluous qualities. But they have a most remarkable reality and directness, and Velasquez is in fact the name that rises to your lips as you look at them." Their great quality was their extreme naturalness, their unmixed, unreduced reality (pages 31, 74, 76, and 78). Most of the paintings were sold, and one of them was bought by Elizabeth Boott, a close friend of Henry James.

When Duveneck returned to Munich, he brought along Twachtman, who became one of our leading Impressionists, and Henry Farny, who ended up as a successful Indian painter. (Twachtman's father was a Cincinnati policeman known as "Die Wacht am Rhein.") Surrounded by his "boys," Duveneck was pursued by women ranging from Lady Colin Campbell to Lizzie Boott. The latter persuaded him to move from Munich to Florence, where she made him start an art school which was just as successful as she said it would be. She handled his business affairs and made him buy a dress suit. She had no trouble with Duveneck, but she had a great deal with her father, who was pathologically devoted to her. A woman of forty, she'd never spent a night away from home. When she insisted on marrying Duveneck, the old man nearly died: it was the worst thing that had happened to him since his wife died just after Lizzie was born.

Henry James didn't help much; for him, the Bootts were marvels of imagination. "When originally alighting among us en *plein Newport*," James said, "they had seemed fairly to reek with a saturation, esthetic, historic, romantic, that everything round about made precious. As for the admirable, the infinitely civilized and markedly *produced* Lizzie — this delightful girl, educated, cultivated, accomplished, toned above all, as from steeping in a rich old medium; she was to be thrown away on a brawling, illiterate barbarian from the low saloons and bawdy

waterfronts of the West." As for the father, "A not other than lonely and bereft American addicted to the arts and endowed for them housed to an effect of long expatriation in a massive old Florentine villa with a treasured and tended little daughter by his side, that was the germ which for reasons beyond my sounding the case of Frank Boott had been appointed to place deep down in my view of things."

Despite Henry James' predictions of disaster, Lizzie was supremely happy in her marriage, and she had a son, whom Henry James called a little red worm. When Lizzie died suddenly, Duveneck turned his son over to his possessive father-in-law and moved back to Cincinnati. The local art world adored him, but his painting fell apart. He tried to paint in the new Impressionist manner, but he never made it. His series of religious paintings across the river in Covington are incredibly bad. The nudes he painted for his favorite saloons were knockouts, but when this great painter died in 1919, he was forgotten by the world.

Duveneck's artistic career was lopsided. He started out as a realist and ended up as a failed Impressionist, for the later work would never have made a reputation for one of his students. If he had come back to New York after Lizzie's death, he would have been sustained by his artist friends; after all, Sargent called him the greatest talent of his generation. In Cincinnati, Duveneck had a fine time as the local great man, feeling a bit sorry for himself, but after his wife died, he couldn't make it. His drive was gone. Cincinnati gave him reverence and affection, but that didn't help his painting, in which the tremendous talent which had flamed in youth died down to nothing.

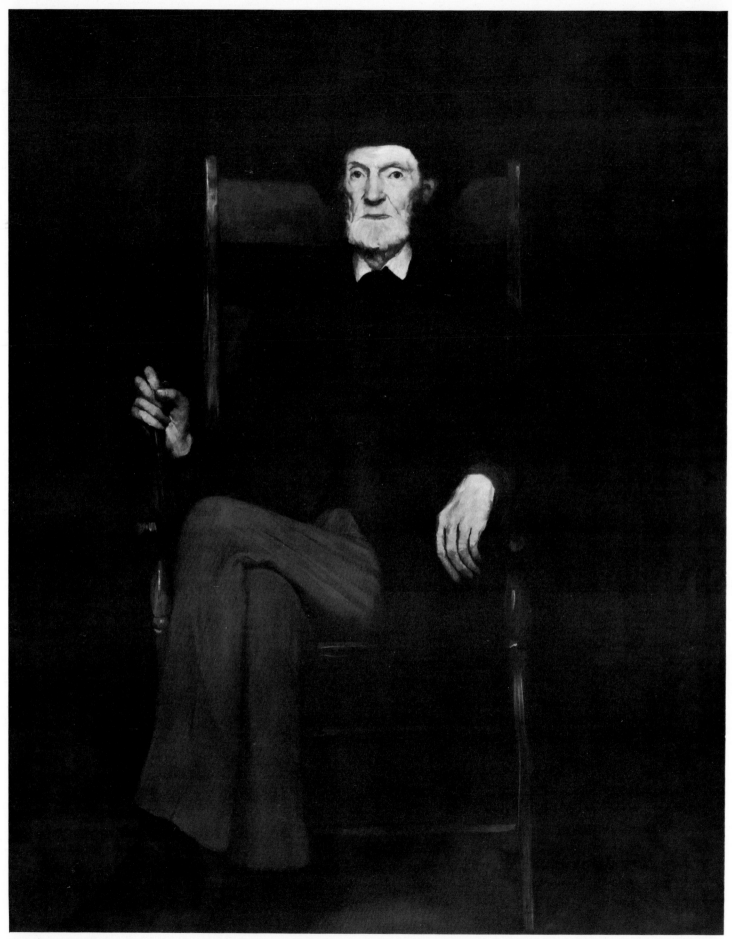

Portrait of William Adams by Frank Duveneck, 1874. Oil on canvas, 60 1/8″ x 48 1/4″ (152.8 x 122.6 cm).
*Milwaukee Art Center Collection, Milwaukee, Wisconsin. Gift of Mr. and Mrs. Myron Laskin, Mr. and Mrs. George G. Schneider,
and Dr. and Mrs. Arthur J. Patek, Jr., in memory of Dr. and Mrs. Arthur J. Patek.*

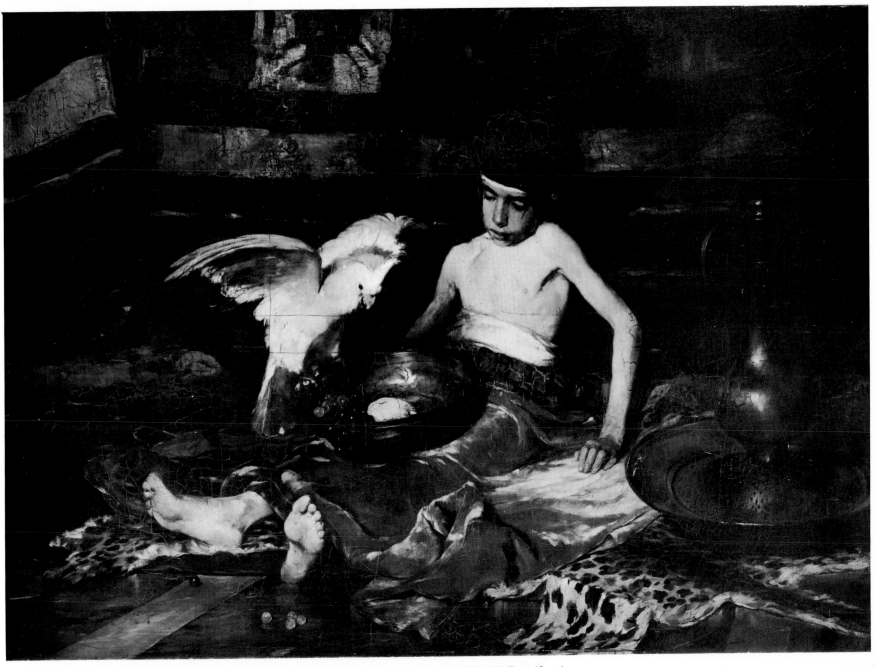

The Turkish Page by *Frank Duveneck, 1876. Oil on canvas, 42" x 58 1/4" (106.7 x 148 cm). Pennsylvania Academy of the Fine Arts, Philadelphia, Pennsylvania. Temple Fund Purchase.*

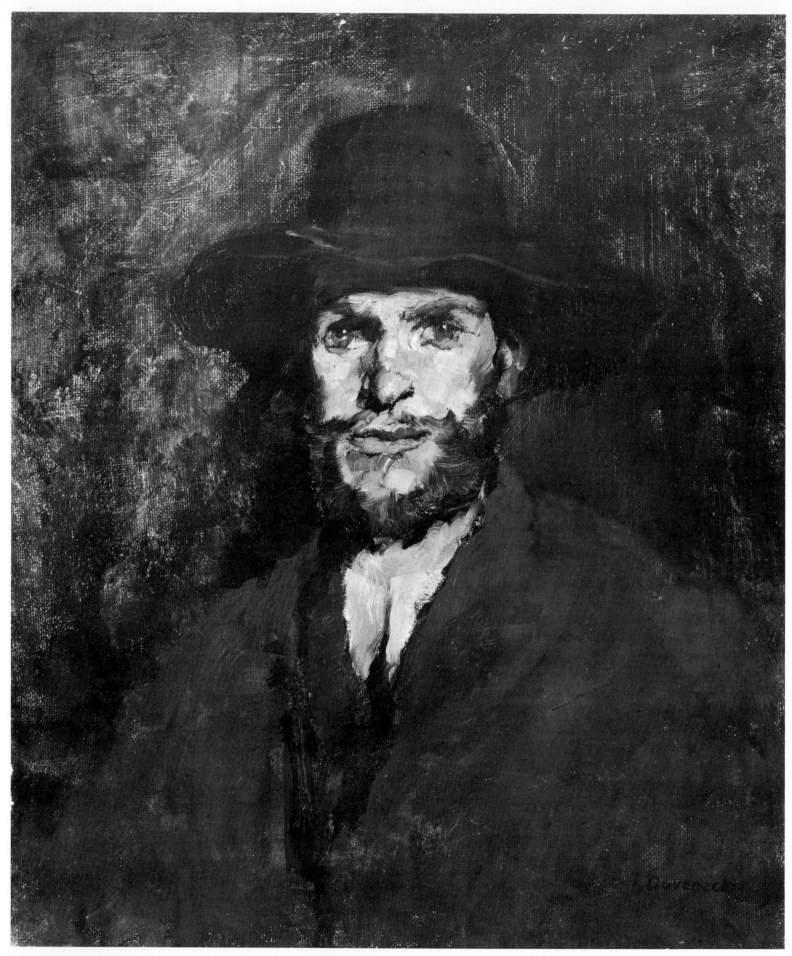

J. Frank Currier *by Frank Duveneck, 1876. Oil on canvas, 24 1/2" x 21" (62.2 x 53.3 cm).*
The Art Institute of Chicago, Chicago, Illinois. Friend of American Art Collection.

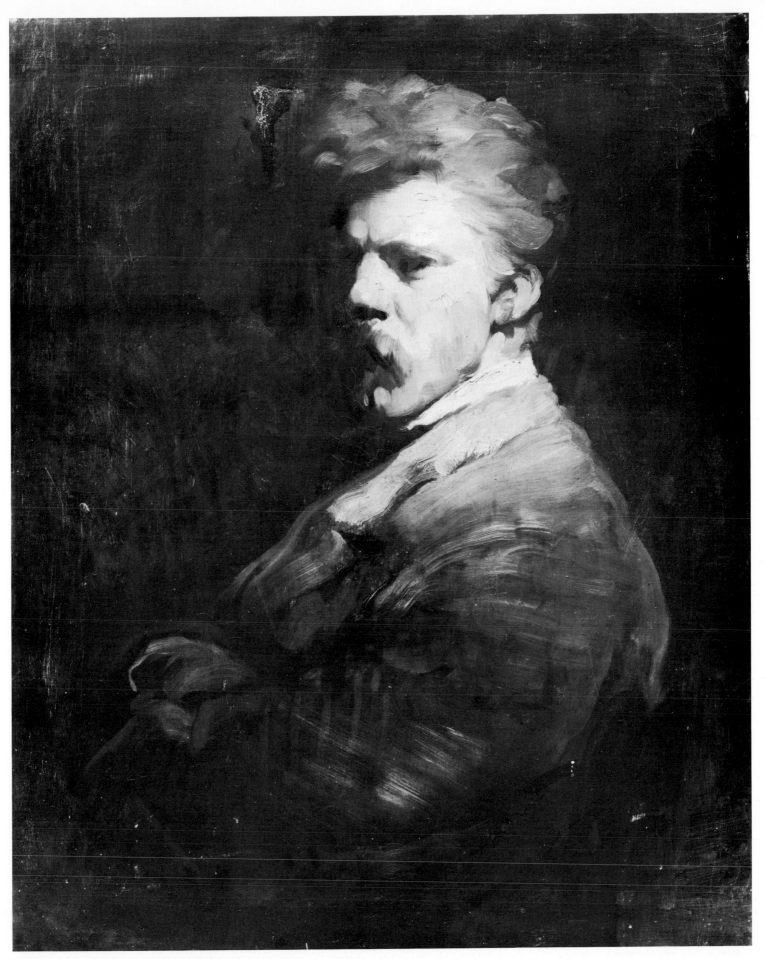

Self Portrait *by Frank Duveneck, c. 1877. Oil on canvas, 29 1/4" x 23 1/2" (74.3 x 59.7 cm).*
Cincinnati Art Museum, Cincinnati, Ohio. Gift of the artist.

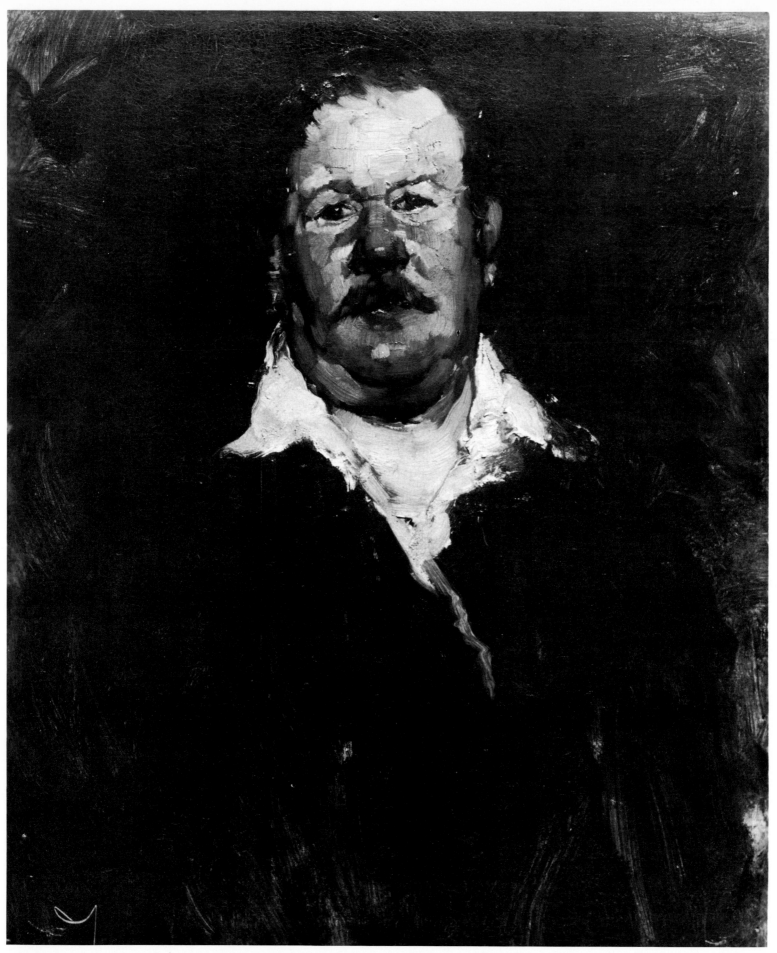

The Blacksmith by Frank Duveneck, c. 1879. Oil on canvas, 27″ x 21 7/8″ (68.6 x 55.6 cm).
Cincinnati Art Museum, Cincinnati, Ohio. Gift of the artist.

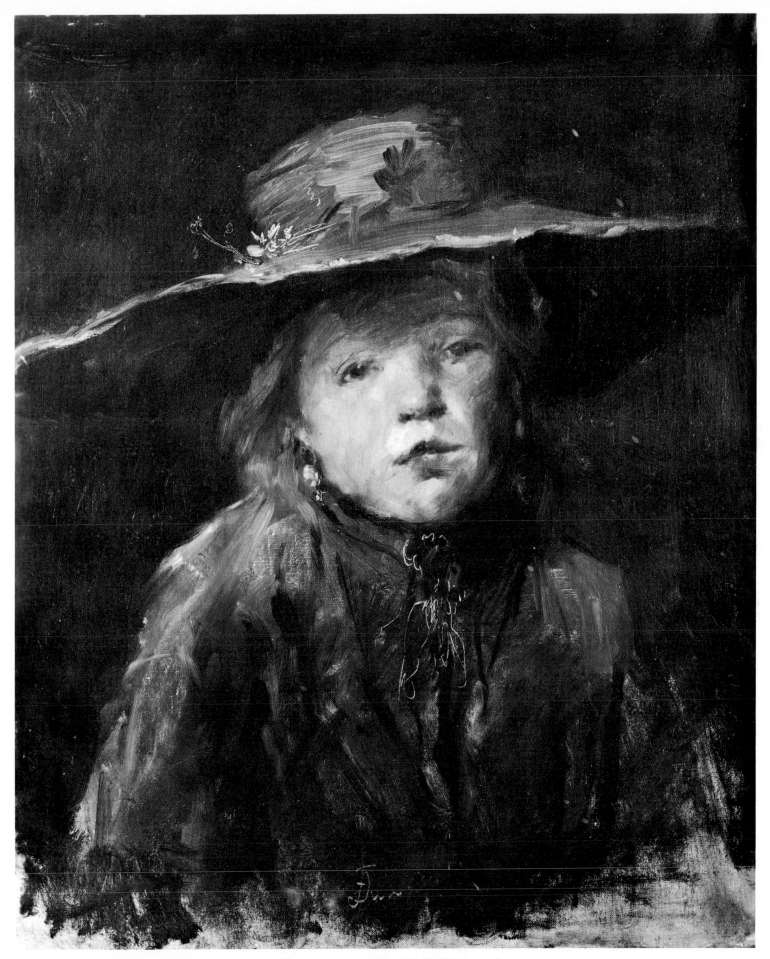

Girl with Straw Hat *by Frank Duveneck, c. 1880. Oil on canvas, 21 1/8″ x 17 1/2″ (53.7 x 44.5 cm).*
The Corcoran Gallery of Art, Washington, D.C.

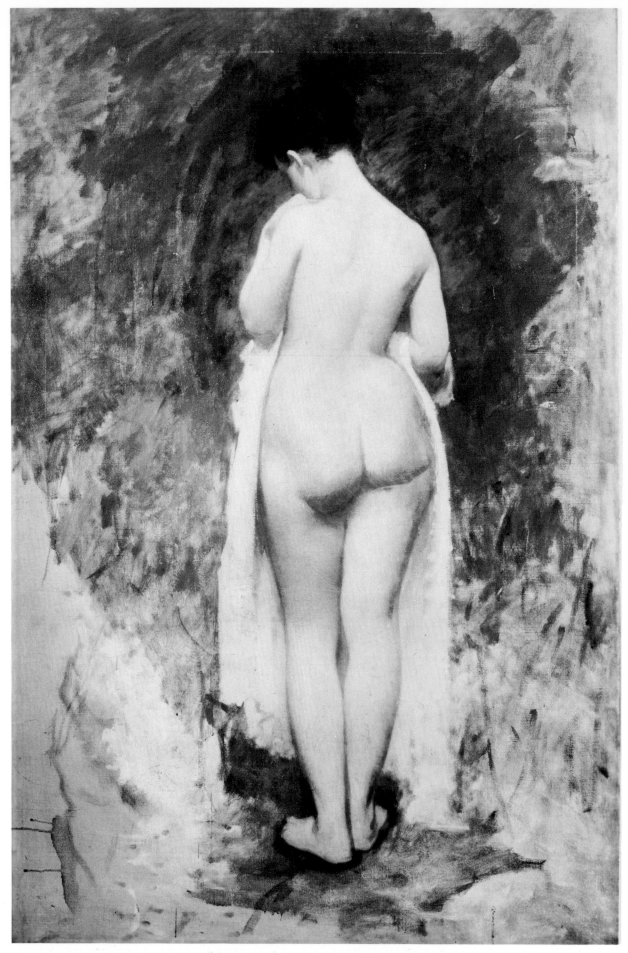

Nude Standing *by Frank Duveneck, c. 1892. Oil on canvas, 59" x 36" (149.8 x 91.4 cm).*
Cincinnati Art Museum, Cincinnati, Ohio. Gift of the artist.

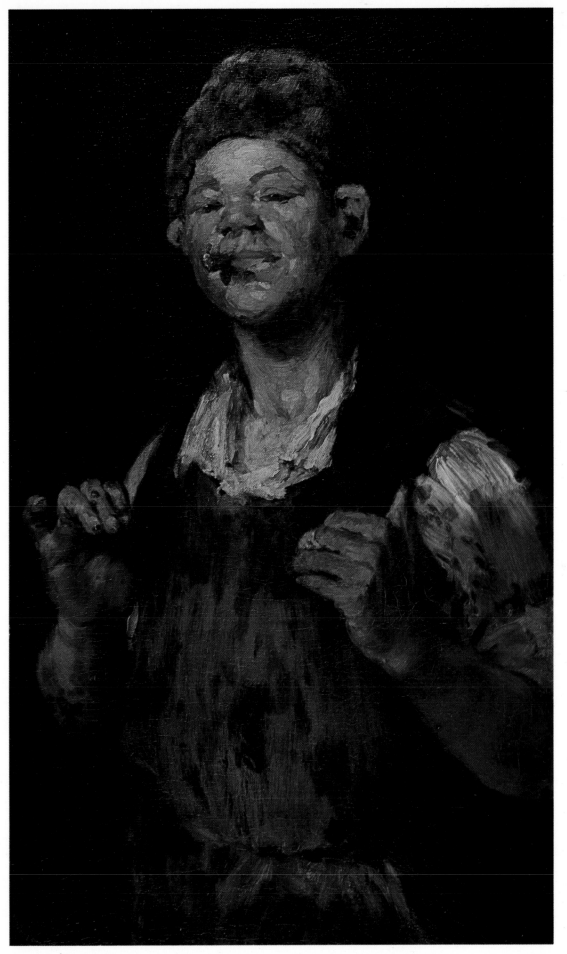

The Leader *by William Merritt Chase, c. 1873. Oil on canvas, 26" x 16" (66 x 40.6 cm).*
Addison Gallery of American Art, Phillips Academy, Andover, Massachusetts.

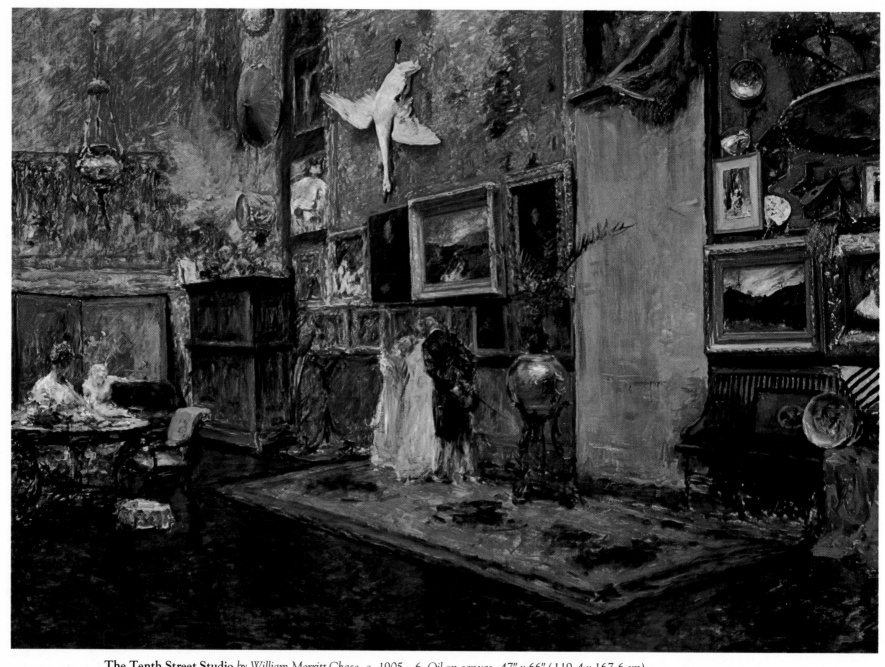

The Tenth Street Studio by *William Merritt Chase, c. 1905– 6. Oil on canvas, 47" x 66" (119.4 x 167.6 cm). Museum of Art, Carnegie Institute, Pittsburgh, Pennsylvania.*

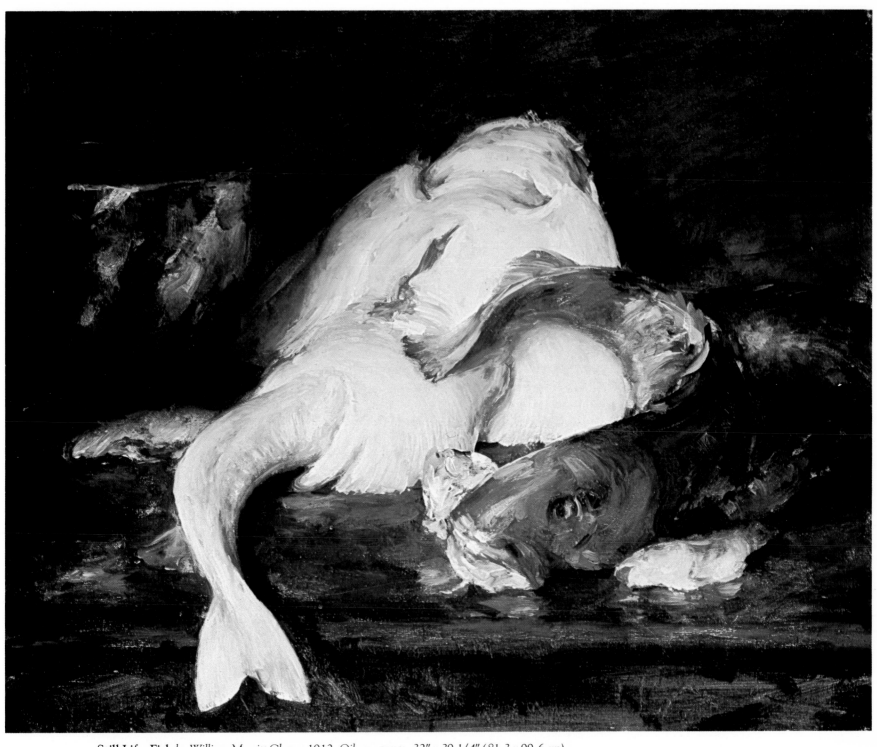

Still Life, Fish *by William Merritt Chase, 1912. Oil on canvas, 32″ x 39 1/4″ (81.3 x 99.6 cm).*
The Brooklyn Museum, Brooklyn, New York. J. B. Woodward Memorial Fund.

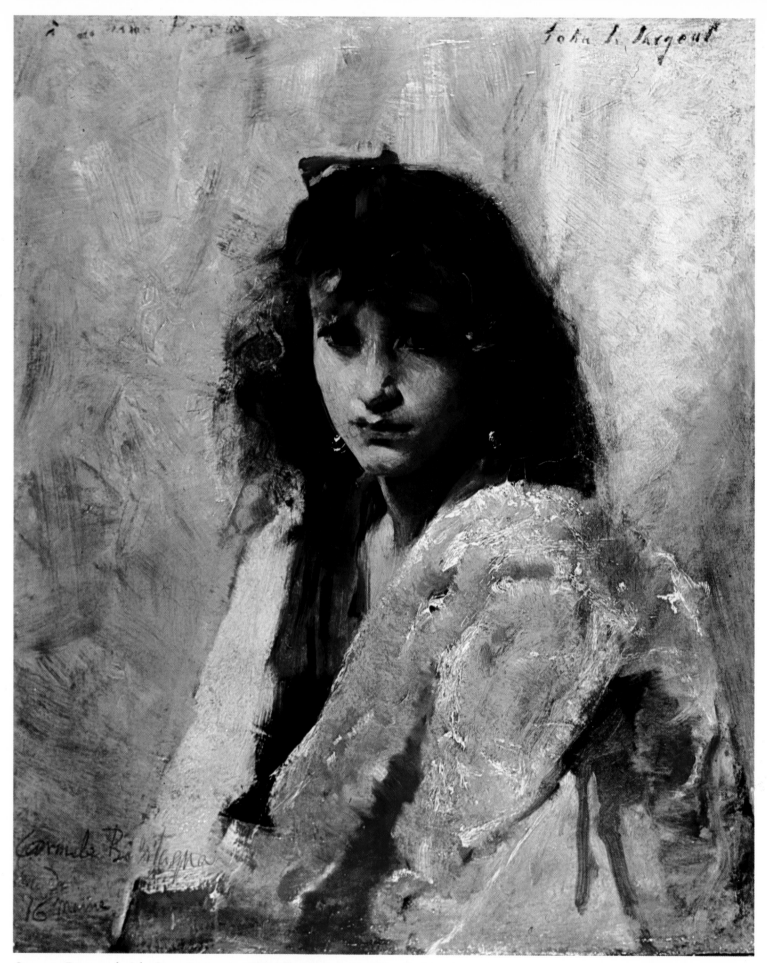

Carmena Bertagna by John Singer Sargent, c. 1880. Oil on canvas, 23 1/2" x 19 1/2" (59.7 x 49.5 cm).
The Columbus Gallery of Fine Arts, Columbus, Ohio. Bequest of Frederick W. Schumacher.

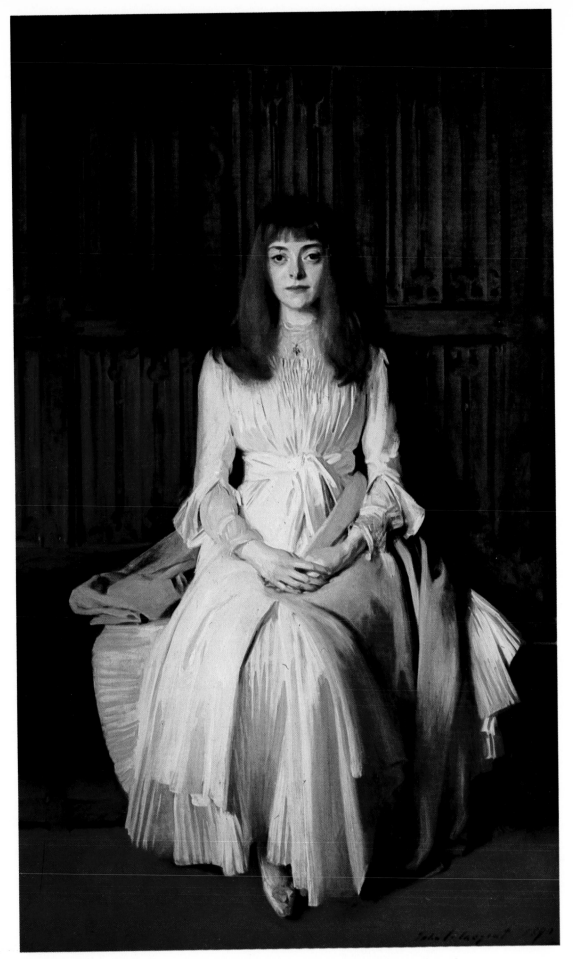

Miss Elsie Palmer *by John Singer Sargent, 1890. Oil on canvas, 13" x 10" (33 x 25.4 cm).*
Colorado Springs Fine Arts Center, Colorado Springs, Colorado.

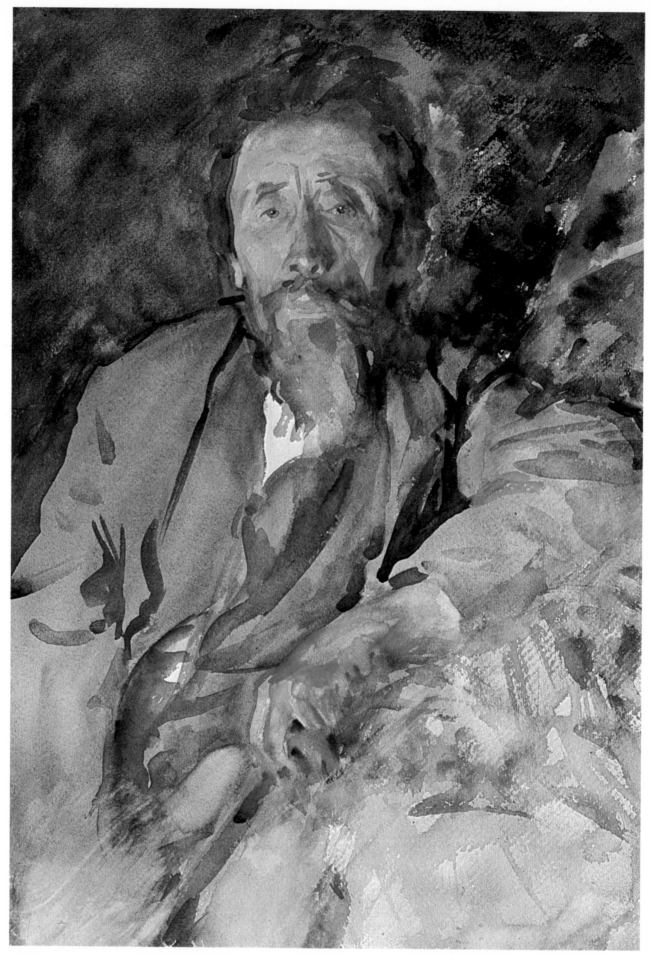

A Tramp *by John Singer Sargent, after 1900. Watercolor, 19 11/16" x 13 13/16" (50.3 x 35.1 cm). The Brooklyn Museum, Brooklyn, New York.*

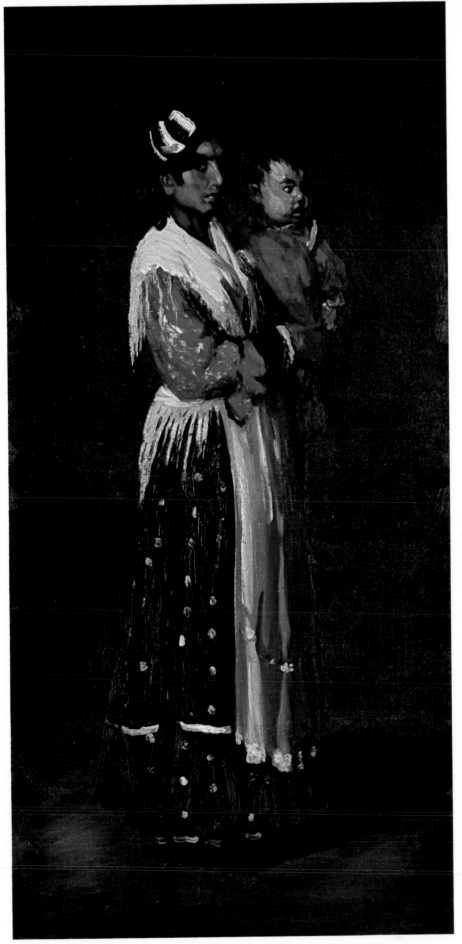

Maria y Consuelo *by Robert Henri, 1906. Oil on canvas, 78″ x 38″ (198.1 x 96.5 cm).*
University of Nebraska — Lincoln Art Galleries, Lincoln, Nebraska. F. M. Hall Collection.

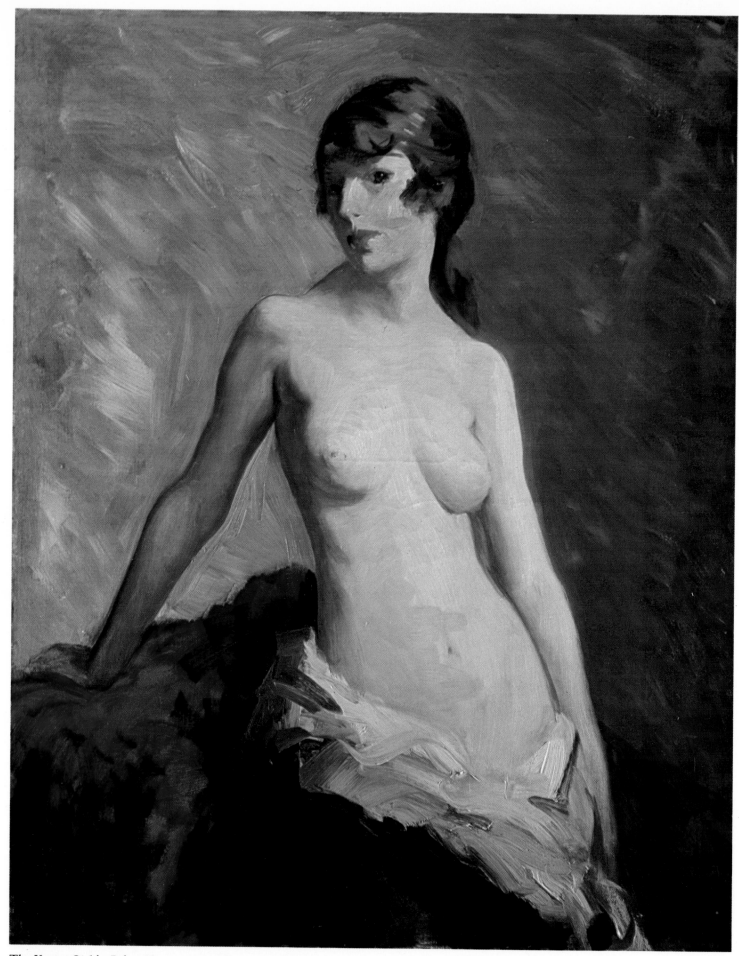

The Young Girl *by Robert Henri, 1907. Oil on canvas, 41" x 33" (104.1 x 83.8 cm).*
The Detroit Institute of Arts, Detroit, Michigan.

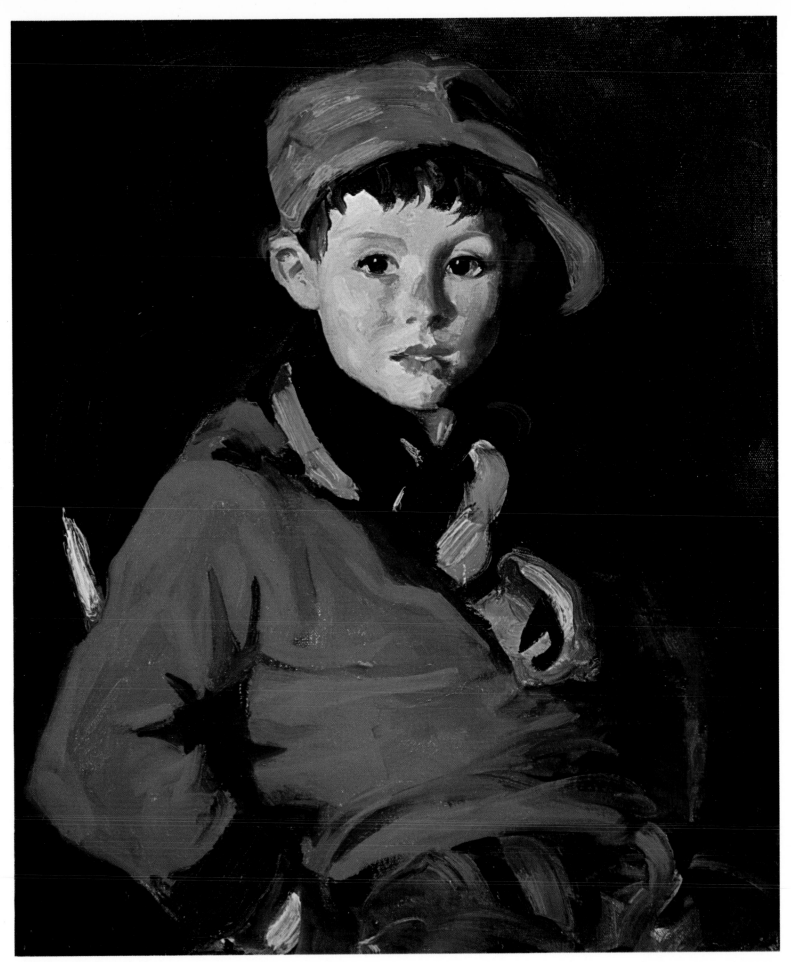

Tom Cafferty *by Robert Henri, 1925. Oil on canvas, 24" x 20" (61 x 50.8 cm).*
Memorial Art Gallery of the University of Rochester, Rochester, New York.

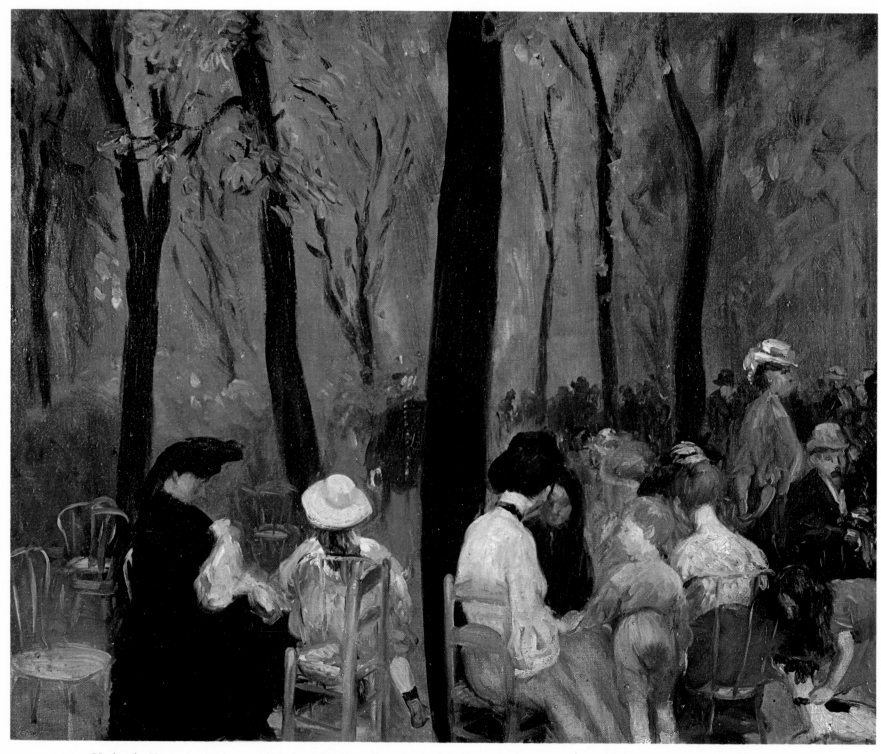

Under the Trees, Luxembourg Gardens by *William Glackens, n.d. Oil on canvas, 19 3/4" x 24 1/4" (48.3 x 61 cm).*
Munson-Williams-Proctor Institute, Utica, New York.

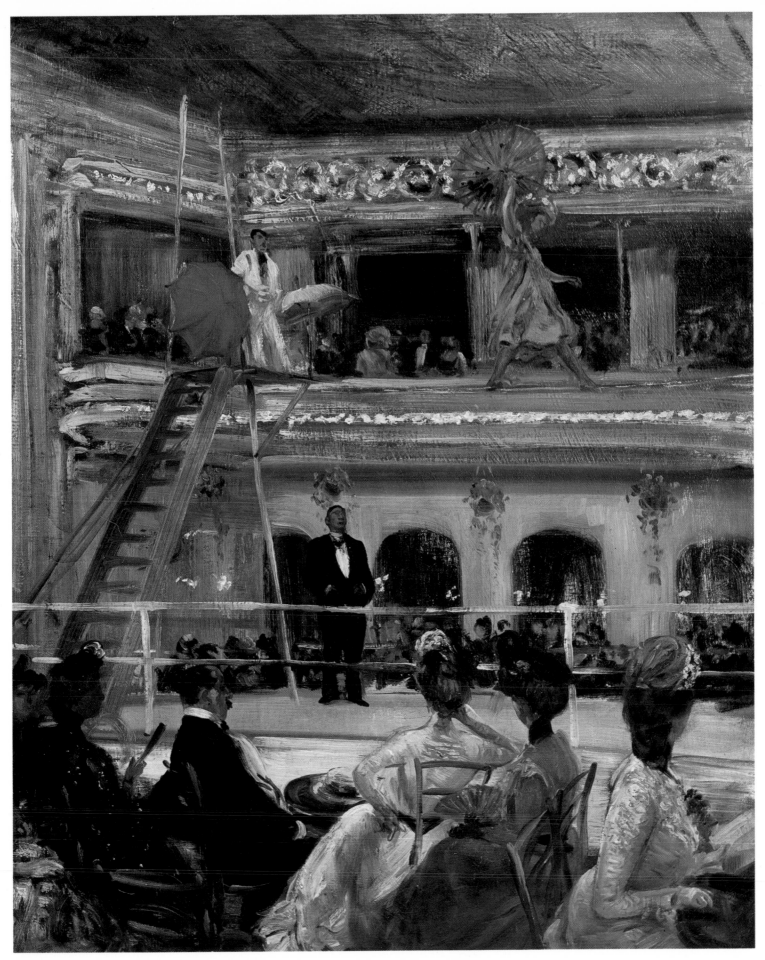

Hammerstein's Roof Garden *by William Glackens, c. 1901. Oil on canvas, 30″ x 25″ (76.2 x 63.5 cm).*
Whitney Museum of American Art, New York, New York.

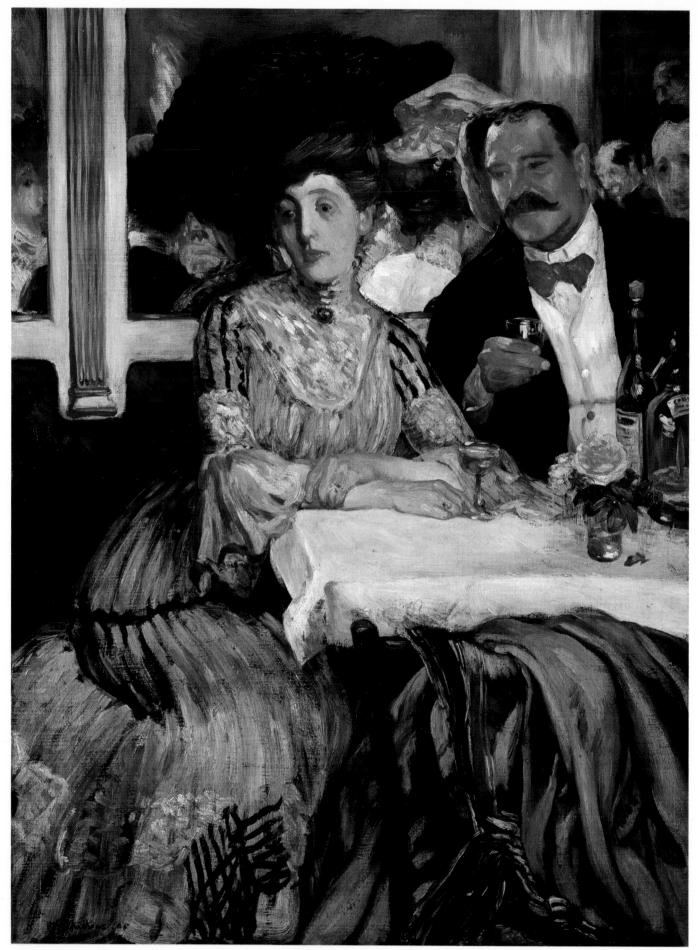

Chez Mouquin *by William Glackens, 1905. Oil on canvas, 48" x 39" (121.9 x 99 cm).*
The Art Institute of Chicago, Chicago, Illinois.

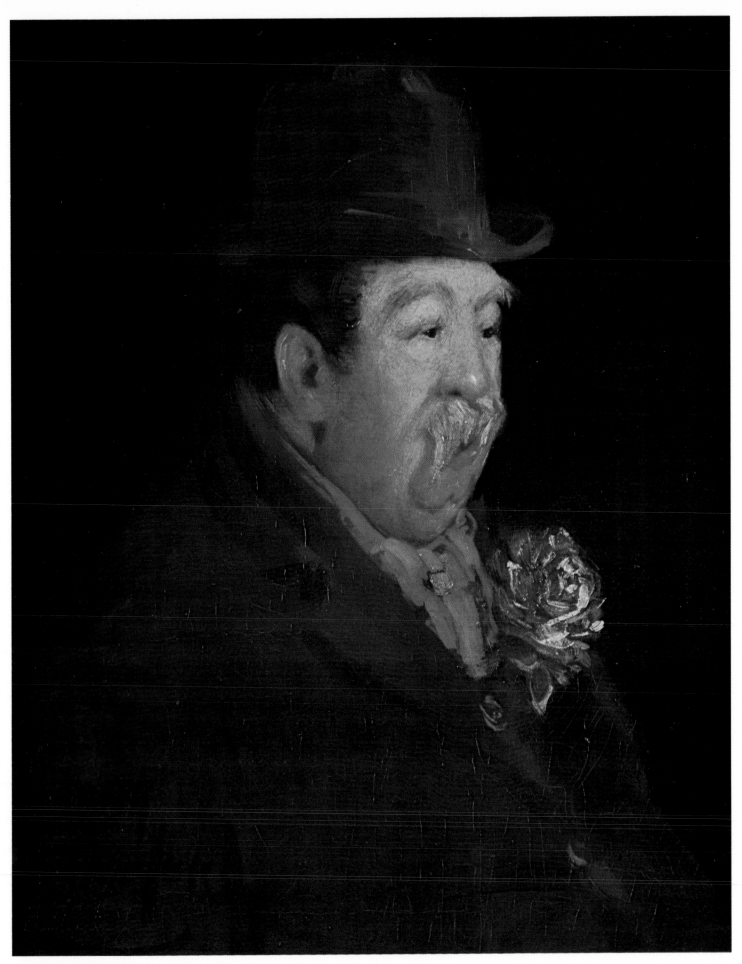

London Bus Driver by George Luks, 1889. Oil on canvas, 27" x 22" (68.6 x 55.9 cm).
Memorial Art Gallery of the University of Rochester, Rochester, New York. Marion Stratton Gould Fund.

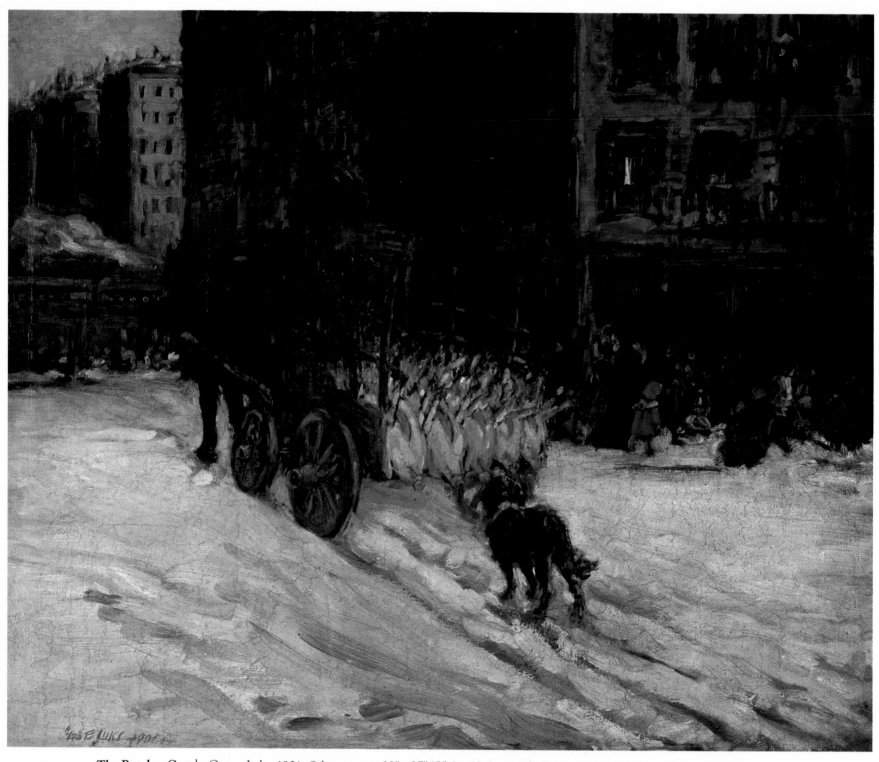

The Butcher Cart *by George Luks, 1901. Oil on canvas, 22" x 27" (55.9 x 68.6 cm). The Art Institute of Chicago, Chicago, Illinois.*

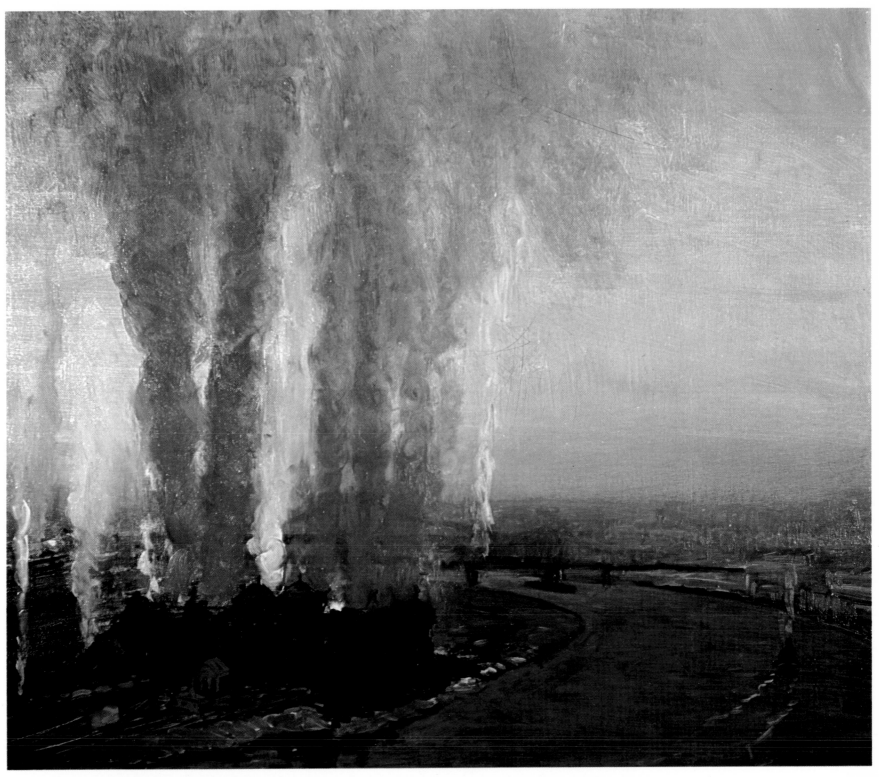

Roundhouses at Highbridge *by George Luks, 1909. Oil on canvas, 30 3/8″ x 36 1/8″ (77.2 x 91.8 cm). Munson-Williams-Proctor Institute, Utica, New York.*

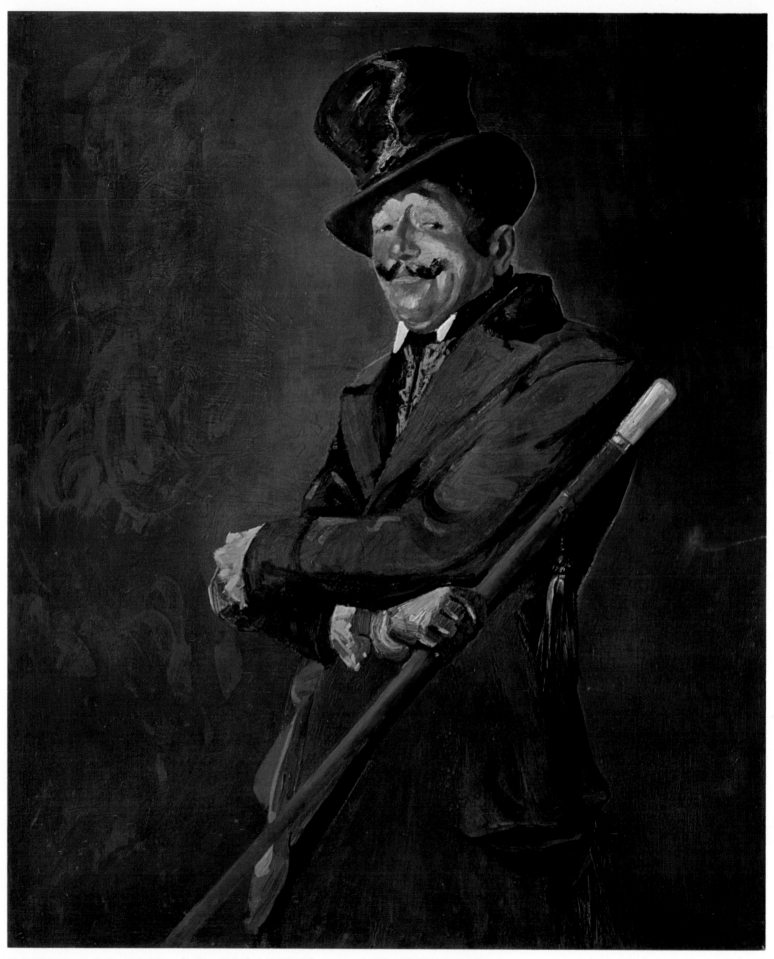

Otis Skinner as Colonel Brideau *by George Luks, 1919. Oil on canvas, 52" x 44" (132 x 111.8 cm).*
The Phillips Collection, Washington, D.C.

William Merritt Chase

1849 - 1916

In Munich, Duveneck's best friend was William Merritt Chase, who had started out painting just like Duveneck. Although Chase's palette lightened under the influence of Impressionism, he remained a realist all his life. His god was Velasquez. Like Duveneck, he admired Frans Hals' brilliant highlights, the brushstrokes that curve around the cheeks of his models.

When Chase, traveling in Italy with Duveneck, was offered a teaching job in New York, he went on a splendid splurge in the antique shops. Chase never cared whether or not what he bought was real, but he intended to have the finest studio in New York, and he certainly did (page 82). Under the stuffed swan, the Spanish dancer Carmencita put on a special performance for Sargent and Mrs. Jack Gardner, the great Boston collector, while outside the door Chase's black cook, Daniel, stood guard with a red fez and a white Russian wolfhound.

When Chase became a member of the Tile Club, their canal boat on the famous trip up the Hudson was furnished from his studio — down to the Japanese gong whose boom announced that the great hairy Twachtman was loose — while Daniel provided glorious meals awash in whiskey and wine. He was a perpetual astonishment, with a tremendous flair for painting and for life. His pupils, particularly the young ladies, adored him. Duveneck was so inarticulate that he had to get Farny, the Wild West friend who'd been one of his boys in Munich, to make his speeches for him. But Chase would give a speech at the drop of a hat.

He had a fine, lordly manner in art and in life. As he painted in front of his class at Carmel, that Bohemian artist colony, with the seals barking on the rocks in the distance, he wore a stiff straw hat, a high collar, and spats. When he crossed the ocean, with his yachting cap and double-breasted jacket, he looked more nautical than the captain. The high spot of each academic season, wherever his class might be, was when Chase painted a portrait in one sitting.

Like Mary Cassatt, Chase advised collectors. On a trip to Europe in 1881, he and Alden Weir bought two paintings from Manet which went into the Metropolitan in 1889, long before there were any Manets in the Louvre. Chase got along famously with other artists, excepting Whistler, with whom it was impossible to live in harmony. They painted each other's portraits, but Whistler took his back — he didn't think Chase made him handsome enough.

Along with his realistic, Velasquez-like figures, Chase painted Central Park the way the French Impressionists painted the Luxembourg Gardens, and his Long Island beach scenes look like their views of Normandy. His still lifes came out of seventeenth century Holland and eighteenth century France; according to the contemporary critic Sadakichi Hartman, Chase was the painter of metal surfaces: of copper, brass, and pewter vessels.

Chase made a hit with his dashing still lifes of fish (page 83) — which you must paint fast while they last. But he could paint anything. His best work has a remarkable freshness; his fish look as though they were still flopping on the pier. In 1907, Frank Jewett Mather, a Princeton professor and a tremendous pundit, thought it was a good bet that Matisse would fade out of history before Chase, but it didn't work out that way. He *is* an original painter who should be cherished; there aren't that many.

Nothing affected Chase's gusto, not even bankruptcy. In his summer school at Shinnecock Hills on Long Island, the local gentry brought their guests to see the master perform on criticism day, which was better than a party. Unlike Duveneck, he changed and matured with the times, and he was still going strong when he died.

He loved to paint his wife and daughters (pages 100 to 105), and the trails over the sand dunes to the water. For him, that was all there was. He didn't paint divine discontent: he found life exhilarating and even surprising. There was more than enough to paint. For him, as for Velasquez, life was reality, and that was what he tried to paint.

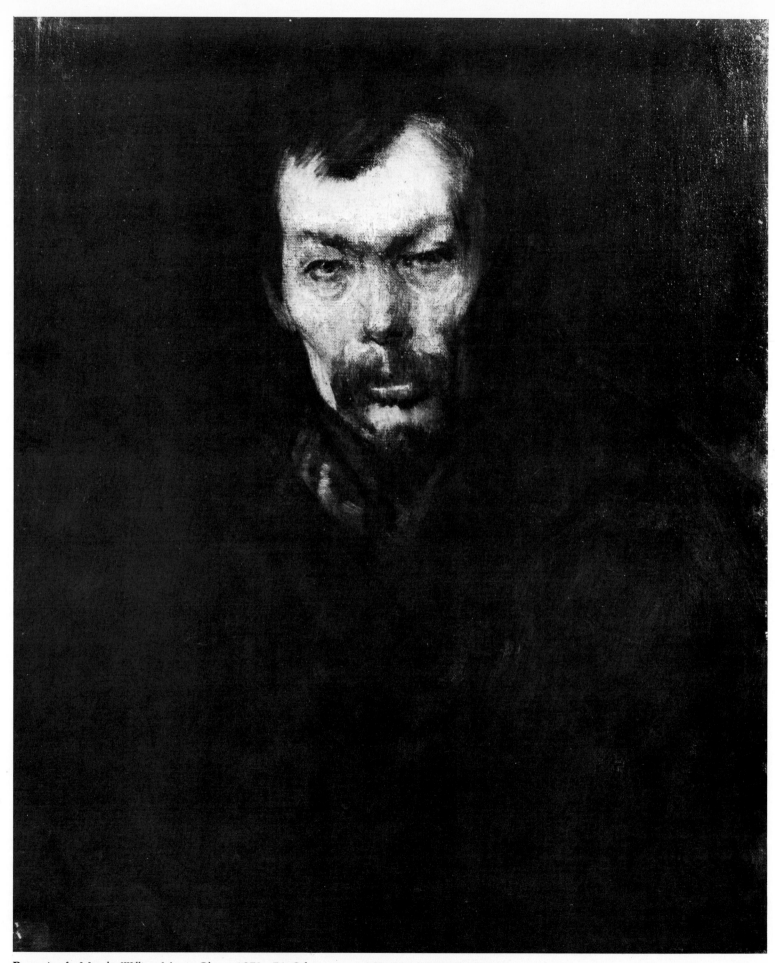

Portrait of a Man by William Merritt Chase, 1873–76. Oil on canvas, 25″ x 20 1/2″ (63.5 x 52 cm).
Albright-Knox Art Gallery, Buffalo, New York. Fellows for Life Fund, 1926.

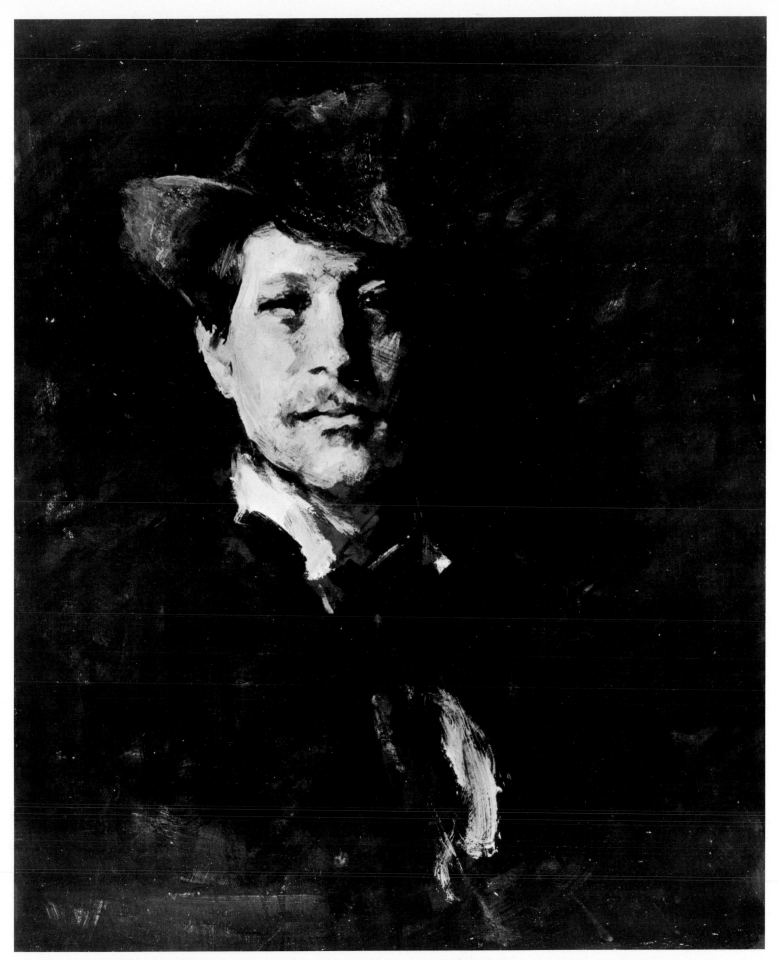

The Unknown Dane *by William Merritt Chase, c. 1876. Oil on canvas, 24" x 20" (61 x 50.8 cm).*
Philadelphia Museum of Art, Philadelphia, Pennsylvania. Bequest of Annie Lovering Perot.

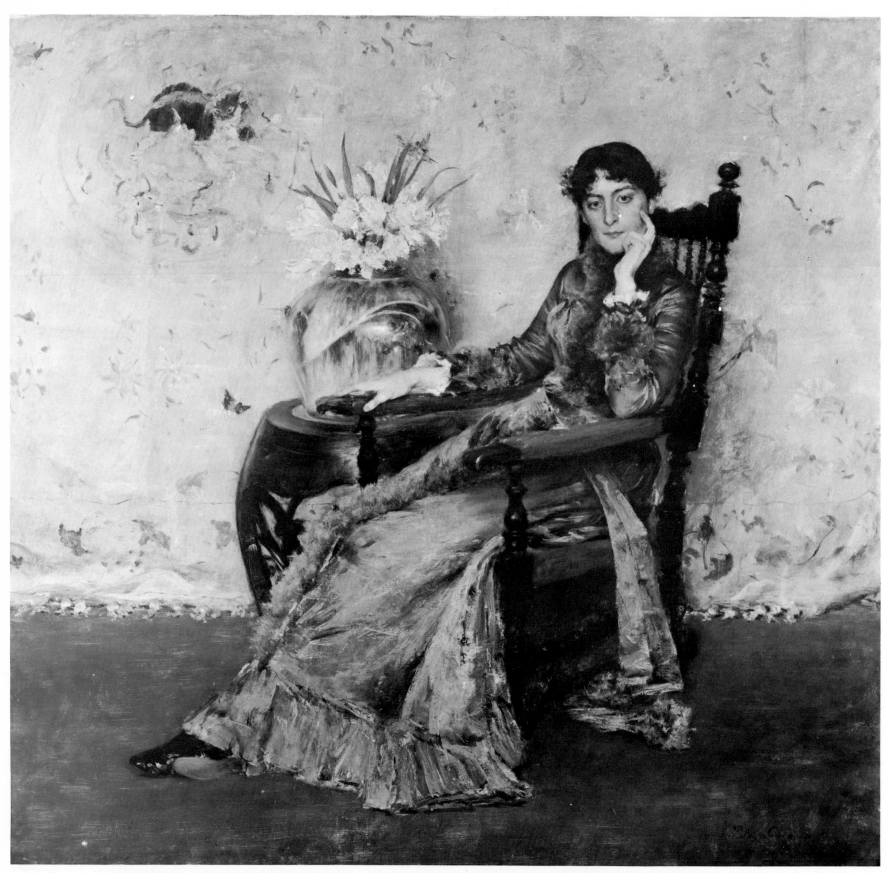

Portrait of Miss Dora Wheeler by *William Merritt Chase, 1883. Oil on canvas, 62 1/2" x 65 1/4" (158.8 x 165.7 cm).*
The Cleveland Museum of Art, Cleveland, Ohio. Gift of Mrs. Boudinot Keith, in memory of Mr. and Mrs. J. H. Wade.

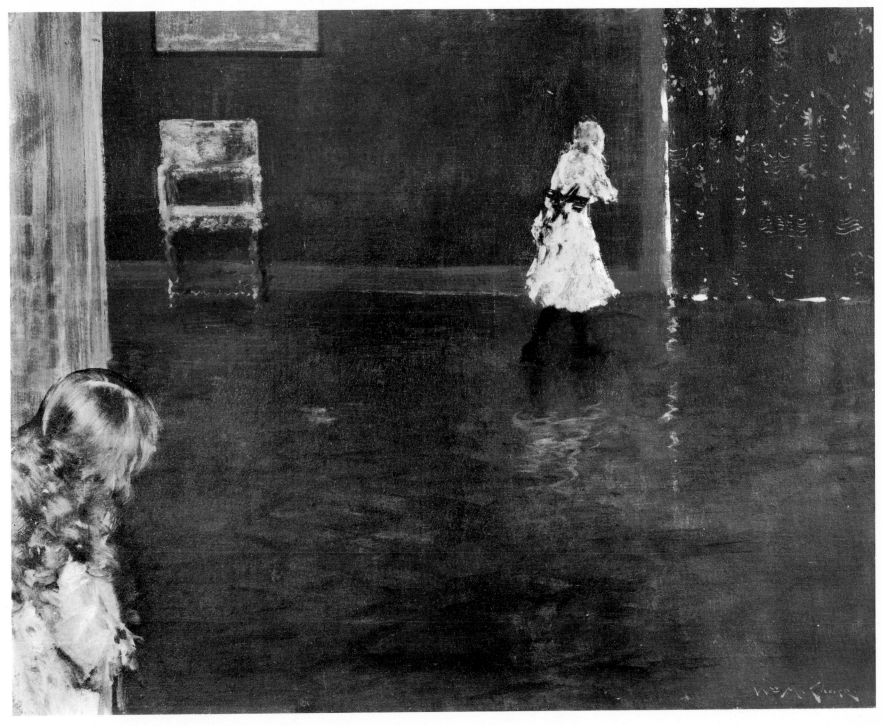

Hide and Seek *by William Merritt Chase, 1888. Oil on canvas, 27 1/2" x 36" (69.9 x 91.4 cm).*
The Phillips Collection, Washington, D.C.

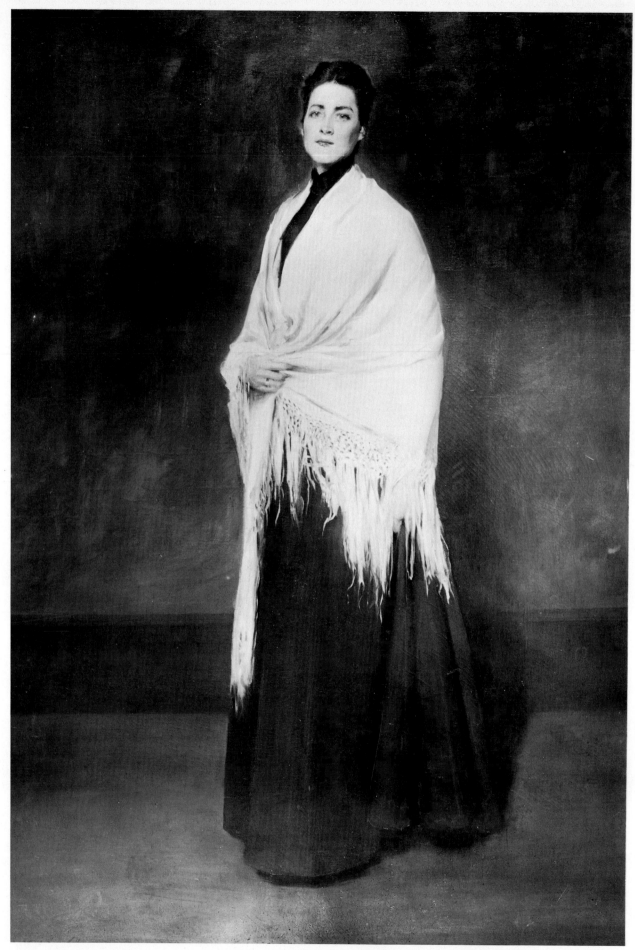

Lady with the White Shawl by William Merritt Chase, 1893. Oil on canvas, 75" x 52" (190.5 x 132 cm). *Pennsylvania Academy of the Fine Arts, Philadelphia, Pennsylvania. Temple Fund Purchase.*

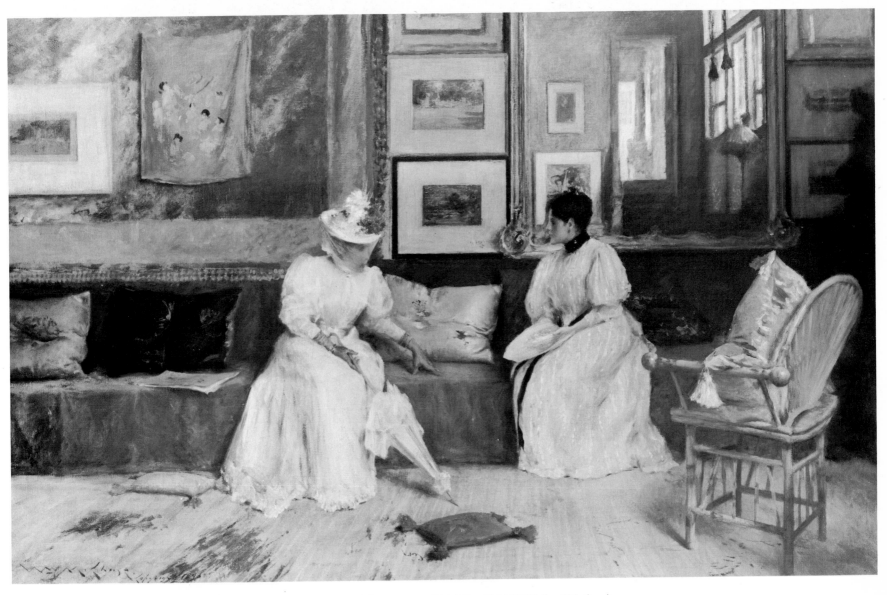

A Friendly Call *by William Merritt Chase, 1895. Oil on canvas, 30 1/8″ x 48 1/4″ (76.5 x 122.6 cm).*
National Gallery of Art, Washington, D.C. Gift of Chester Dale.

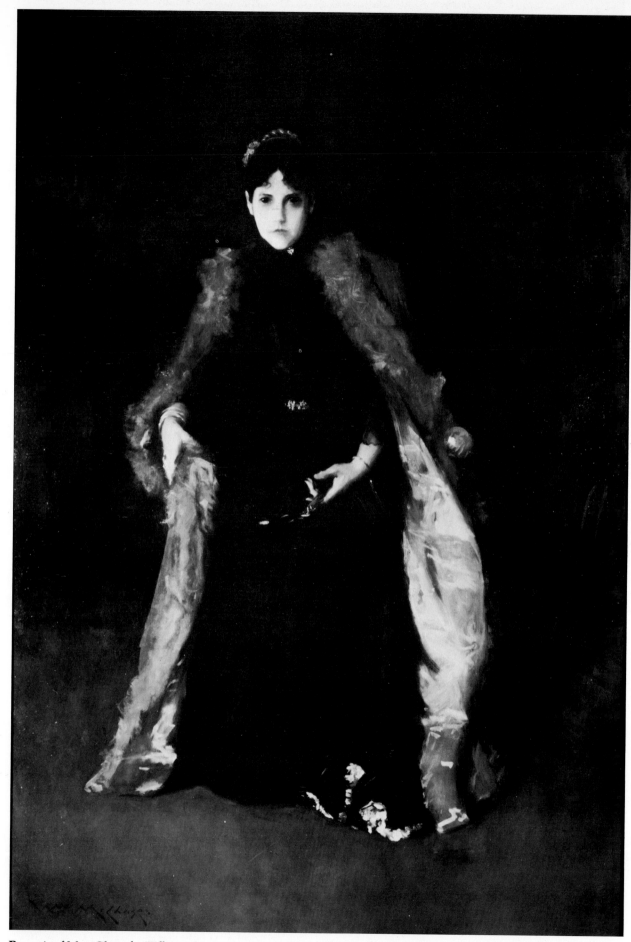

Portrait of Mrs. Chase *by William Merritt Chase, n.d. Oil on canvas, 72″ x 48″ (182.9 x 121.9 cm).*
Museum of Art, Carnegie Institute, Pittsburgh, Pennsylvania.

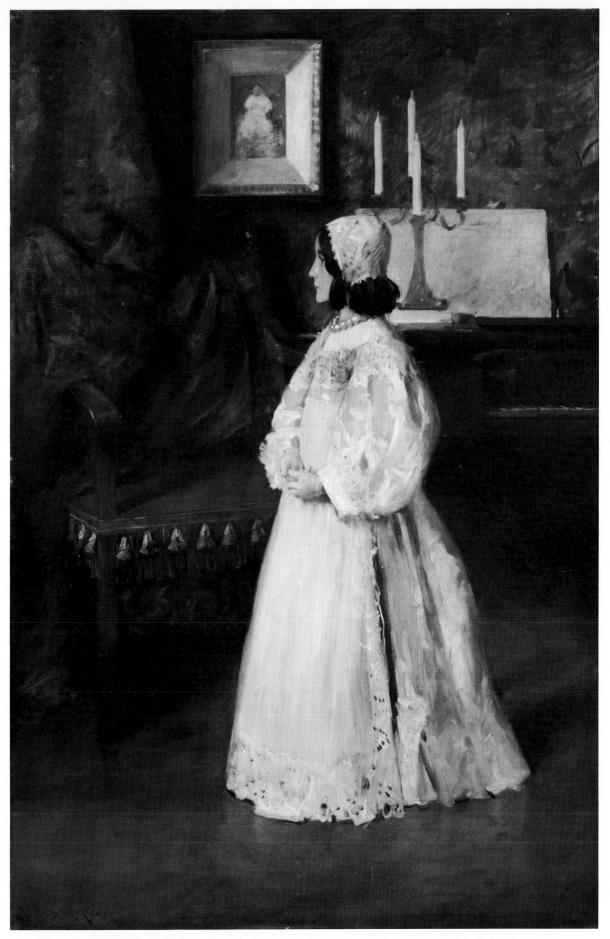

Portrait of My Daughter Alice *by William Merritt Chase, n.d. Oil on canvas, 72" x 48" (182.9 x 121.9 cm).*
The Cleveland Museum of Art, Cleveland, Ohio. Gift of Mr. and Mrs. Hermon A. Kelley,
in memory of their daughter Virginia Kelley Newberry.

John Singer Sargent

1856-1925

Sargent's father was a Philadelphia doctor who gave up his career to go to Europe. There the family lived in Jamesian discomfort in hotels and rented lodgings, spending the winter in Italy. As Dr. Sargent said, "We lead a very quiet sort of life, balancing between winter quarters and a summering place. We have very few acquaintances, and those which we have are in the same category with ourselves, people who have, as a rule, no superfluity of means." Vernon Lee, a friend, remembered him as a rather pale man who always seemed to disapprove. Duveneck's wife Lizzie Boott also grew up in the same querulous atmosphere of exile, though on a far grander scale. Both their fathers deliberately chose expatriation, then hated it because there was not enough to do.

Sargent was born in Florence, where his vague schooling was short on boredom and long on languages and music. He enjoyed charades with Vernon Lee and bombarding the pigs outside the Porto del Popolo. He was deeply attached to his mother and sister. His father wanted him to go to Annapolis, but Sargent preferred the art school in Florence — which the father managed to disregard, calling it the most unsatisfactory institution imaginable — and the Beaux-Arts in Paris — where Paul Helleu (page 115), the fashionable French painter, remembered Sargent as an exceptionally well-dressed student, but not otherwise outstanding. Then the artist to watch around the Quarter was R.A.M. Stevenson, Robert Louis' cousin, who never made the grade. But Sargent soon surpassed everybody.

He quickly learned the knack of painting bad portraits, which clients prefer; he flattered them outrageously, and turned vacant idiots, desolate hags, and crashing bores into beautiful people. Sargent laid it on with a trowel, and they loved it. No portrait was ever turned down for being too beautiful; Sargent revealed beauties the sitters alone knew they had. Naturally he got ahead fast. But beneath the dazzling display, he was saying something about them, as though he painted two pictures every time: you can see, if you look hard, a third-rate man or woman tricked out in junk. As a relief from lying, he loved to bang away at the piano, while (as the six-year-old daughter of a client remembered him) dancing jigs and singing Negro songs.

Like Whistler, Sargent made his career in England. When Mary Cassatt said that Sargent and Henry James were spoiled by society, the old girl was right. After the English market thinned out, Sargent harvested crops of American heiresses, while painting brilliant watercolors in North Africa and Venice for fun. His portraits of his friends are by far his best. Vernon Lee said of her portrait in the Tate Gallery (page 112), that by everyone's admission it was extraordinarily clever and characteristic, though rather fierce and cantankerous. (When she saw him after nine years' absence, he was very stiff. Then, quite unbidden, he sat down at the piano and banged out all sorts of bits of things, ends and middle of things, just as he had when he was a boy.) Except for Vernon Lee, who didn't like men, and Mrs. Jack Gardner, who never remarried, Sargent didn't like women. The rumored affair with Mrs. Gardner is totally out of character.

He loathed his clients, who were delighted to be painted nine feet tall. To blow off steam, Sargent made a study of a magnificent carved stairway and balustrade leading to a grand façade: he thought it would be delightful to paint a rather anxious, overdressed, middle-aged lady there, with all her pearls and her bat look and, of course, never be chosen to do portraits anymore. That was his vengeful fantasy. Meanwhile he churned out the portraits at extravagant prices. Yet this bear of a man could do great things when the mood was on him, like the watercolor of his old friend Mrs. Gardner, more dead than alive.

Sargent's work is split down the middle. He tried hard to be a bad painter, and sometimes he succeeded. But his watercolors, which he painted to please himself, are far and away the greatest American watercolors except for Winslow Homer. He loathed what he did for hire, but the good part of his work is always realistic. When he felt comfortable and could let himself go, as on paintings of his friends or on his landscapes, he was superb. After a certain point, he didn't even need the money; God knows what he did with it, for he was not a rich man when he died. Something drove him to success, and Sargent was tremendously successful, but nobody wins a competition without entering it in the first place. Sargent had all the ability to be a great artist, but the flaw was in himself. Despite success, the world was a very unsatisfactory place for Sargent, and he was very unsatisfactory to himself. The only thing that pleased him was when he knocked off a good one, and these are the pictures which mean so much today.

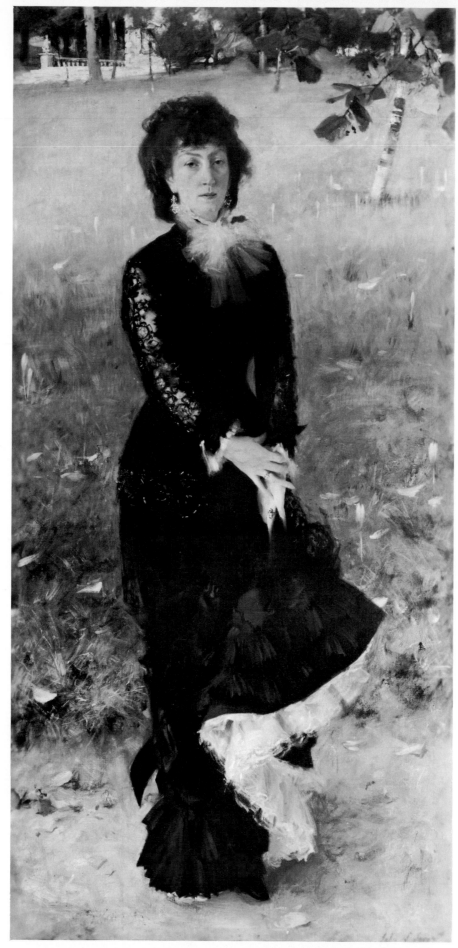

Madame Edouard Pailleron *by John Singer Sargent, 1879. Oil on canvas, 82″ x 39 1/2″ (208.3 x 100.3 cm). The Corcoran Gallery of Art, Washington, D.C.*

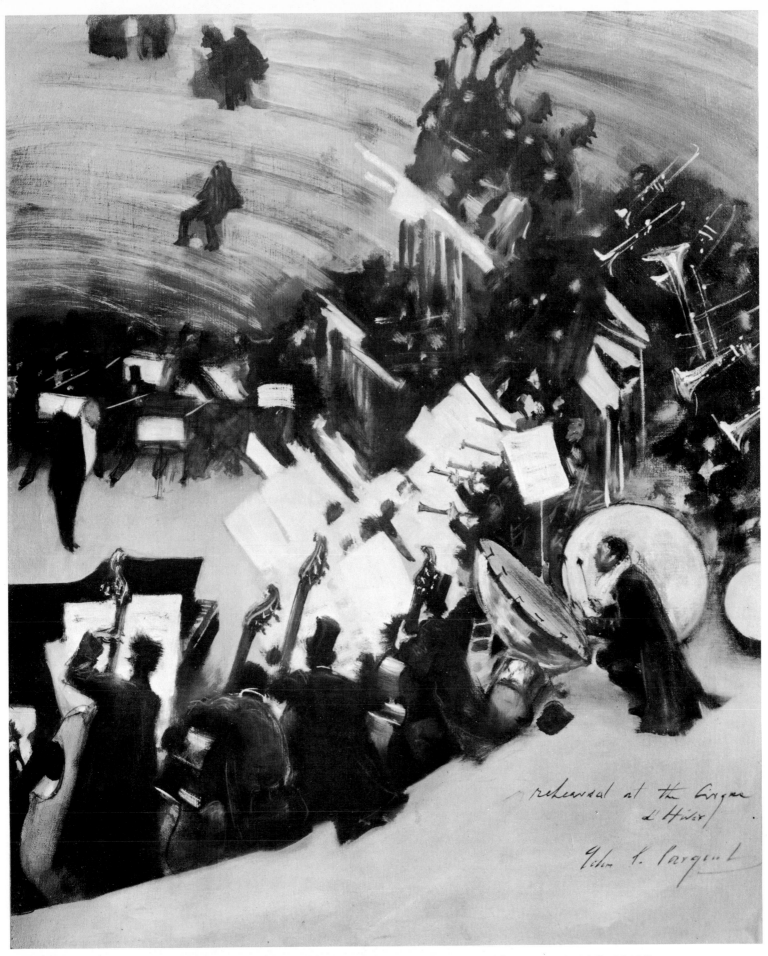

Rehearsal of the Pas de Loup Orchestra at the Cirque d'Hiver *by John Singer Sargent, 1876. Oil on canvas, 21 3/4" x 18 1/4"*
(55.2 x 46.4 cm). Museum of Fine Arts, Boston, Massachusetts. Charles Henry Hayden Fund.

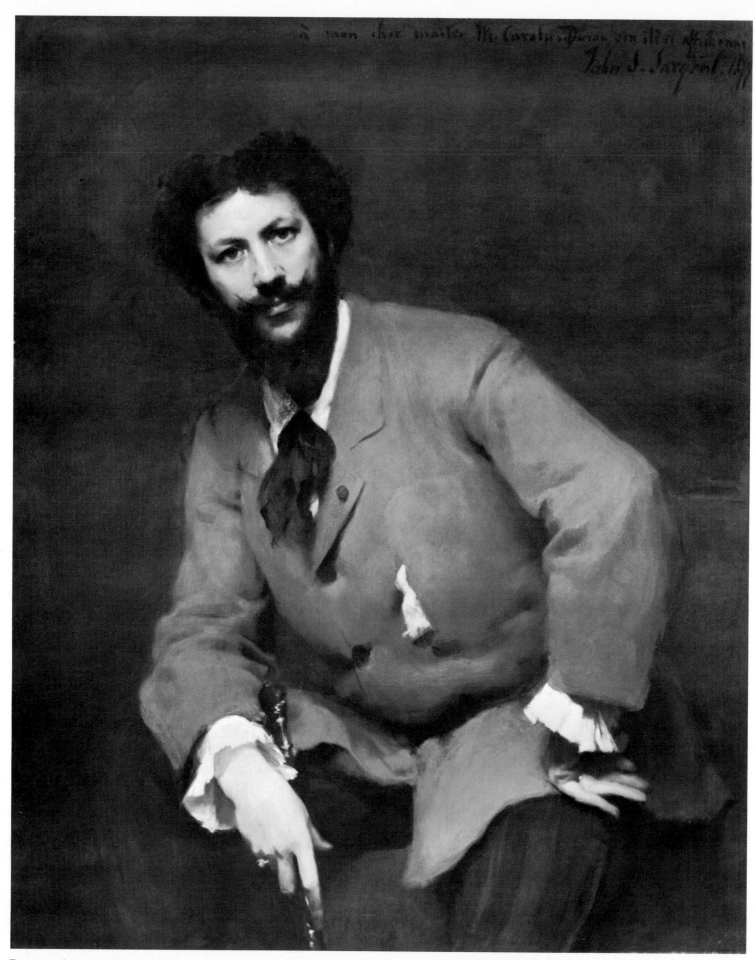

Portrait of Carolus-Duran *by John Singer Sargent, 1879. Oil on canvas, 46" x 37 13/16" (116.9 x 96 cm).*
Sterling and Francine Clark Art Institute, Williamstown, Massachusetts.

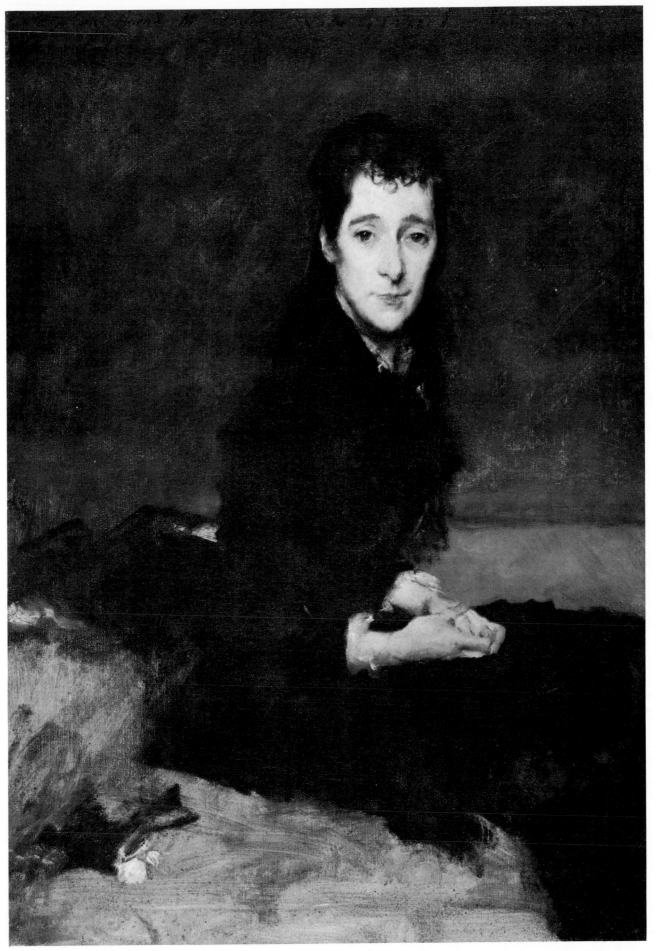

Mrs. Charles Gifford Dyer *by John Singer Sargent, 1880. Oil on canvas, 24 1/2" x 17 1/4" (63.2 x 43.8 cm).*
The Art Institute of Chicago, Chicago, Illinois. Friend of the American Art Collection.

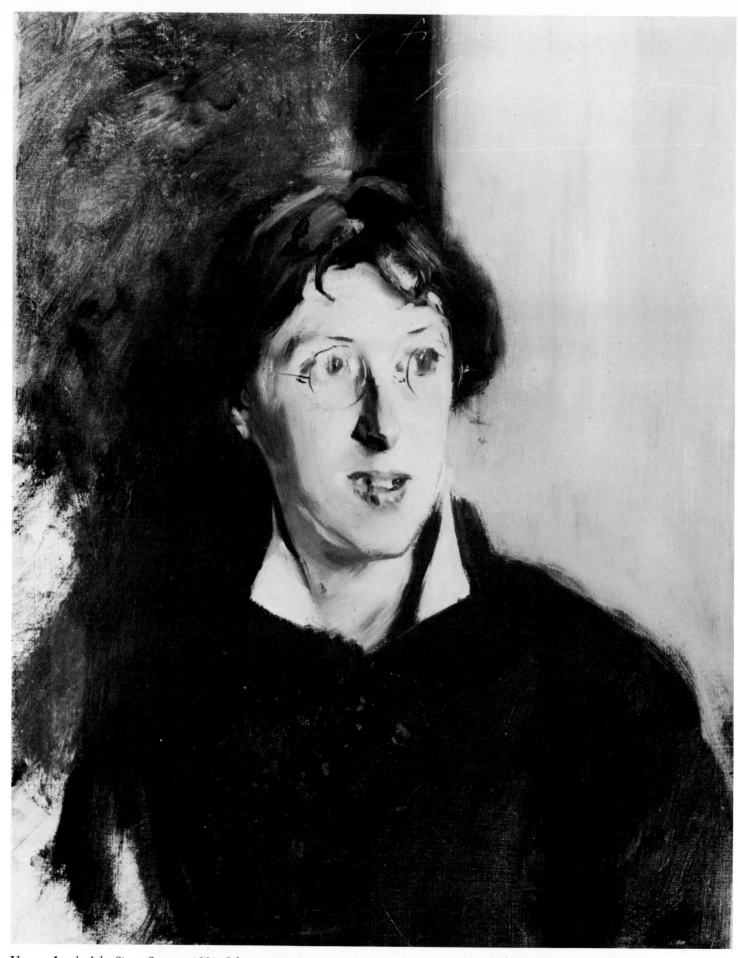

Vernon Lee by John Singer Sargent, 1881. Oil on canvas, 21 1/8" x 17" (53.7 x 43.2 cm).
The Tate Gallery, London.

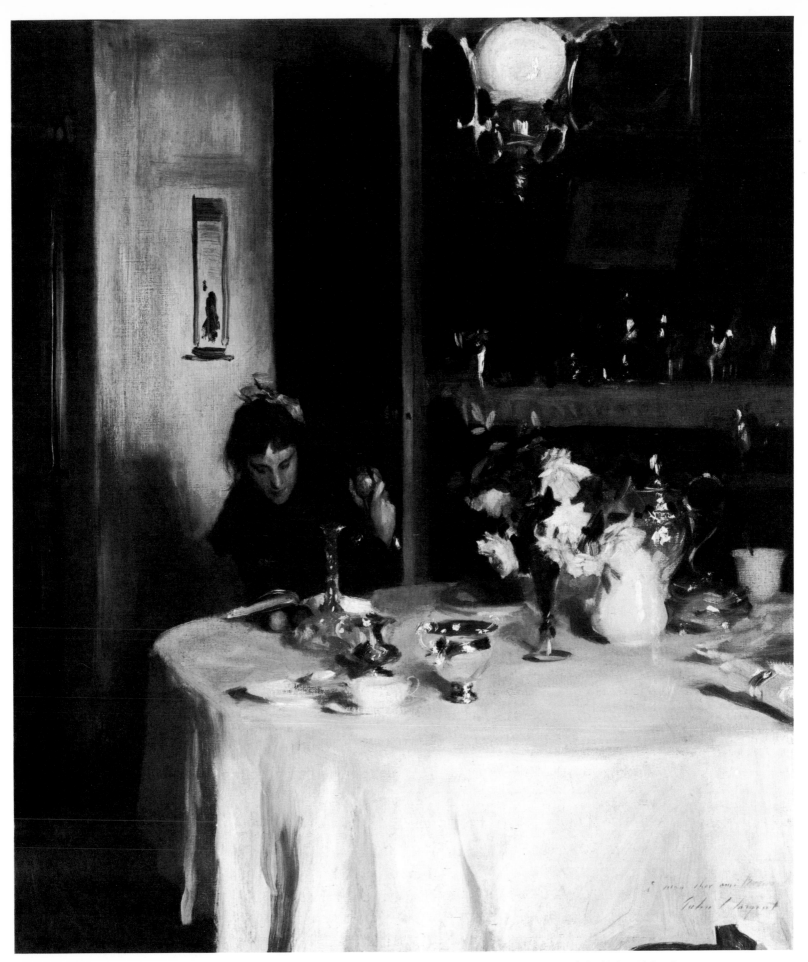

Breakfast Table (*La jeune fille dans la salle à manger*) by John Singer Sargent, 1884. Oil on canvas, 21 3/4″ x 18 1/4″ (55.2 x 46.3 cm). *Fogg Art Museum, Harvard University, Cambridge, Massachusetts. Grenville L. Winthrop Bequest.*

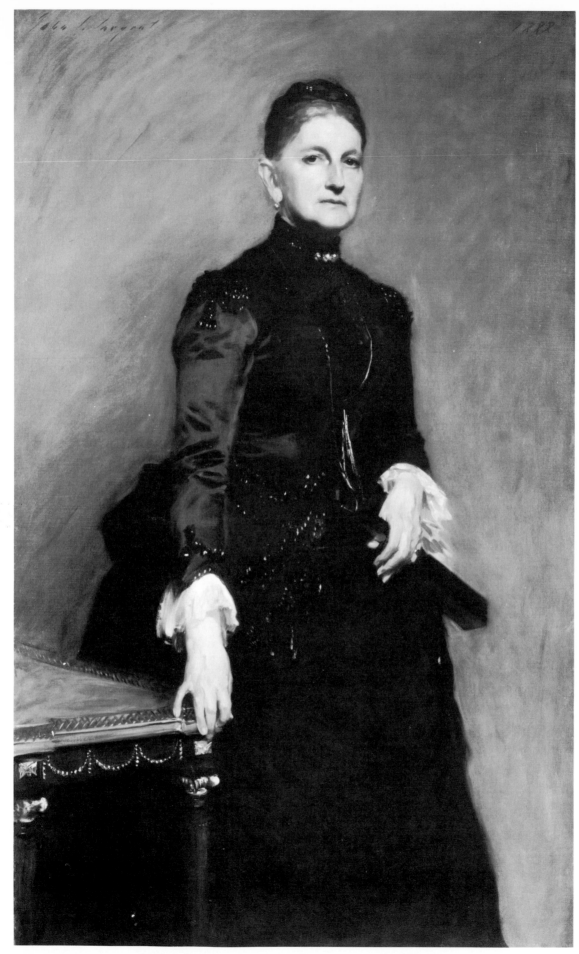

Mrs. Adrian Iselin *by John Singer Sargent, 1888. Oil on canvas, 60 1/2" x 36 5⁄8" (153.7 x 93 cm).*
National Gallery of Art, Washington, D.C. Gift of Ernest Iselin.

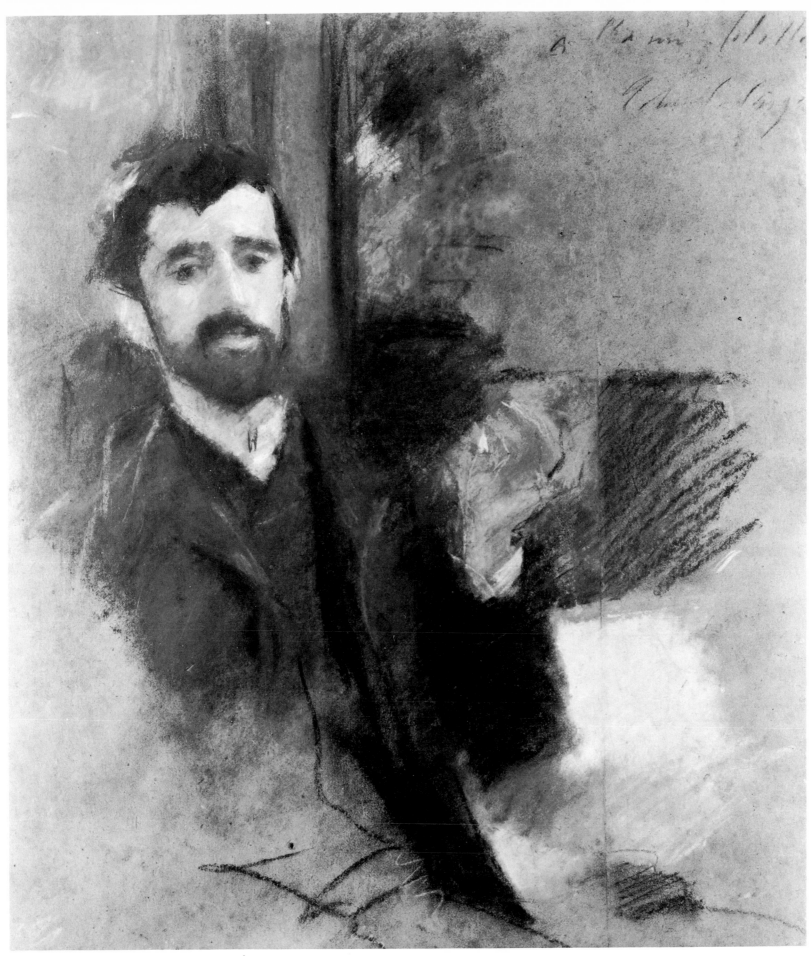

Paul Helleu *by John Singer Sargent, c. 1889. Pastel, 19 1/2″ x 17 5/8″ (49.5 x 44.8 cm).*
Fogg Art Museum, Harvard University, Cambridge, Massachusetts. Bequest of Mrs. Annie Swan Coburn.

Robert Henri

1865 - 1929

Robert Henri was responsible for the second wave of American realism, which looked for a while like the future. Impressionism was going strong in this country when Henri reversed the field. He and his followers came on strong, like a bunch of revolutionaries, which is the nicest thing people called them — the "black gang" in the beginning because their paintings were dark, the Ashcan School in the end because these urban realists painted mean streets where every tenement had a bunch of ashcans. The Henri people insisted that they were *the* native American school, and their doctrine was dominant between the two world wars.

Henri was brought up in Cozaddale, Ohio, and Cozad, Nebraska, both towns named after his father. Cozaddale was going to be the Saratoga of Ohio, while it was the destiny of Cozad, on the hundredth meridian, to be the capital of Nebraska, maybe of the United States. Cozad financed his real estate ventures by professional gambling, first on riverboats and then on trains. After killing a man in a fight, he left Cozad one jump ahead of the sheriff; and when he turned up in Atlantic City, he had changed his name to Richard Lee and his sons' names to Robert Henri and Frank Southrn (page 122). His handsome and sinister figure is always right behind Henri.

Henri worshipped his father, who gave the boy a sense of being apart from ordinary people; he didn't need to boast about what his father could do to your father. Being the son of a professional gambler who had killed his man was the best thing that ever happened to Henri; it was his source of strength. Henri had his father's fearlessness and his ability to lead; he was aloof, the way the boss should be, and people were bowled over when he spoke to them so close to their heart's desire.

When Frank Southrn went to medical school in Philadelphia, Henri signed up at the Pennsylvania Academy, where the other students deferred to him,

for he had commanding presence and looked as though he had just gotten off a horse. When Henri caught Paris fever at the Academy, his father bankrolled a trip to France.

Henri wanted to be a great artist, a great man. He loved to read, and he loved the Paris streets, where he felt he was walking through the stories of Maupassant and the novels of Zola — realism was all around him. There was a particular quality in French life that he loved, for this self-conscious American, who spent many years in France, learned everything he knew there, and Paris was far more his home than Philadelphia or, Heaven knows, Atlantic City.

Henri tried Impressionism in France, but he preferred the dark side of the palette; he *liked* the dark (page 120). How can you make your highlights count if they don't blaze against the dark? Impressionism was too pale for Henri. He liked strong colors and strong characters, which he found later in the Spanish gypsies (pages 87 and 123); he didn't want to paint a clear day at the shore. Because he loved the strong flavors of life, he ended up painting only people; people were what interested him and how they *looked* (pages 88, 89, 118, 119, 121, 124, 125). He had a great sense of life, and he could make you feel it. He had the gift of making people see for themselves, which made him a great teacher.

On a trip home, he was offered a job in a girl's school in Philadelphia and, like Duveneck and Chase, he taught all his life. In the evenings he presided over a sketch class full of newspaper artists, men like Sloan, Glackens, and Luks who had no intention of becoming painters. John Sloan said that without Henri he never would have thought of being an artist. Henri was the only reason Luks took up painting, but he wouldn't give him any credit. All these men painted the way they did because of Henri, and their best work is straight Henri. They all painted his dark cityscapes, his striking characters.

They saw, thought, and painted through Henri. Henri was clearheaded enough to know that they all went beyond him, yet without him they all would have remained commercial hacks. He made it possible for them to be better artists than he was. If they resented his knowing this a tiny bit, that's only human.

For Henri himself, things didn't work out too well. After inventing the street scenes on which the Ashcan School was founded, he dropped landscape completely. He tried to paint portraits, but he would neither flatter his sitters nor drink tea with them (pages 123 and 124). His paintings of people are tremendously vivid, but they're far from profound. A good painter and a remarkable man, he wasn't sufficiently obsessed with his own work. Because of his teaching, he had only the summer in which to paint.

Henri's painting didn't improve. He thought too much about his work; he tried to get it all in words; he taught too much. His painting got simpler, as though he had everything figured out, and he lost what had made it important in the first place. The mystery he always kept personally was lost in his paintings. He knew too clearly what he meant to do, left too much out, left no room for the play of the human spirit. He dominated his own work too much; he was too facile. He didn't do what he told his students to do; he was not sufficiently himself. He may have known this, but he never complained. When he died of cancer in New York Hospital, he was trying out new tackle for next year's trout in Ireland.

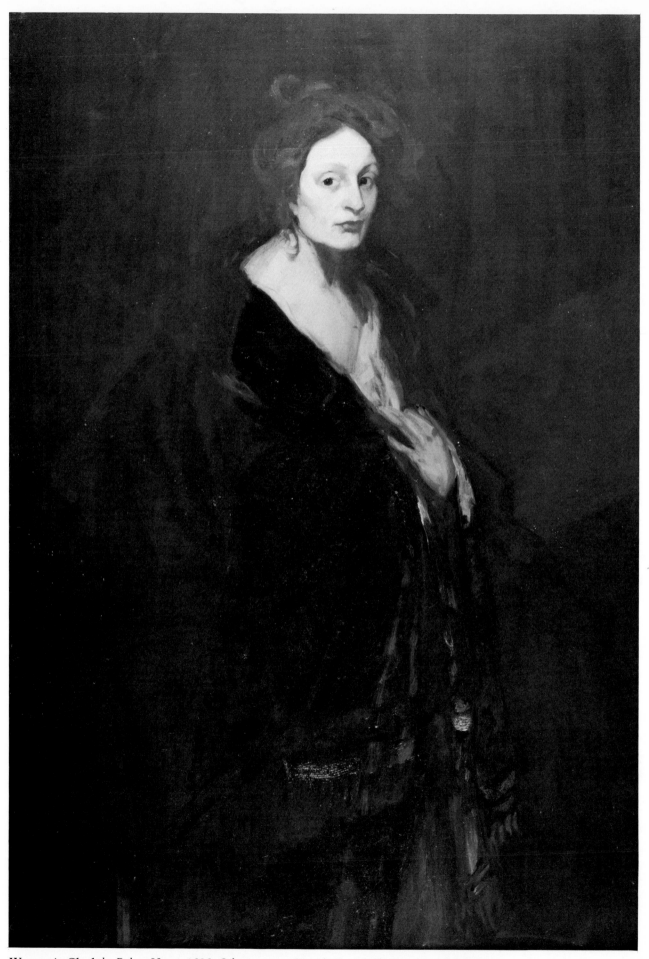

Woman in Cloak *by Robert Henri, 1898. Oil on canvas, 56 11/16″ x 38 7/16″ (144 x 97.6 cm).*
The Brooklyn Museum, Brooklyn, New York.

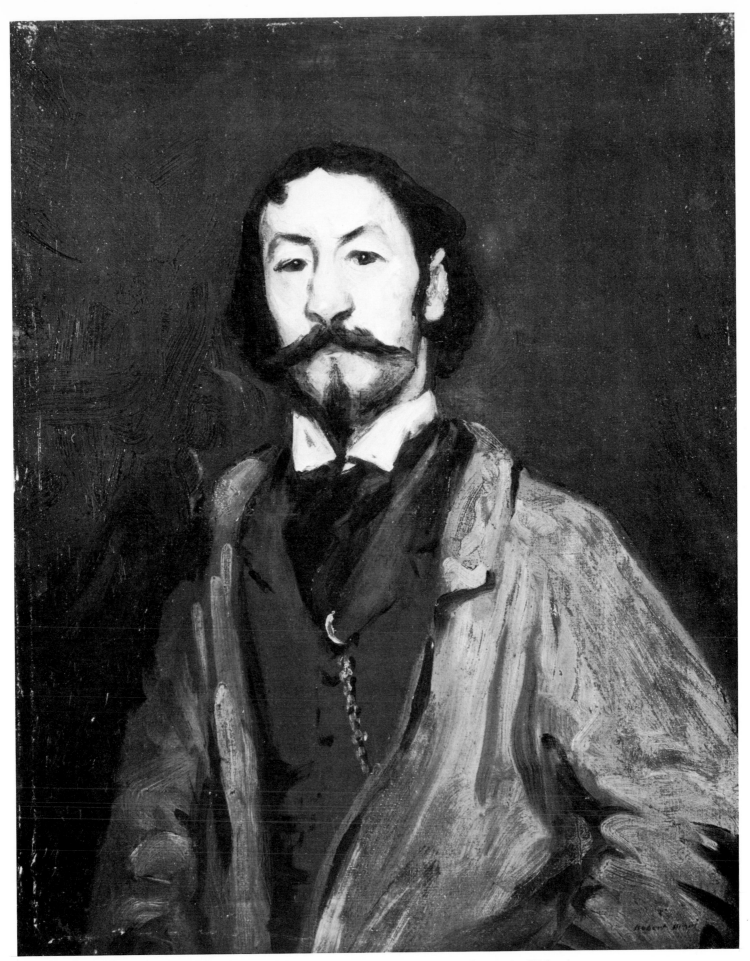

The Man Who Posed as Richelieu *by Robert Henri, 1898– 99. Oil on canvas, 32" x 25 5/8" (81.3 x 57.5 cm).*
The Brooklyn Museum, Brooklyn, New York.

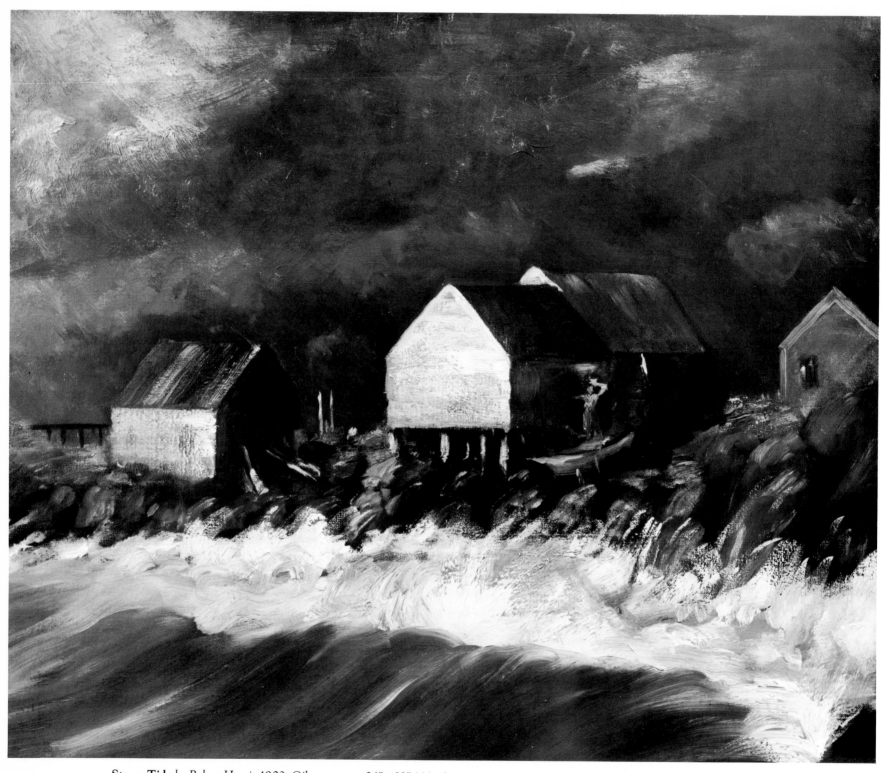

Storm Tide by Robert Henri, 1903. Oil on canvas, 26" x 32" (66 x 81.3 cm).
Whitney Museum of American Art, New York, New York.

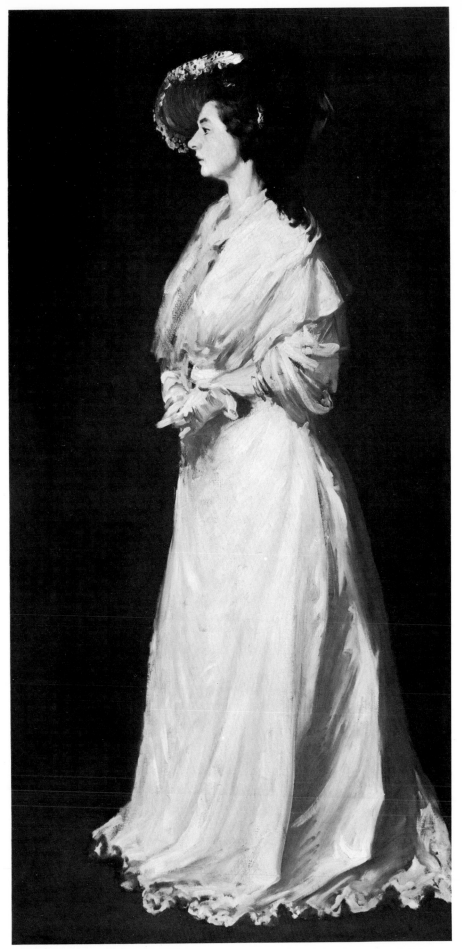

Young Woman in White *by Robert Henri, 1904. Oil on canvas, 78 1/4" x 38 1/8"*
(199.4 x 96.9 cm). National Gallery of Art, Washington, D.C. Gift of Miss Violet Organ.

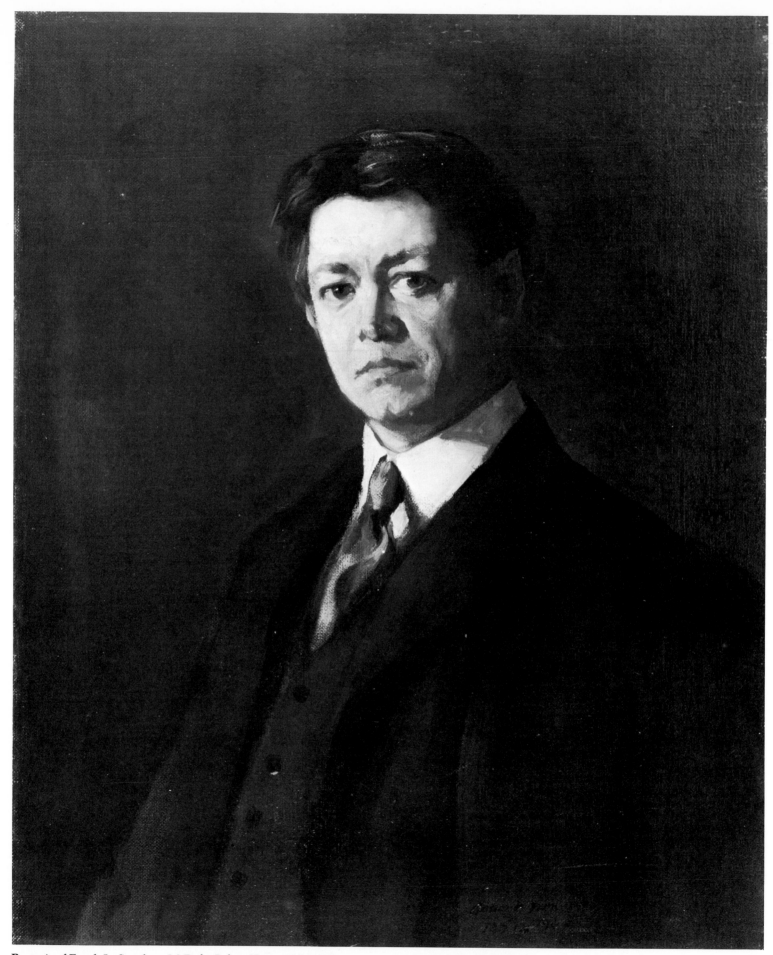

Portrait of Frank L. Southrn, M.D. *by Robert Henri, 1904. Oil on canvas, 32" x 26" (81.3 x 66 cm). University Collection, University of Nebraska — Lincoln Art Galleries, Lincoln, Nebraska. Gift of Mrs. Olga N. Sheldon.*

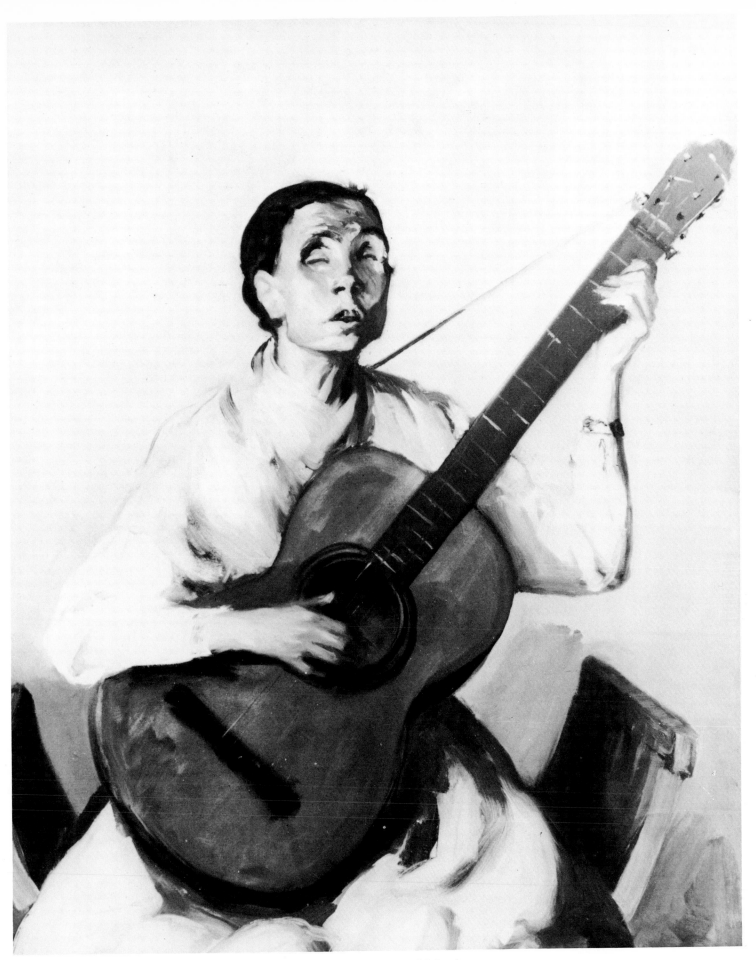

Blind Spanish Singer *by Robert Henri, 1912. Oil on canvas, 41″ x 33″ (104.1 x 83.8 cm).*
National Collection of Fine Arts, The Smithsonian Institution, Washington, D.C. Gift of J. H. Smith.

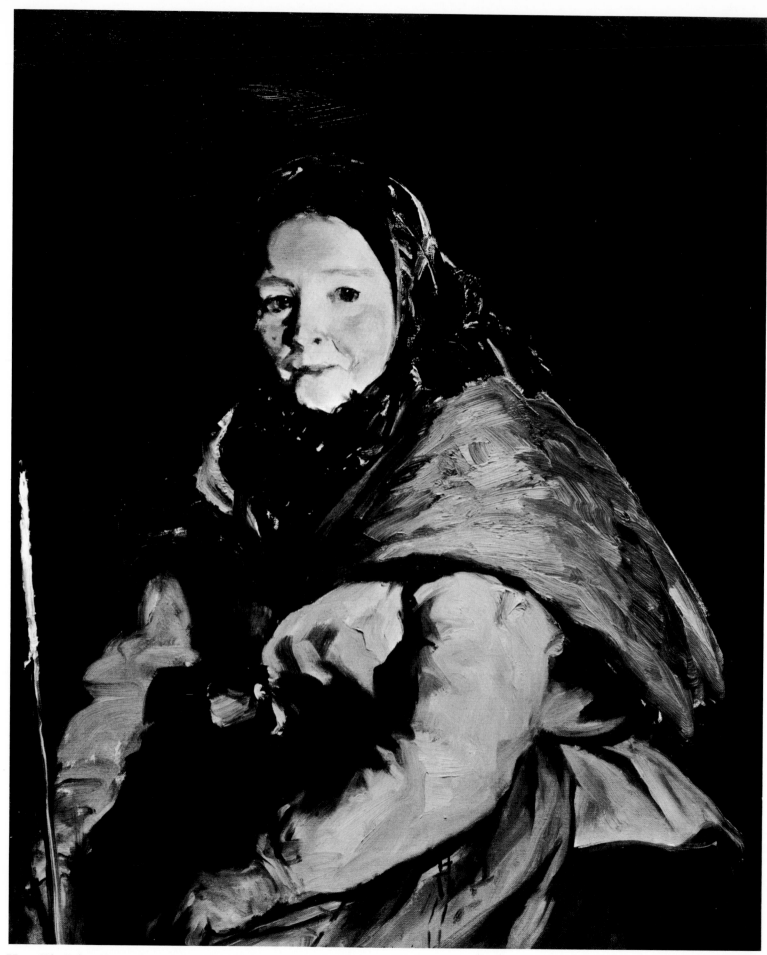

Herself by Robert Henri, 1913. Oil on canvas, 32″ x 26″ (81.3 x 66 cm).
The Art Institute of Chicago, Chicago, Illinois. Walter H. Schultze Memorial Collection.

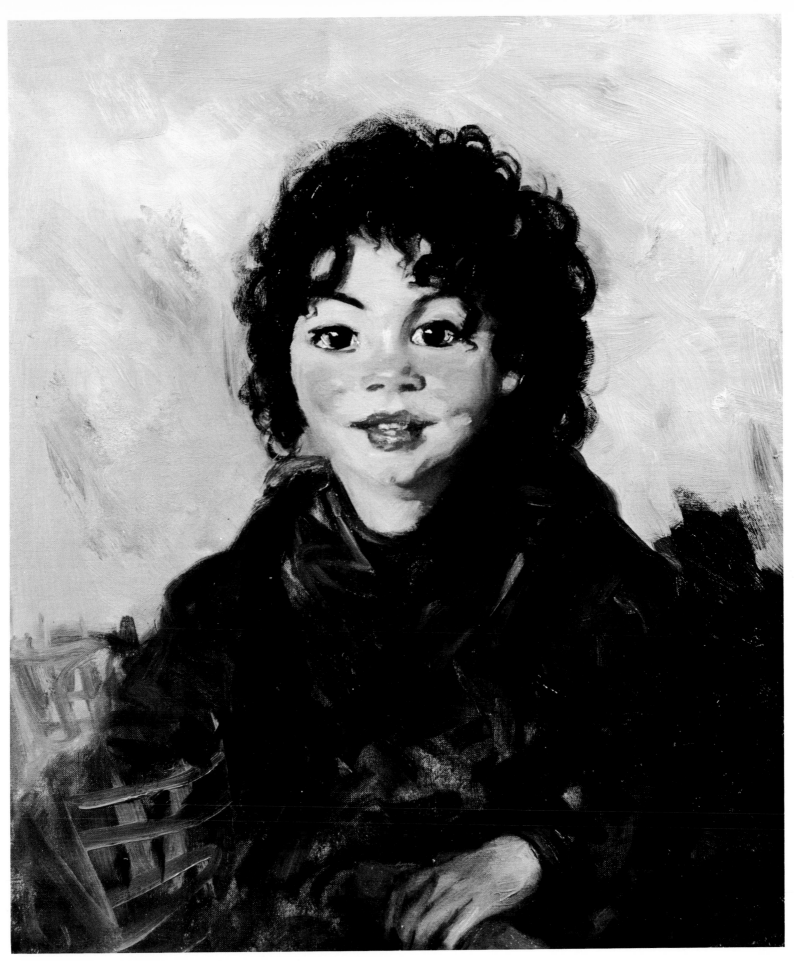

Thammy by Robert Henri, 1913. Oil on canvas, 24″ x 20″ (61 x 50.8 cm).
Museum of Fine Arts, Boston, Massachusetts. Gift of Mrs. Albert J. Beveridge.

William Glackens

1870 - 1938

Glackens went to the same high school as John Sloan, but his real friend was Albert Barnes, another baseball fan, who later made a fortune out of Argyrol, the foul-tasting medicine they used to paint our throats with. When Glackens found he could draw, he got a job on the *Philadelphia Press,* covering fires and spectacular disasters. He could draw anything. He didn't become a real Henri disciple, as Sloan did, but he learned his great early style from Henri. He didn't take Henri's ideas or any others, too seriously.

He easily broke into the magazine world in New York, where his Philadelphia friends joined him. To poor devils like Sloan, Glackens led a charmed life, particularly when a wealthy student of Chase's insisted on marrying him, to his delight and her family's dismay. Glackens was made for family life. They had a wonderful place in Greenwich Village: delicious meals, children, everything. When his wife's parents died, Glackens went to Paris, and from then on he spent as much time in Paris as he could. The main reason he liked New York was because it reminded him of Paris.

When Glackens ran into Barnes again, he got Barnes interested in collecting, and Barnes sent him to France on a buying trip. Glackens did well for his client, but somewhere along the line, Glackens was overwhelmed by Renoir. He painted smaller and easier paintings, always pleasing, but too much like the master. He used the same purple tones and his paintings became soft and lush. Perhaps Henri had been more important than he seemed; he gave Glackens the stiffening he needed.

Glackens did everything with amazing ease. He had lots of talent, and he let things happen, which is not a bad way to be. He was a very quiet man who let other people have their way and did exactly what he pleased. While Sloan had to slave to get out his Sunday feature, Glackens could knock out illustrations as fast as he could draw — and he could draw

fast. For Sloan, it was pure drudgery in a style that he hated, whereas Glackens drew just the way he wanted to, and the editors wanted anything he drew. It was the same way with painting: once Glackens got the hang of it, painting was the easiest thing in the world for him. It must have been obvious to him very quickly that he could paint better than Henri or anybody else on this side of the water.

If Glackens had never painted anything beside *Chez Mouquin* (page 92), he'd rank close to the top. Mary Cassatt would have been proud of that picture, which she never surpassed. This masterpiece is a French picture of a French restaurant in New York.

Glackens took what he needed from artists other than Henri. We like to talk about an American school of illustration, but it's more closely tied to England. Charles Keene, who worked for *Punch,* is conveniently forgotten, but in those days he was a god whom even Whistler praised. All these men cut out Keene's drawings and stashed them away in dusty portfolios. Glackens' strong line comes straight out of Keene; so do the slum scenes and street fights.

Glackens' paintings do have tremendous charm and distinction. They mirror his life: his wife, who bossed things except in the studio (page 128), and his children, whom he adored (page 129). Once his wife got him to march in a parade, but mainly he stayed in character. The thing he was most against was the Prohibition; he always knew where to buy the best wine in Greenwich Village (page 91). The other artists admired his work and envied him a bit, though they never held his good fortune against him. Maybe they felt that he should push himself a little harder.

Henri did for Glackens all that any teacher could do. Glackens found out early what he could do and he stuck to it, producing as pleasing and distinctive a body of work as you'll find in American art. He didn't ask for more. He was happy with the world as it was, and things always turned out well for him.

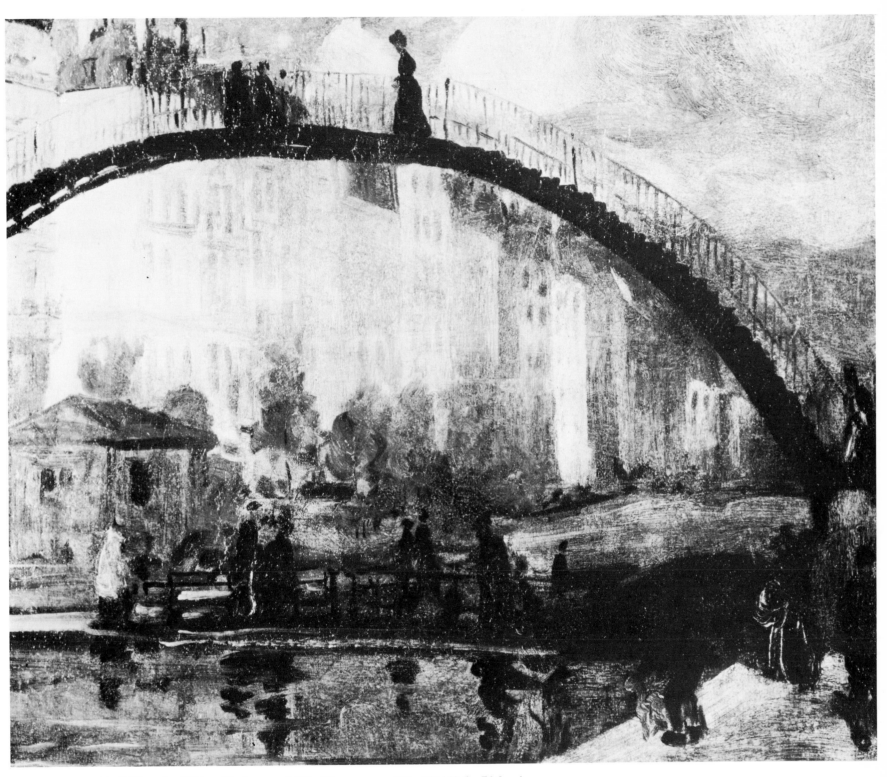

La Villette by William Glackens, c. 1895. Oil on canvas, 25" x 30" (63.5 x 76.2 cm).
Museum of Art, Carnegie Institute, Pittsburgh, Pennsylvania.

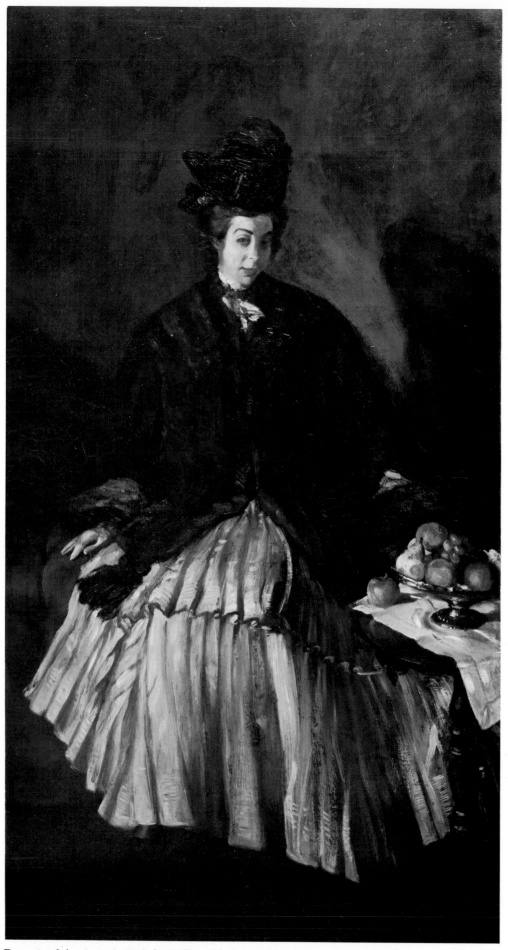

Portrait of the Artist's Wife *by William Glackens, 1904. Oil on canvas, 75" x 40"*
(190.5 x 101.6 cm). Wadsworth Atheneum, Hartford, Connecticut. Gift of Ira Glackens.

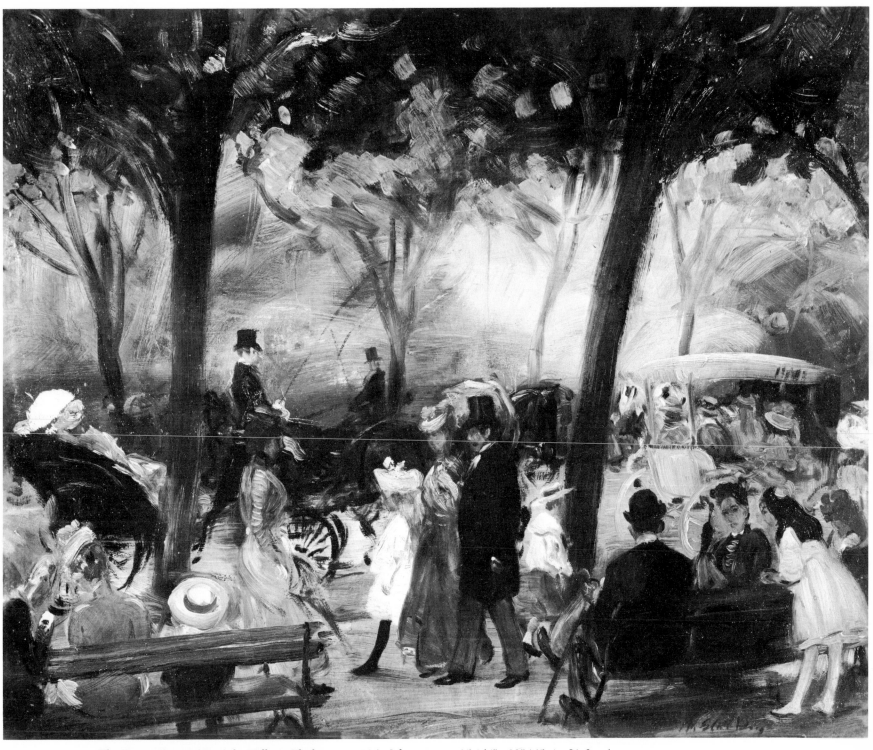

The Drive, Central Park *by William Glackens, c. 1905. Oil on canvas, 25 3/4" x 32" (65.4 x 81.3 cm).*
The Cleveland Museum of Art, Cleveland, Ohio. J. H. Wade Collection.

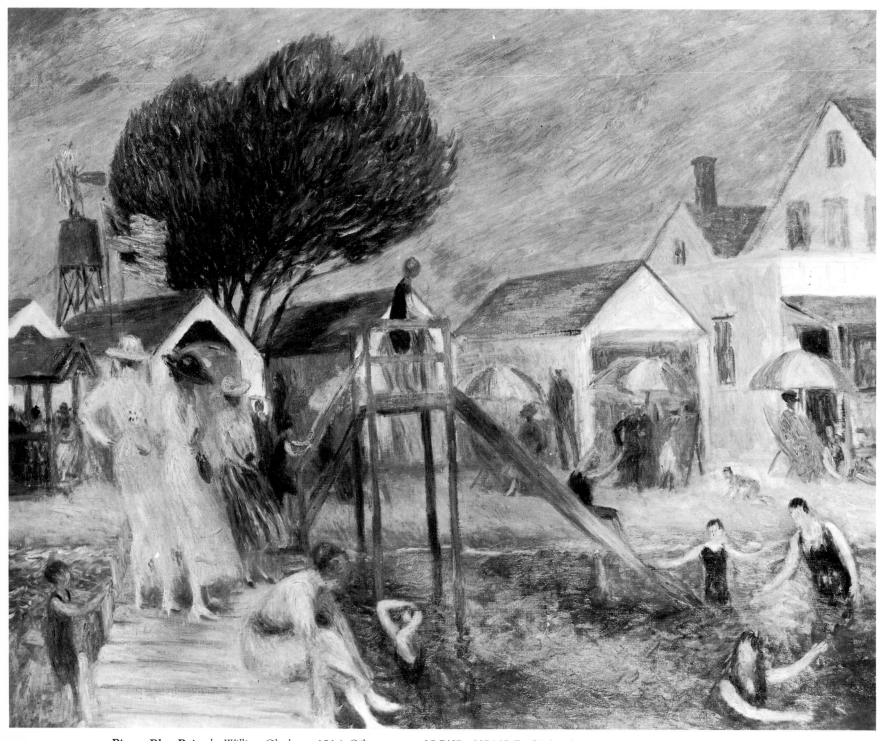

Pier at Blue Point by William Glackens, 1914. Oil on canvas, 25 7/8" x 32" (65.7 x 81.3 cm).
The Columbus Gallery of Fine Arts, Columbus, Ohio. Ferdinand Howald Collection.

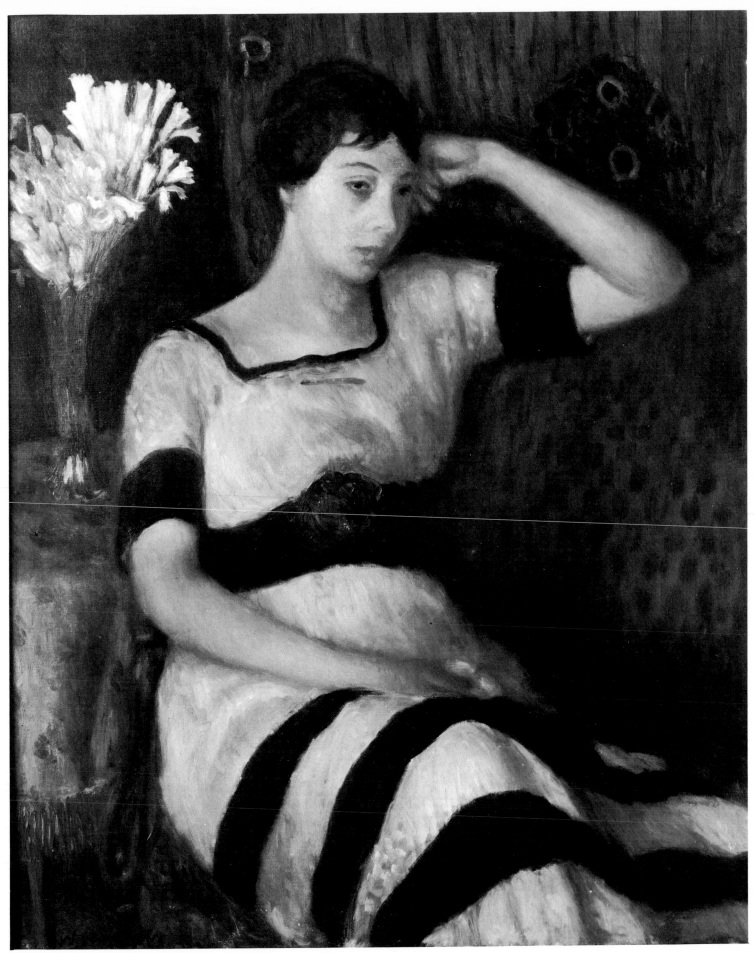

Girl in Black and White *by William Glackens, 1914. Oil on canvas, 32" x 26" (81.3 x 66 cm).*
Whitney Museum of American Art, New York, New York. Gift of the Glackens Family.

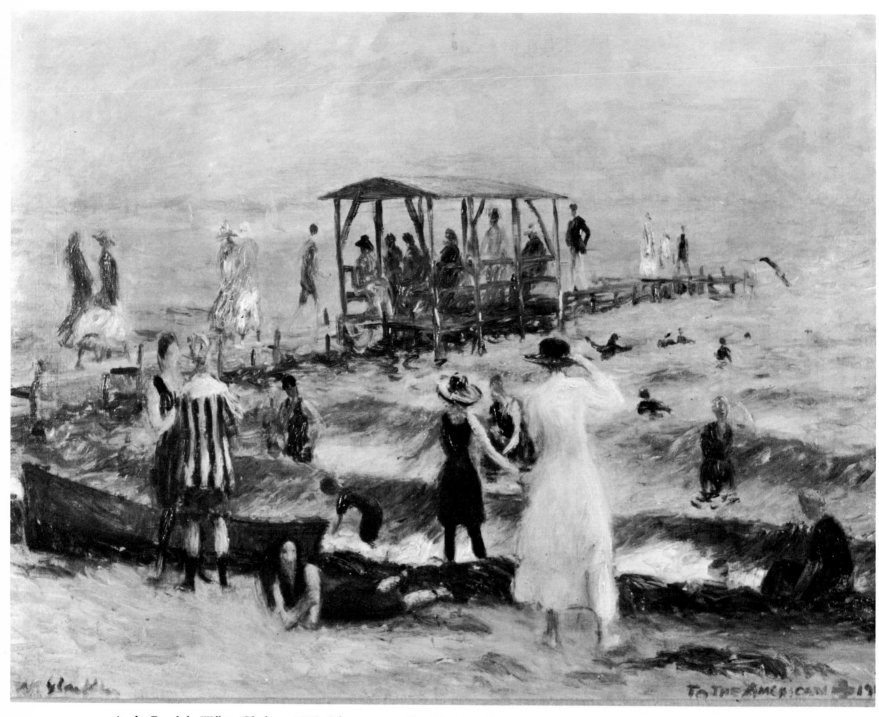

At the Beach *by William Glackens, 1917. Oil on canvas, 18" x 24" (45.7 x 61 cm).*
Pennsylvania Academy of the Fine Arts, Philadelphia, Pennsylvania.

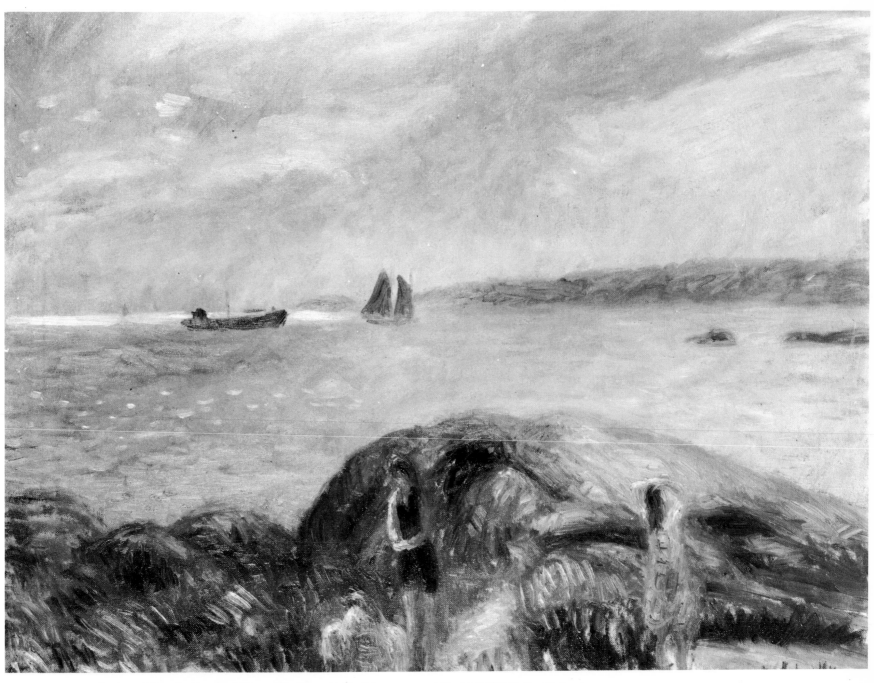

Bathing Near the Bay *by William Glackens, 1919. Oil on canvas, 18″ x 23 7/8″ (45.7 x 60.6 cm)*
The Columbus Gallery of Fine Arts, Columbus, Ohio. Ferdinand Howald Collection.

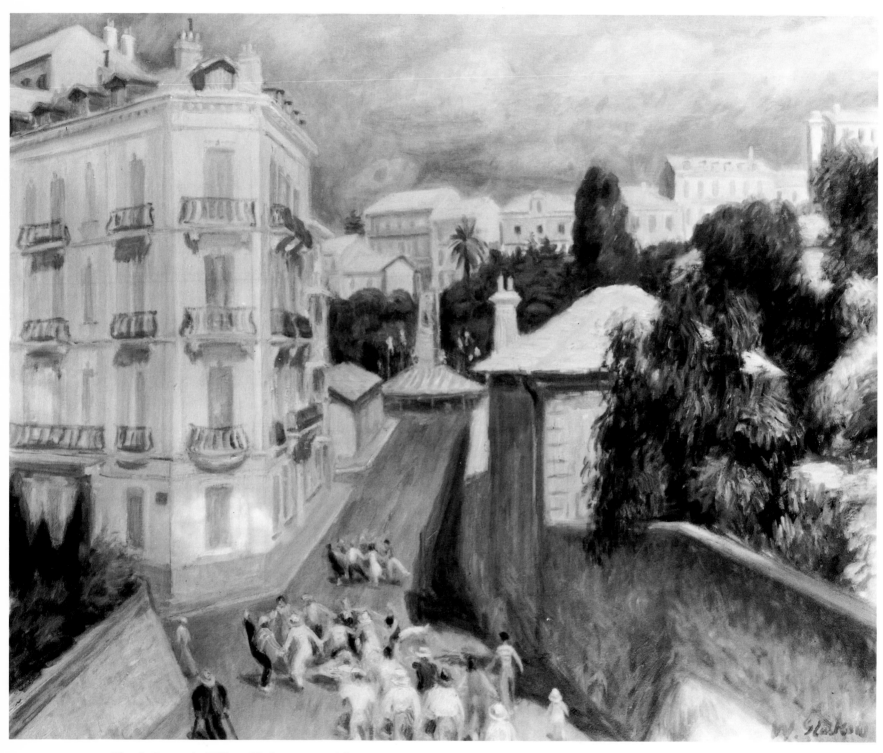

Fête de Suquet *by William Glackens, 1932. Oil on canvas, 25 3/4" x 32" (63.7 x 81.3 cm).*
Whitney Museum of American Art, New York, New York.

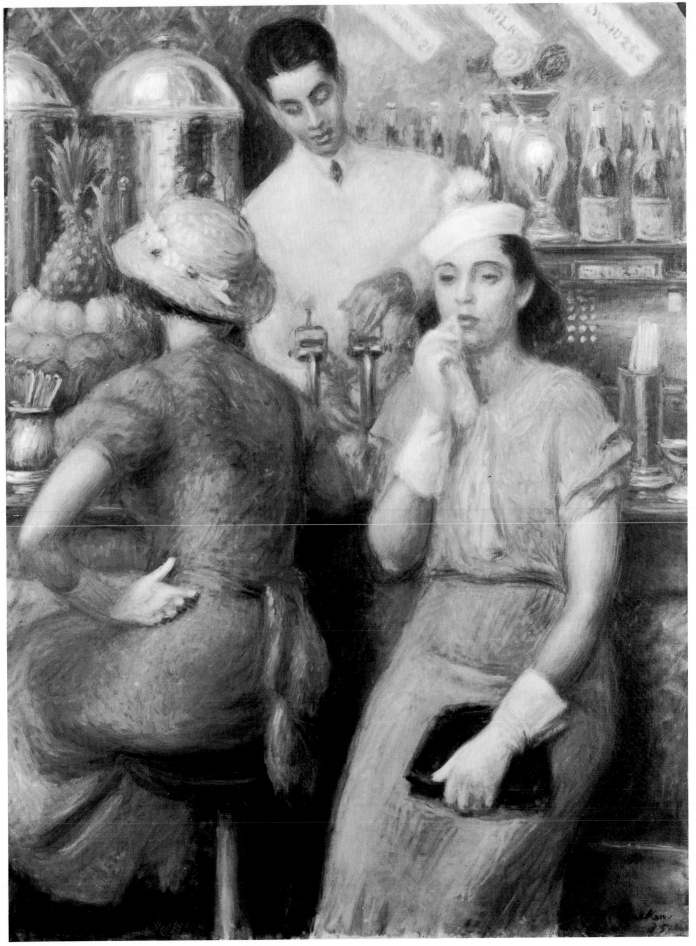

The Soda Fountain *by William Glackens, 1935. Oil on canvas, 48″ x 36″ (121.9 x 91.4 cm).*
Pennsylvania Academy of the Fine Arts, Philadelphia, Pennsylvania. Temple and Gilpin Fund Purchase.

George Luks

1867 - 1933

George Luks was no man's disciple; he was far too difficult. He never admitted that he owed anybody anything, yet he would never have been a painter if it hadn't been for Henri, and he painted in Henri's manner all his life. Luks liked to pretend that he was already a painter before they met, but by then Luks wasn't painting at all — he was drinking, which he preferred. Somewhere inside this bellicose little man there may have been a tender soul, but it was very hard to find.

Luks was a Pennsylvania Dutch boy whose people wandered up into the coal fields. The family was artistic: one sister sang with Lillian Russell; one brother was a violinist; and one played straight man to George in a professional vaudeville act, unless that was one of George's fantasies. For Luks' lies were unending: he said he spent his student years in Europe living with a retired liontamer in Düsseldorf, and with his father's family in London — though his father was Pennsylvania Dutch! He said he studied under Lowenstein, Jensen, Gambrinus, all brands of German beer, and with some Frenchmen, from whom he never learned anything. Obviously, he had more respect for brewmasters than schoolmasters. Yet even when Luks was running himself down, he was such a liar that he could never be trusted. But he must have spent more time painting than he let on, for the wonderful small oils in the Munson-Williams-Proctor Institute at Utica, which were painted in Paris in the nineties, look like Henri before Luks met him.

By the time he joined the *Philadelphia Press,* he had apparently given up painting, but you can't be sure that anything Luks said was true. He roomed with Everett Shinn, a teetotalling fellow slave at the *Press*, whose job it was to haul Luks out of the saloon. Luks was a great man in a bar, where he liked to imitate a brass band, toot for toot. But mostly he was a prizefighter, former light-heavyweight champion of

the world: Lusty Luks, Socko Sam, Curtains Conway, or Monk the Morgue. He said he had fought one hundred and fifty bouts as Chicago Whitey, and people believed him. His favorite trick was to start an argument in a bar and then slip out, leaving the place in a free-for-all. He told Shinn he'd never make the grade because he didn't drink.

In 1896, as a war correspondent for the *Philadelphia Evening Bulletin*, Luks sent back twenty-nine drawings from the Cuban front, some of them double-spreads, but if he got near the fighting, it was by mistake. He said that he carried the message to Garcia through the lines disguised as a dog. After he was fired, he landed a job in New York doing comics for *The World.* Doing a comic strip, which is a murderous strain for most men, was duck soup for Luks, who could literally draw with both hands.

While Glackens and even Sloan wandered off the reservation, Luks was a follower of Henri's manner to the end of his days. After the Paris scenes, he painted the slums of New York, the hopeful dog following the butcher's cart through the dirty snow (page 94). In 1903, Charles Fitzgerald, Glackens' brother-in-law, who blew his horn for the realists, praised Luks' painting of corner boys and toughs, street urchins, ragamuffins, and all kinds of low types (pages 93, 139, and 141); but many people were shocked by his paintings. He was wonderful copy; James Gibbon Huneker, the great critic who introduced so much European painting, writing, and music to this country, said that an afternoon talking with Luks in his studio reconciled him to living in America. Even Guy du Bois, a drinking man himself and a harsh judge who deplored Luks' bragging and his foul language, thought that Luks painted many a great picture; du Bois spoke with authority because their way of life and their subjects had a lot in common.

Luks found a dark glory in his addled characters. He didn't believe in respectable people; he thought

the real robbers were all in church. Maybe kids were all right to start out with, but they got it beaten out of them. Drunks, plug-uglies, waifs, and strays — that's the company Luks liked, and he couldn't find it at the National Academy of Design, or at Mrs. Whitney's parties. Life was a vast joke. Why waste your time on stuffed shirts when there were so many wonderful corners to explore — like the cellar under the saloon where they kept a pig so they could get it drunk. Luks was an extremely intelligent man who genuinely felt that life on the wrong side of the tracks had far more meaning. If his subjects were grim and defeated, that's the way things are. He enjoyed the mockery all right; those aren't life's little ironies — that's the truth. Luks didn't invent what he painted; he saw it all around him.

There was always some good woman to look after Luks when he stumbled home. He gloried in life's wreckage, of which he was a part. Usually his doctor brother could patch him up, but there wasn't much he could do when they found Luks under the "El" one fine morning in 1933, thoroughly beaten up and very much dead.

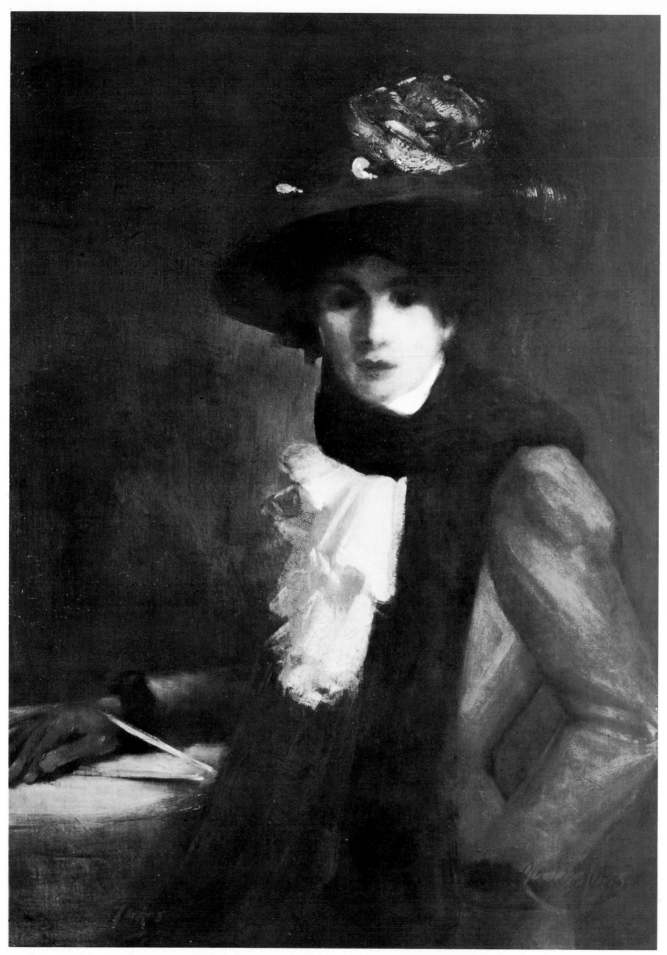

The Little Milliner *by George Luks, 1905. Oil on canvas, 36 1/2″ x 26 1/2″ (92.7 x 67.3 cm).
Toledo Museum of Art, Toledo, Ohio. Gift of Florence Scott Libbey.*

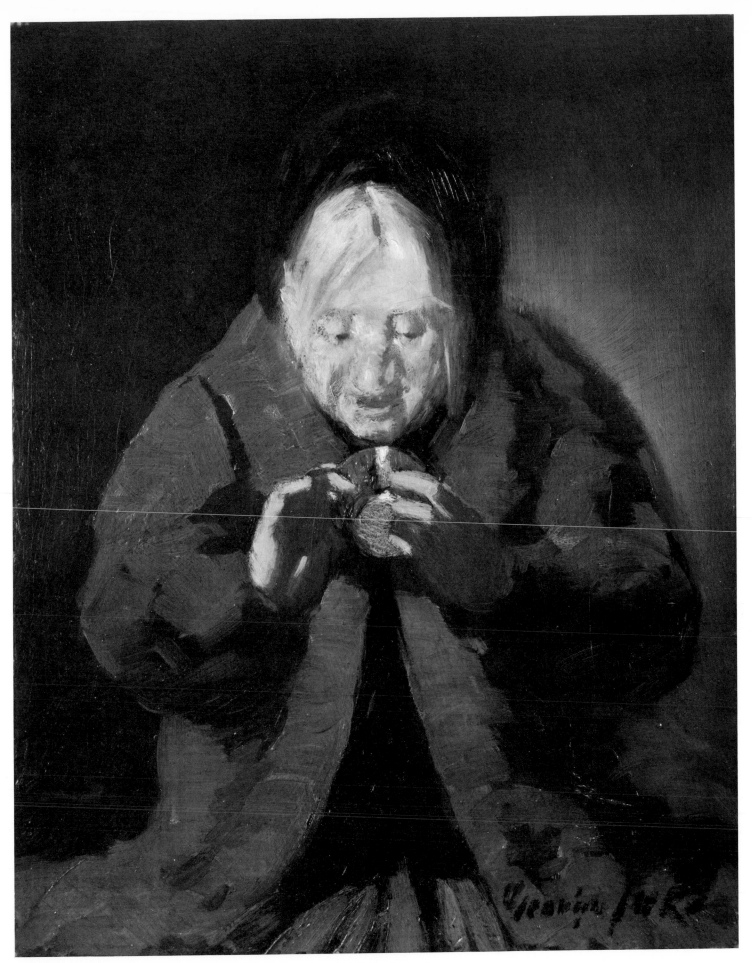

Telling Fortunes *by George Luks, 1914. Oil on canvas, 20" x 16" (50.8 x 40.6 cm).*
The Phillips Collection, Washington, D.C.

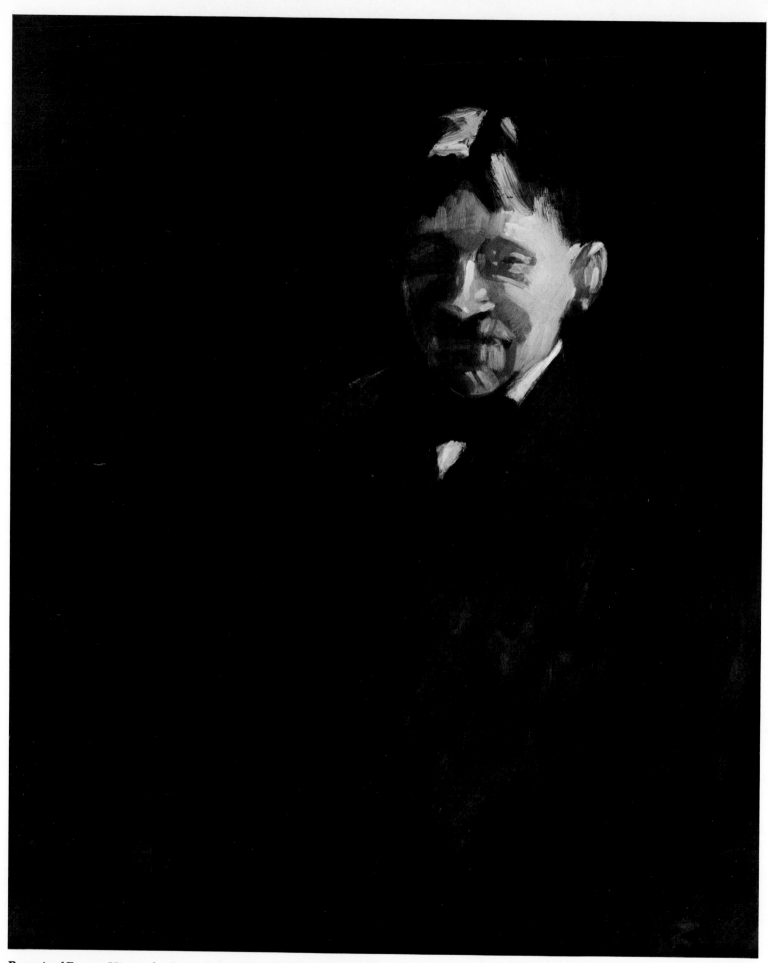

Portrait of Eugene Higgins by *George Luks, 1914–15. Oil on canvas, 29" x 24" (73.7 x 61 cm). The Columbus Gallery of Fine Arts, Columbus, Ohio. Gift of Norman Hirschl.*

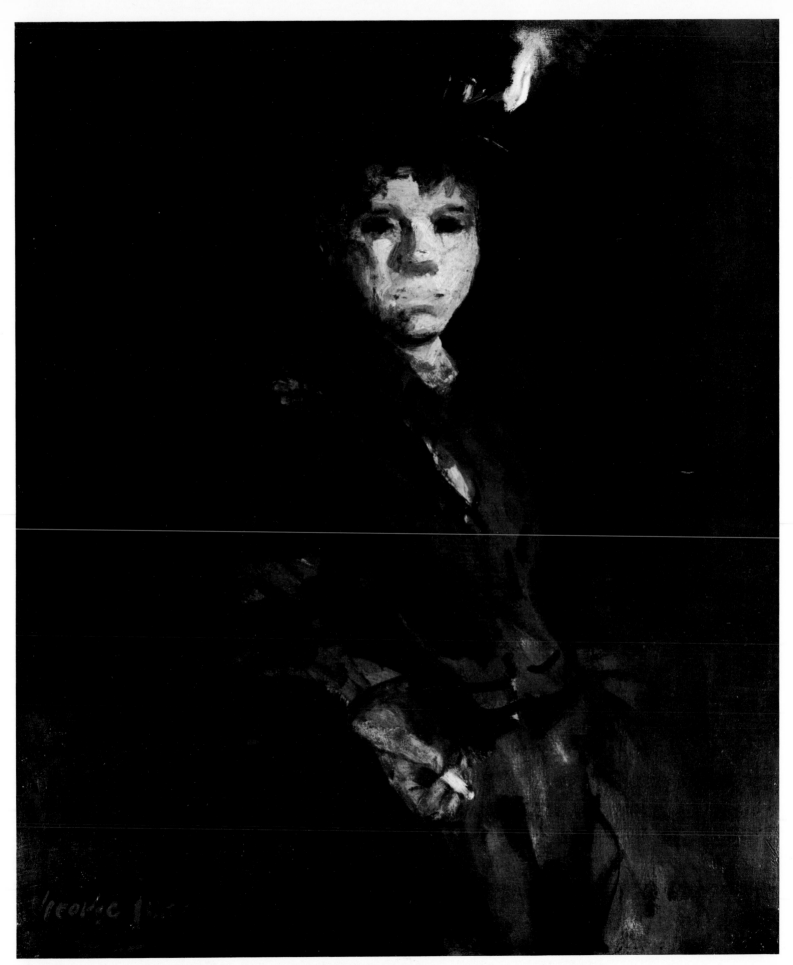

The Breaker Boy by *George Luks, 1921. Oil on canvas, 30" x 25" (76.2 x 63.5 cm).*
Walker Art Center, Minneapolis, Minnesota.

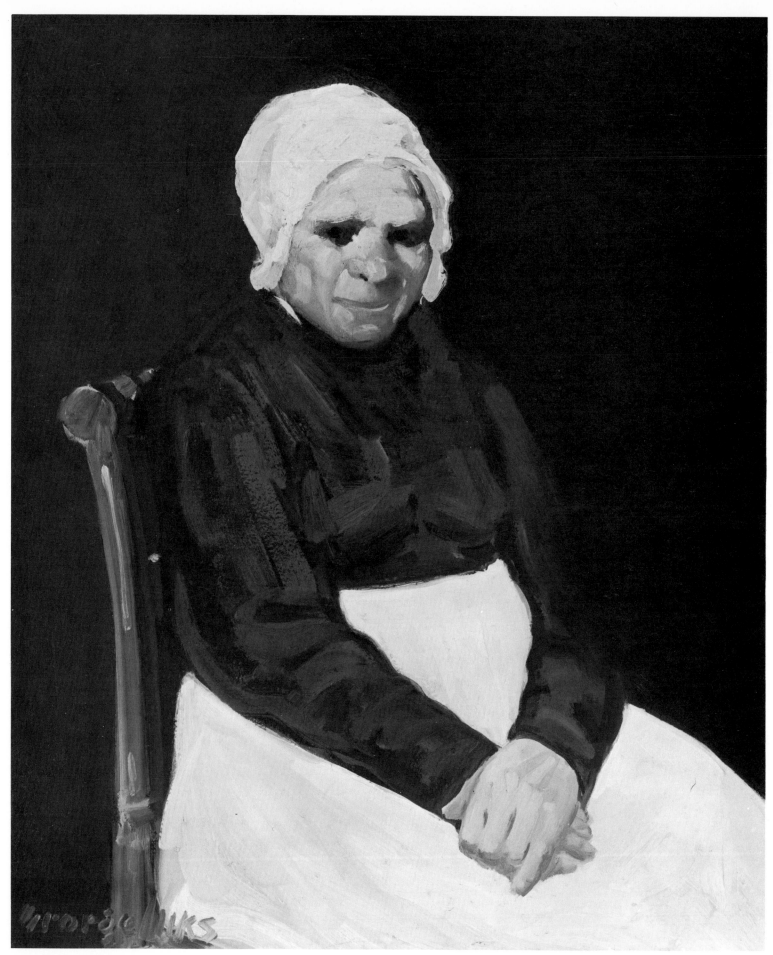

Nora Brady by George Luks, n.d. Oil on canvas, 30" x 26" (76.2 x 66 cm).
New Britain Museum of American Art, New Britain, Connecticut. Harriet Russell Stanley Fund.

142

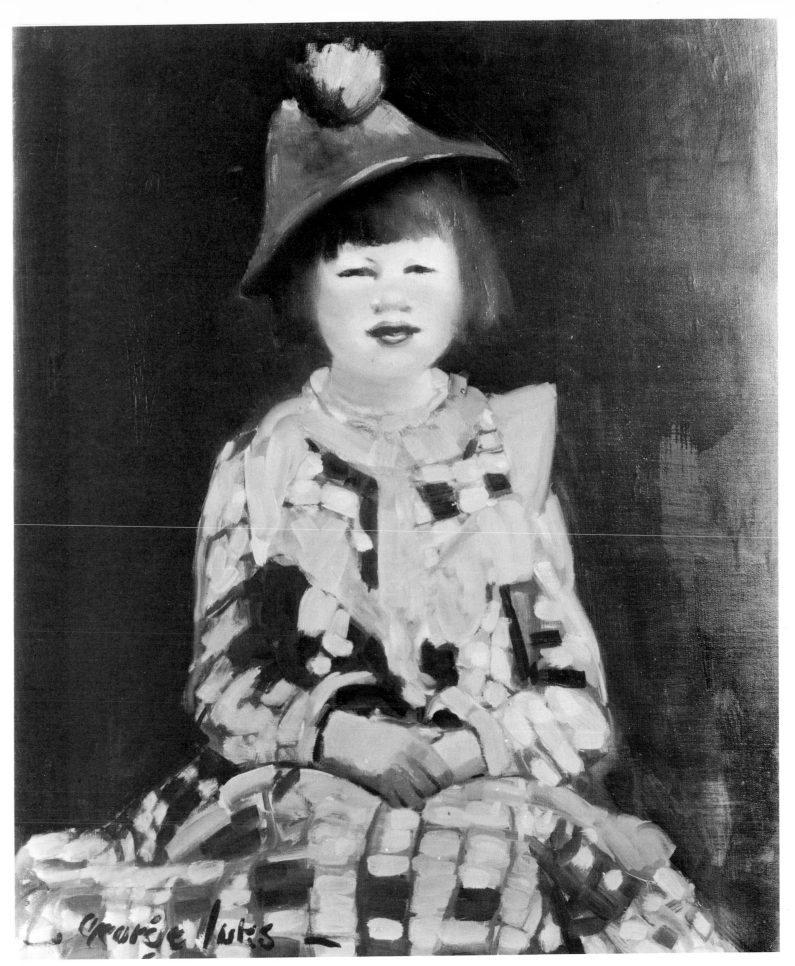

Sassafras (Eleanor) *by George Luks, c. 1927. Oil on canvas, 29 1/4" x 24 3/8" (74.3 x 61.9 cm).*
Museum of Art, Rhode Island School of Design, Providence, Rhode Island. Jesse Metcalf Fund.

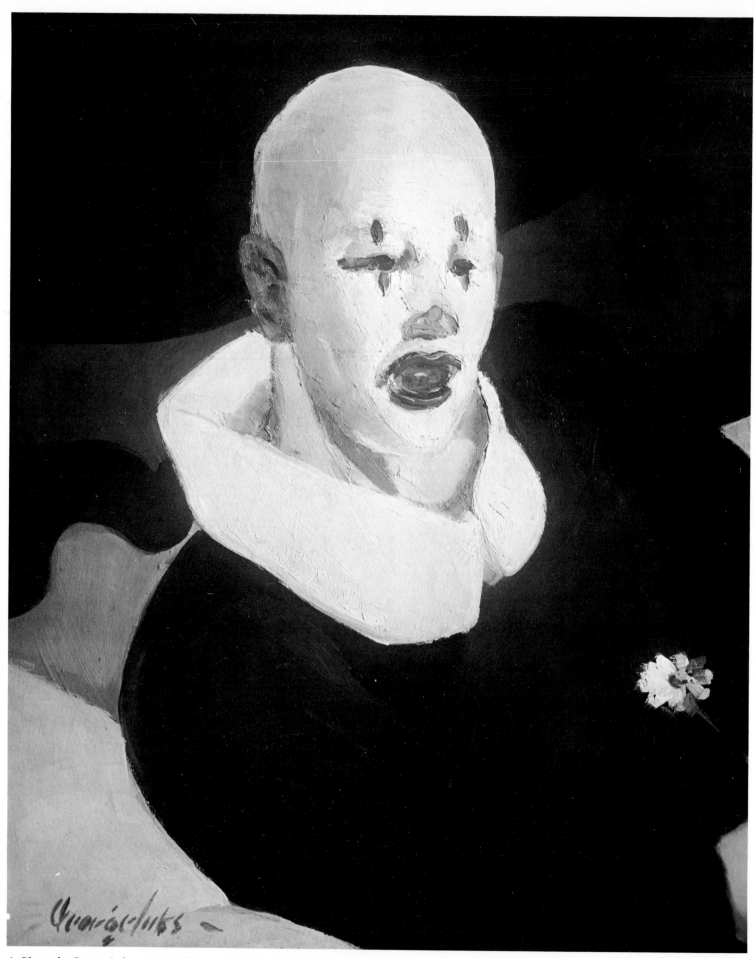

A Clown by George Luks, 1929. Oil on canvas, 24″ x 20″ (61 x 50.8 cm).
The Museum of Fine Arts, Boston, Massachusetts. Bequest of John T. Spaulding.

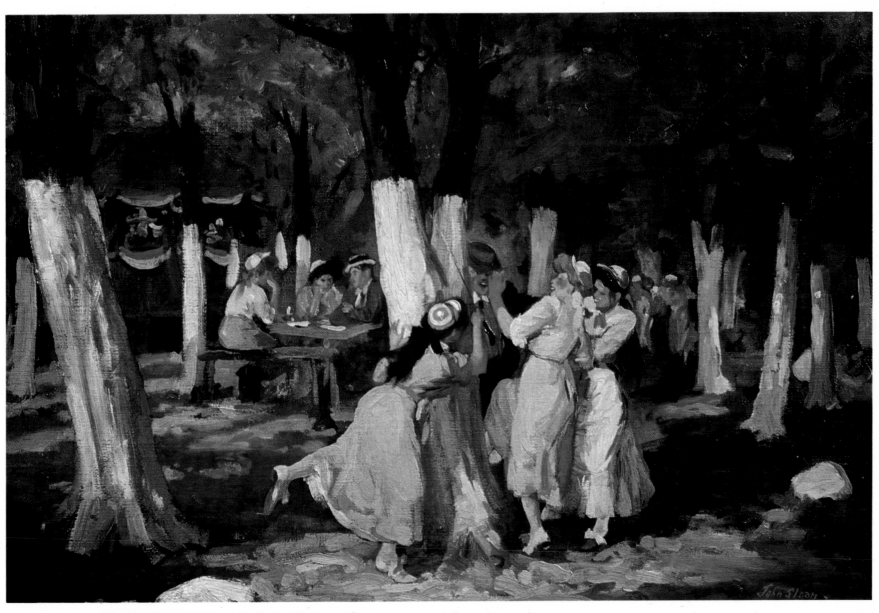

The Picnic Grounds *by John Sloan, 1906– 7. Oil on canvas, 24" x 36" (61 x 91.4 cm). Whitney Museum of American Art, New York, New York.*

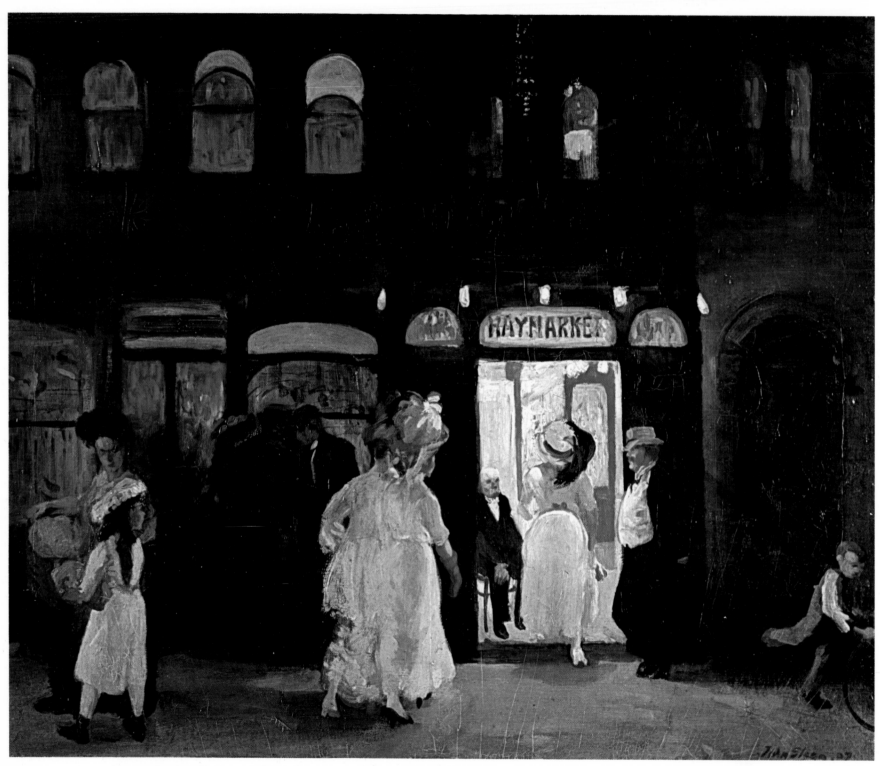

Haymarket by John Sloan, 1907. Oil on canvas, 26″ x 31 7/8″ (66 x 81 cm).
The Brooklyn Museum, Brooklyn, New York. Gift of Mrs. Harry Payne Whitney.

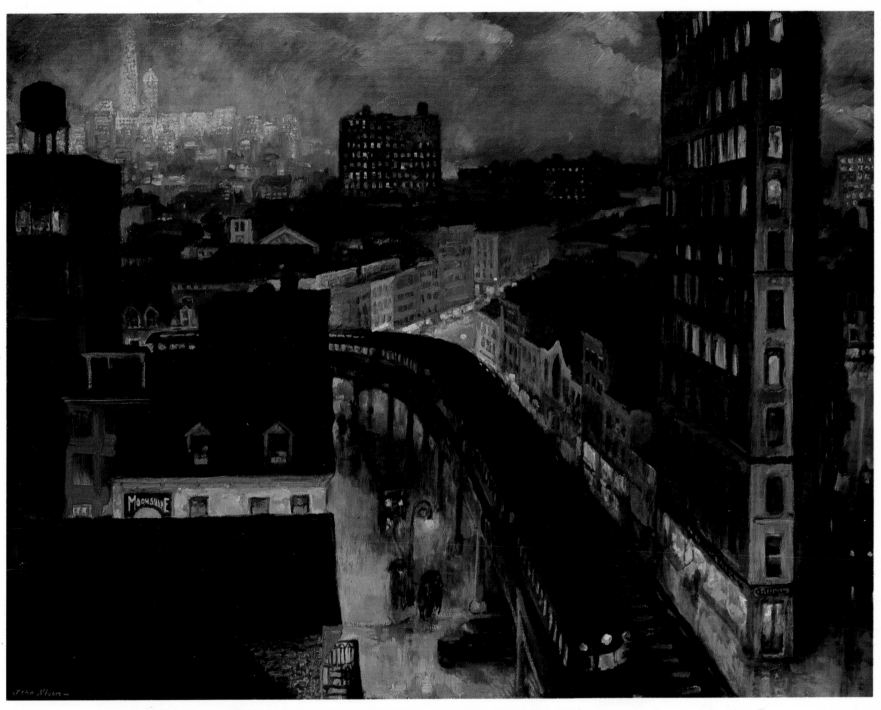

The City from Greenwich Village *by John Sloan, 1922. Oil on canvas, 26" x 33 3/4" (66 x 85.7 cm).*
National Gallery of Art, Washington, D.C. Gift of Helen Farr Sloan.

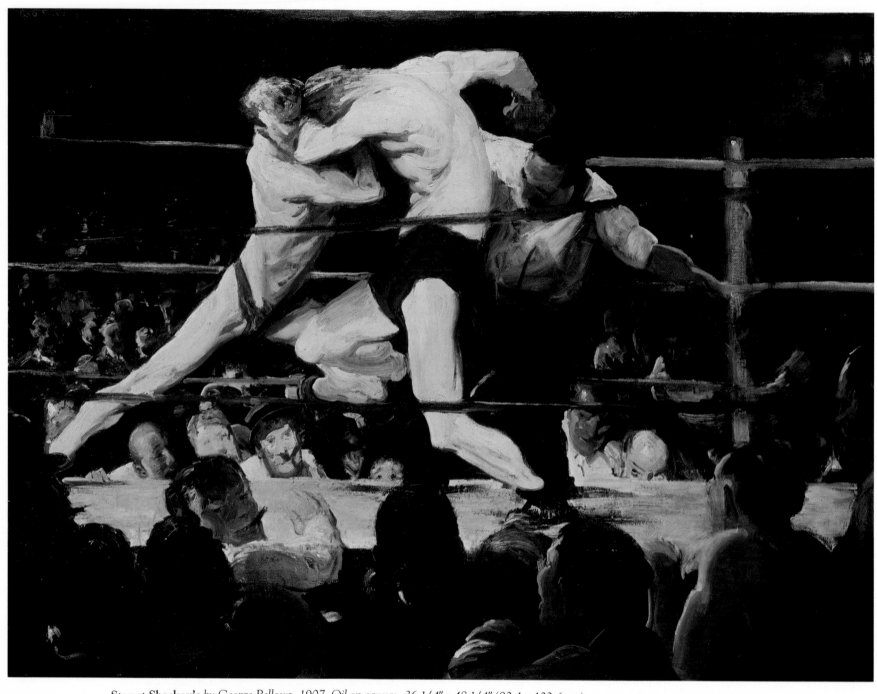

Stag at Sharkey's *by George Bellows, 1907. Oil on canvas, 36 1/4" x 48 1/4" (92.1 x 122.6 cm).*
The Cleveland Museum of Art, Cleveland, Ohio. Hinman B. Hurlbut Collection.

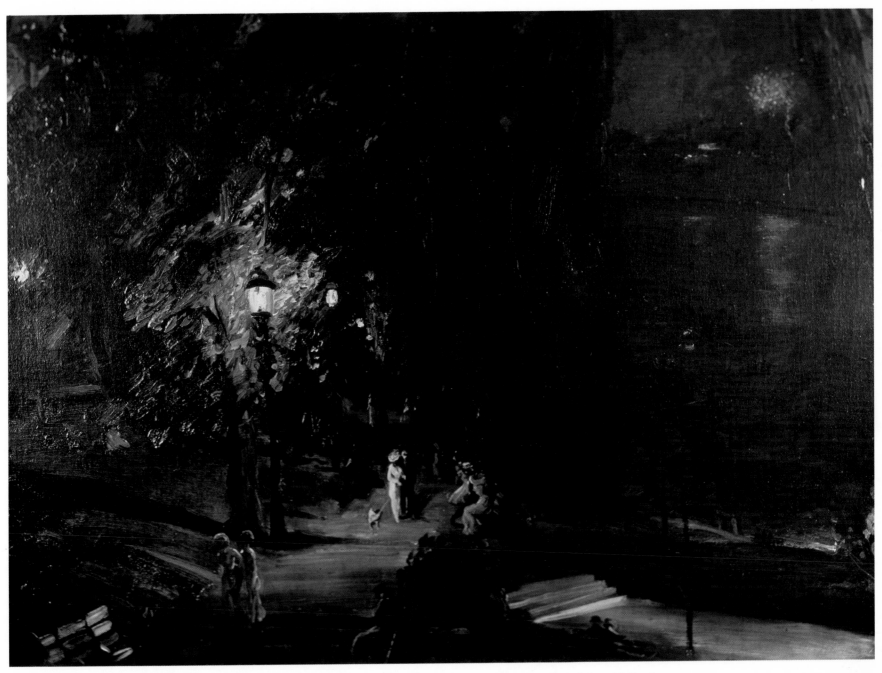

Summer Night, Riverside Drive by George Bellows, 1909. Oil on canvas, 35 1/2″ x 47 1/2″ (90.2 x 120.7 cm).
The Columbus Gallery of Fine Arts, Columbus, Ohio. Bequest of Frederick W. Schumacher.

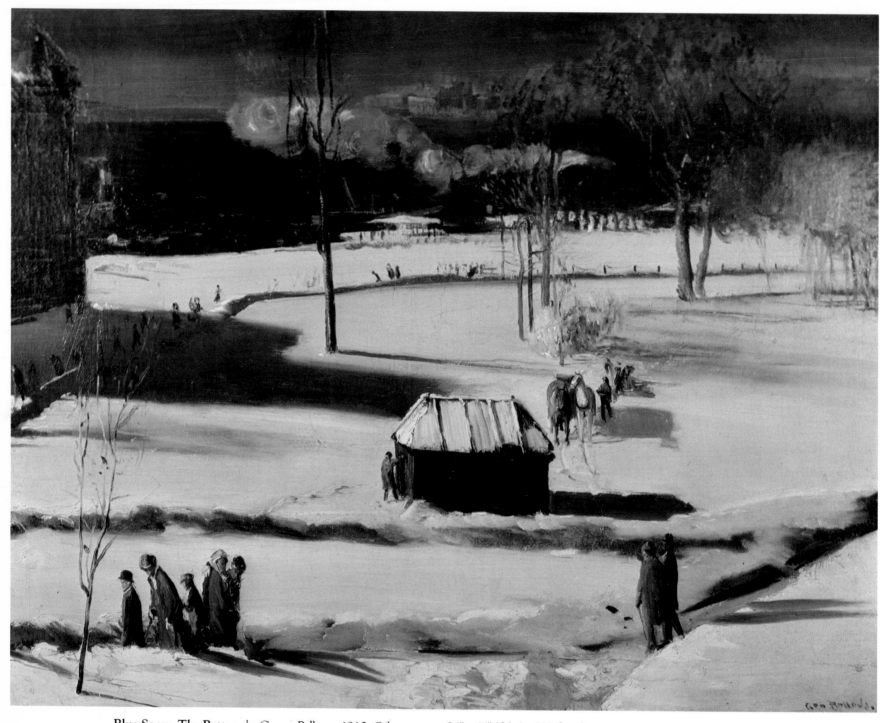

Blue Snow, The Battery *by George Bellows, 1910. Oil on canvas, 34″ x 44″ (86.4 x 111.8 cm).*
The Columbus Gallery of Fine Arts, Columbus, Ohio. Howald Fund Purchase.

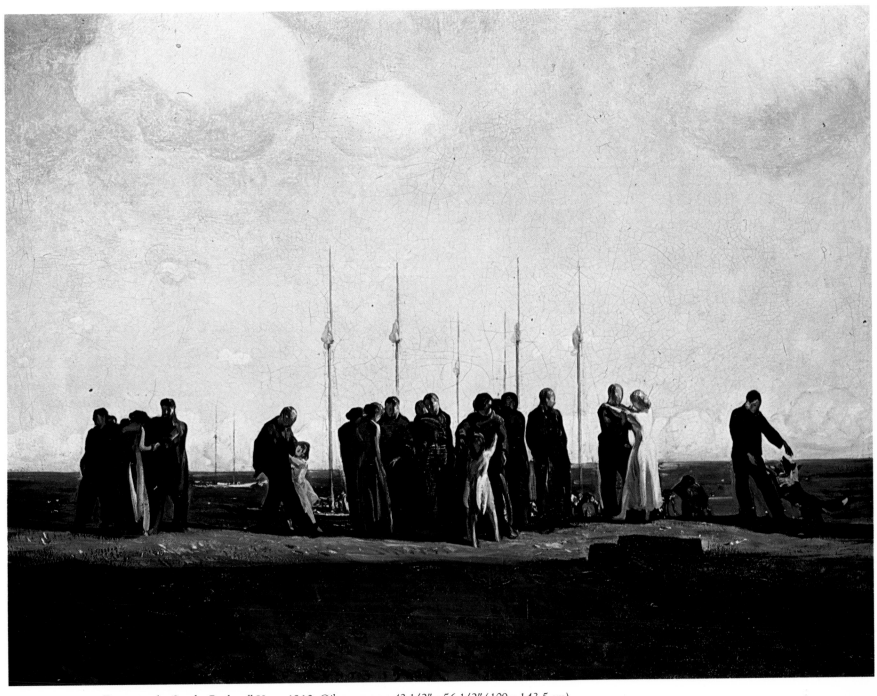

Down to the Sea by Rockwell Kent, 1910. Oil on canvas, 42 1/2" x 56 1/2" (109 x 143.5 cm).
The Brooklyn Museum, Brooklyn, New York. Gift of Frank L. Babbott.

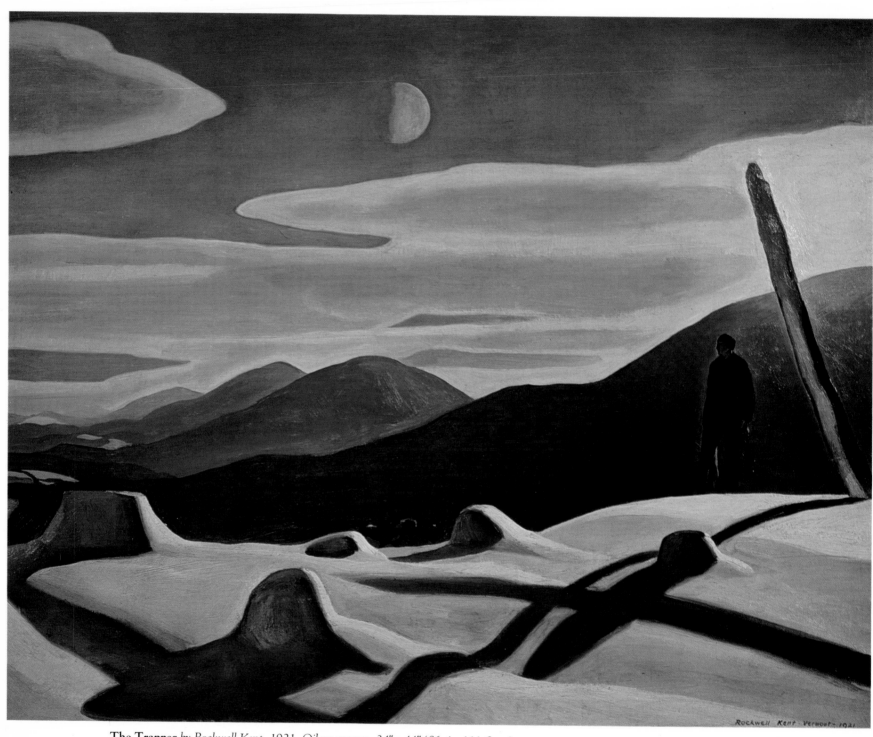

The Trapper *by Rockwell Kent, 1921. Oil on canvas, 34″ x 44″ (86.4 x 111.8 cm).*
Whitney Museum of American Art, New York, New York.

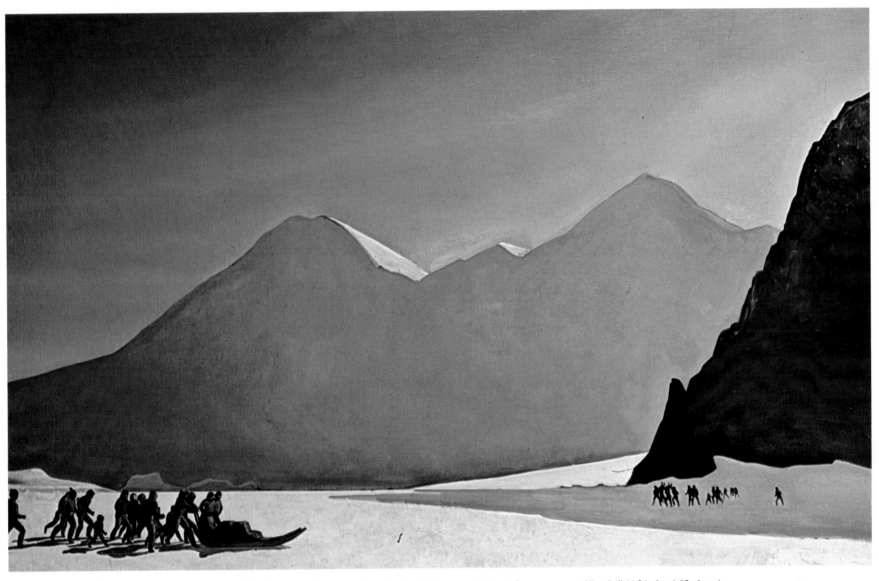

Neither Snow, Nor Rain, Nor Ice . . . Greenland *by Rockwell Kent, c. 1932. Oil on canvas, 40" x 64" (101.6 x 162.6 cm).*
Courtesy Hammer Galleries, New York, New York.

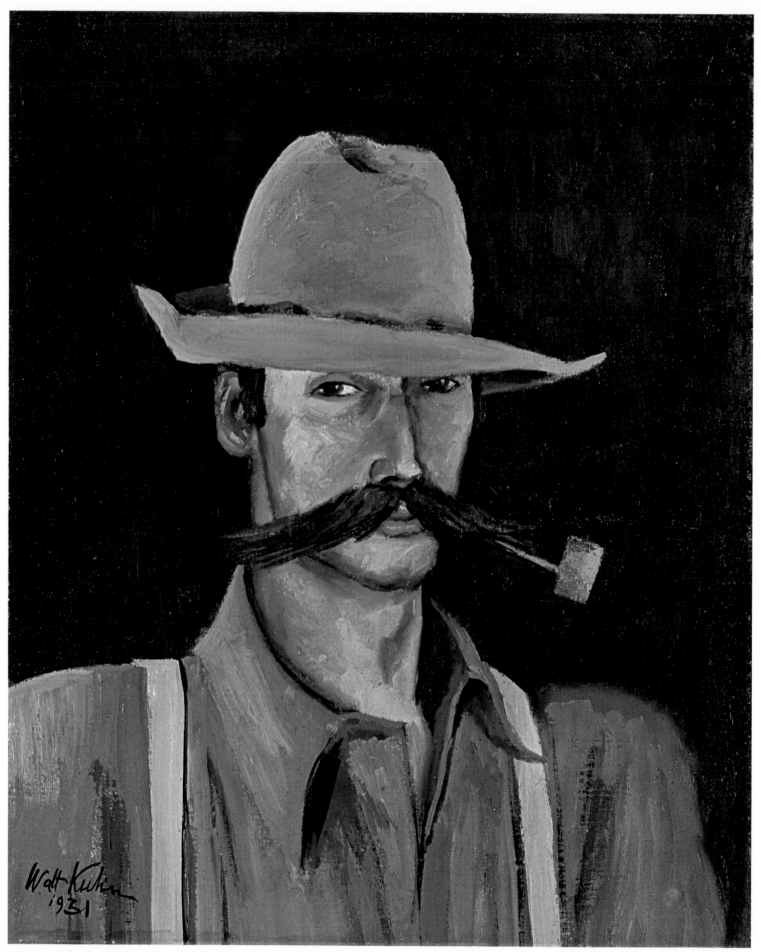

The Guide by Walt Kuhn, 1931. Oil on canvas, 24 1/8″ x 20 1/8″ (61.3 x 51.1 cm). University Collection, University of Nebraska — Lincoln Art Galleries, Lincoln, Nebraska. Gift of Mrs. Olga N. Sheldon.

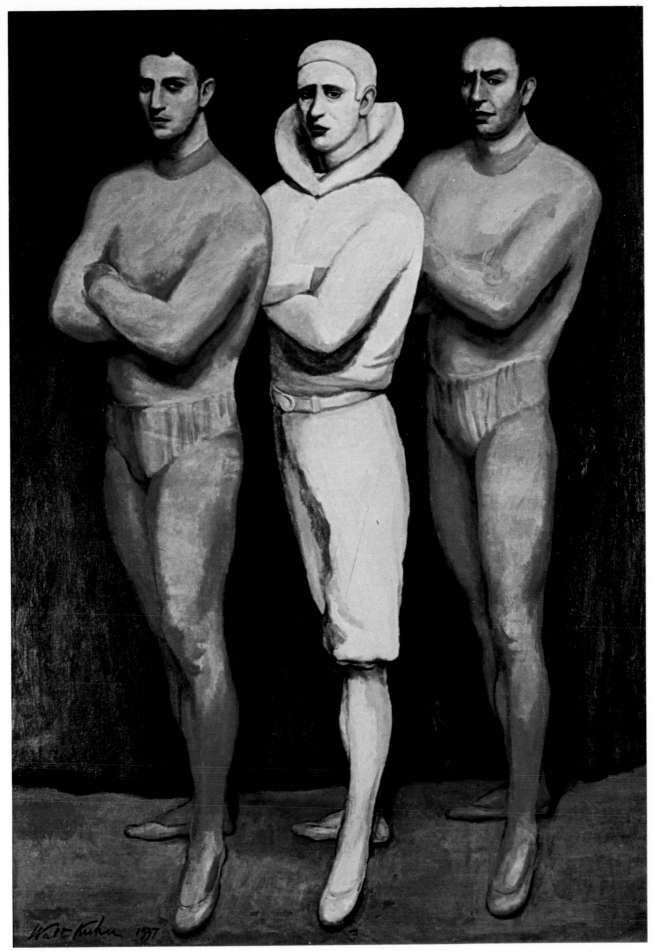

Trio by Walt Kuhn, 1937. Oil on canvas, 20″ x 30″ (50.8 x 76.2 cm). Colorado Springs Fine Arts Center, Colorado Springs, Colorado. Gift of the El Pomar Foundation.

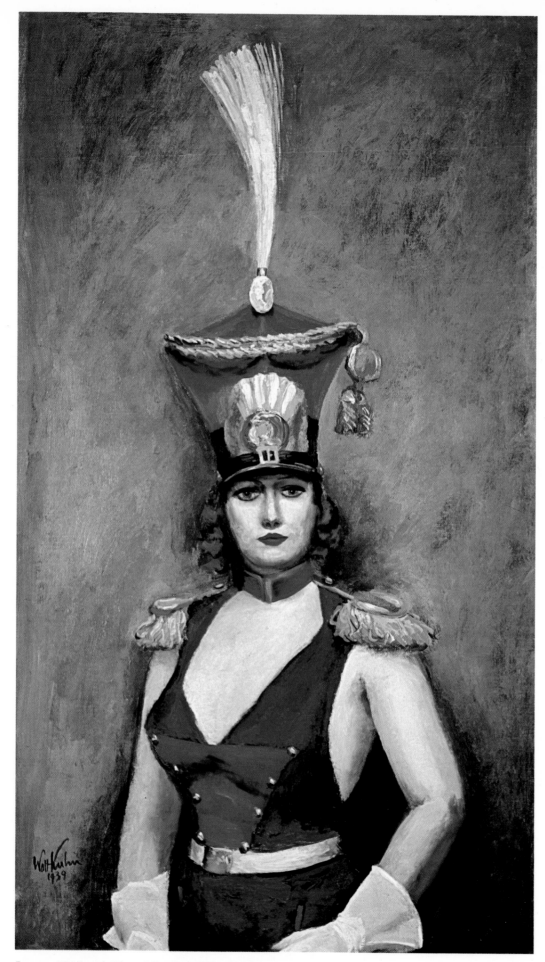

Lancer (Girl with Plume) by Walt Kuhn, 1939. Oil on canvas, 45 1/2" x 26 1/2" (115.6 x 67.3 cm). *The Currier Gallery of Art, Manchester, New Hampshire.*

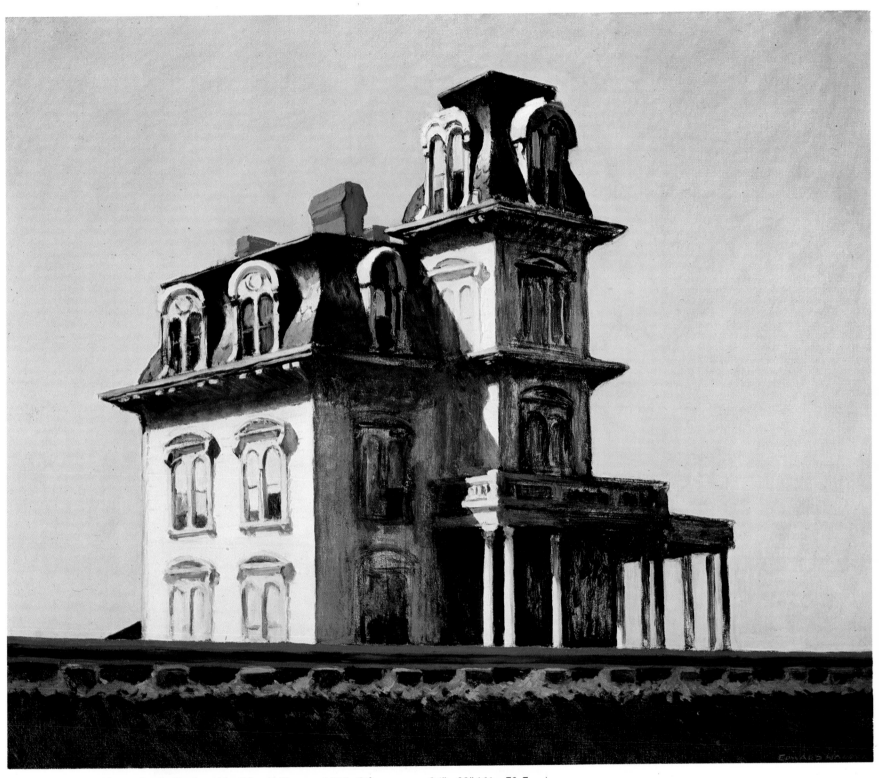

House by the Railroad *by Edward Hopper, 1925. Oil on canvas, 24" x 29" (61 x 73.7 cm).*
The Museum of Modern Art, New York, New York. Given anonymously.

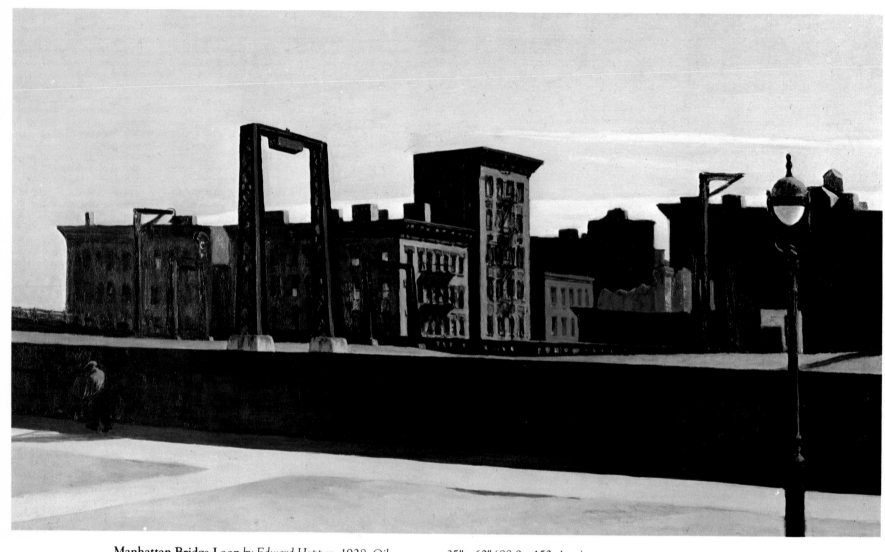

Manhattan Bridge Loop *by Edward Hopper, 1928. Oil on canvas, 35" x 60" (88.9 x 152.4 cm).*
Addison Gallery of American Art, Phillips Academy, Andover, Massachusetts. Gift of Stephen C. Clark.

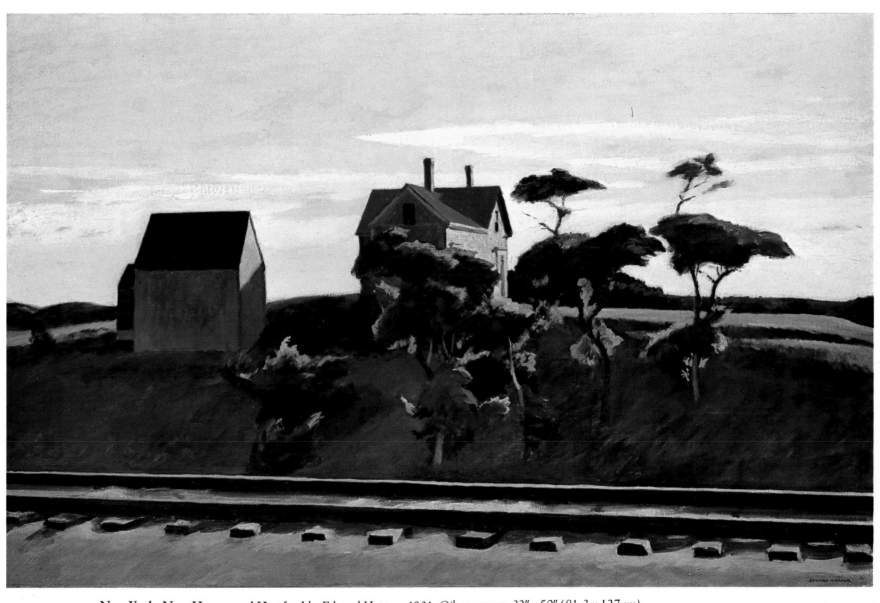

New York, New Haven, and Hartford *by Edward Hopper, 1931. Oil on canvas, 32" x 50" (81.3 x 127 cm).*
Indianapolis Museum of Art, Indianapolis, Indiana. Emma Harter Sweetser Fund.

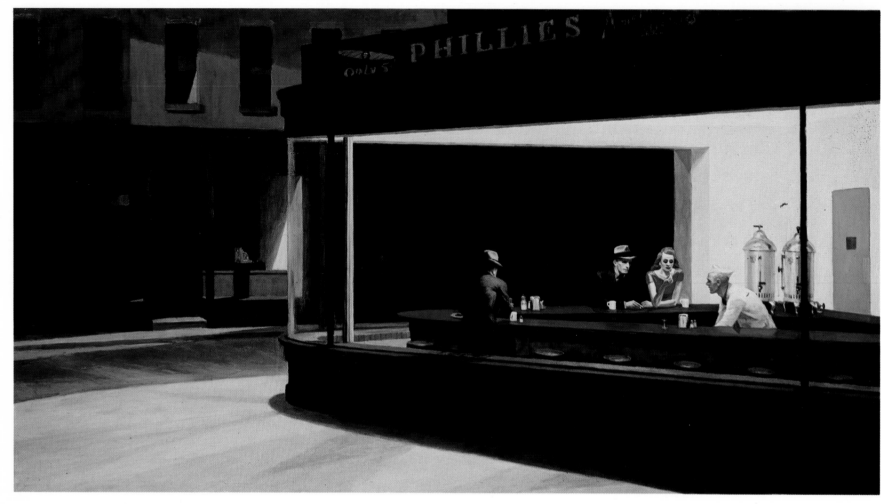

Nighthawks *by Edward Hopper, 1942. Oil on canvas, 33 3/16" x 60 1/8" (84 x 152.8 cm).*
The Art Institute of Chicago, Chicago, Illinois.

John Sloan

1871-1951

Sloan was the closest of all to Henri. A hard-bitten, unbending man, Sloan envied Henri's good looks and his grand manner, just as he envied Glackens his beautiful home and his wife. Dolly Sloan was a drunk whom he had to take care of, while nobody took care of him.

Like Luks, Sloan was born in the boondocks of Pennsylvania. When his father lost his job, Sloan had to give up his dream of dentistry. He had drawn all his life, and he was a staff man on the *Philadelphia Press*, like the rest of them. He could not draw as fast as Luks or Glackens, so he worked for the Sunday edition, which gave him more time.

He learned all he knew about art from Henri. He saw with Henri's eyes, and when he used his own, he failed. His late paintings, where he struck out for himself, are a disaster; they wouldn't have made him even a local reputation. The vision of life he painted came from Henri. This vision of New York is what was best about Sloan, who was a limited man and artist. (This may not be a disadvantage. Henri understood more than was good for him.) With his narrow focus, Sloan painted things Henri could not handle, for he had the intensity that Henri lacked. Sloan painted better than he could talk; Henri, worse. He took up the city scene where Henri left off; it didn't mean much to Henri, but it was everything to Sloan (pages 165 and 169).

The last of the gang to go to New York, every week Sloan sent back to Philadelphia a picture puzzle in willowy Art Nouveau style that had nothing to do with his realistic paintings of New York — paintings in which he liked to catch unguarded moments, when the lights went out. Sloan was a great one for looking out the window; that's where life is. This self-centered little man entered easily into other people's lives. He had amazing sympathy and insight: the family sleeping on the roof on hot summer nights (page 147); men flying pigeons (page 167); women getting their wash done (page 168); dust blowing in the streets; office girls in the park (page 145). When Sloan took the busy ferries on his way to Philadelphia, the air was full of gulls and smoke (page 164).

Sloan didn't sell a picture until he was forty, but he had his share of praise. It's grand to be called the American Hogarth, though Sloan's prints have far more feeling than Hogarth's. John Rothenstein, an English critic not given to praise, called him the painter of the low life of Victorian downtown New York, a fuller-blooded, less capricious, less sardonic Sickert; for the English painter Sickert also specialized in the drab dramas of poor little city shrimps in desperate furnished rooms, who had no money for the rent.

Sloan celebrated Irish Chelsea (page 146), from the cast-iron warehouses of Sixth Avenue to the appalling rooming houses of Suicide Row, with the liners at the end of the street and the sailors off the Fleet. Baudelaire talked about looking over the roofs at a poor old woman with wrinkles, who was always bending over something; and he made up her story. That's the way Sloan worked.

John Quinn, the great collector, bought Sloan's etchings and drove him to Coney Island for his first automobile ride, but he didn't buy his paintings, probably because he didn't think they were good enough.

Those New York years, when Sloan did all his best work, were filled with friends and incredibly cheap French restaurants. Resentful and put upon, he had the time of his life. When his wife Dolly (page 163) was not on a drunk, she was an imp and a charmer, the girl of his dreams. And since Sloan liked to drink himself, they never lacked for friends. Dolly was such a good cook when she was sober, that Henri practically moved in when his first wife died, as did old man Yeats (page 166), the Irish painter and father of the poet; he'd left Dublin because his sons were

putting him in the shade. (Quinn paid Yeats a little something a month to work on his self-portrait, which of course was unfinished when he died.) The Sloans had wonderful evenings with Henri and Glackens and Luks, for it was always a party when Luks was around.

Sloan loved to walk the streets in a fine Whitman mood, and he was a great admirer of Balzac. They worshipped Balzac in those days; they believed that life is infinitely interesting and that other people are endlessly fascinating. Degas once said that we're put here on earth to ride in buses and look at other people.

Through his wife's influence, Sloan even became interested in politics. Dolly Sloan tried to make Socialists out of the cops who were patrolling her picket lines, and they loved her for it. With his cardboard eyeshade, Sloan became Art Editor of *The Masses*, a radical magazine which was the grand-daddy of the liberal weeklies. There he gave his artist friends full-page spreads for their cartoons until Max Eastman, the editor who ended up on the far right, became delighted with his absence — Sloan could be pretty hard to take. His friends said that socialism cost him his sense of humor, but the reason that Sloan was interested in politics was because of his interest in people; he knew that poor people had one hell of a time.

Because of his wife's drinking, Sloan spent a lot of time in Santa Fe, which was not good for his painting. When he began to sell, buyers wanted his early pictures, so he painted new versions in his old style. The harsh red nudes to which he devoted so many years were far from pleasing. He wanted to make paintings as hard as sculpture, and he succeeded. But he wanted to paint like Michelangelo, and that was not exactly his bent. In the winter, he taught at the Art Students League, where he gave the students hell, partly because he had doubts about the way he was painting. He lived at the Chelsea Hotel, on 23rd Street, near his early studio, where he turned out new versions of McSorley's wonderful saloon or of the Sixth Avenue "El" roaring around the bend. They reminded him of the good old days when he had friends like Henri and possessed the near certainty that his work was great.

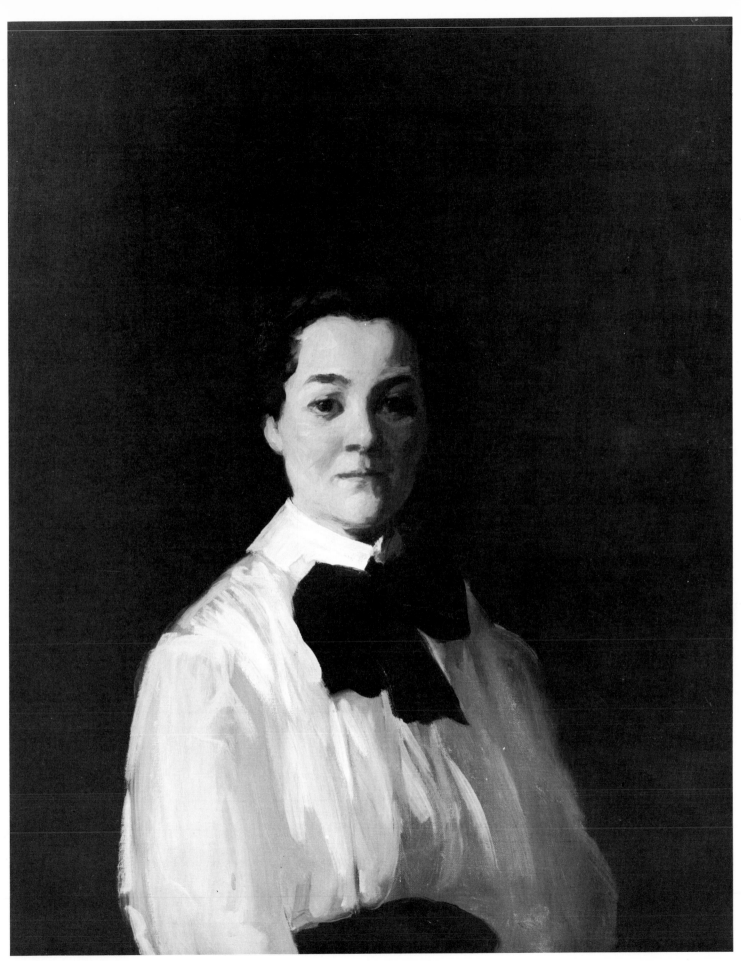

Dolly with a Black Bow *by John Sloan, 1907. Oil on canvas, 32" x 26" (81.3 x 66 cm).*
Whitney Museum of American Art, New York, New York. Gift of Miss Amelia Elizabeth White.

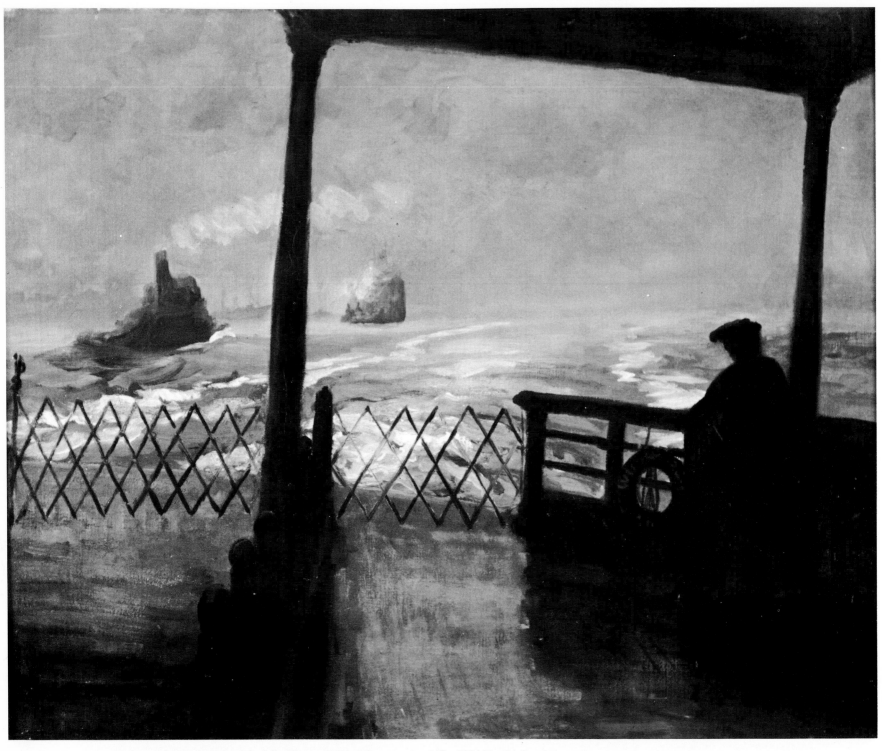

Wake of the Ferry, No. 2 *by John Sloan, 1907. Oil on canvas, 26" x 32" (66 x 81.3 cm).*
The Phillips Collection, Washington, D.C.

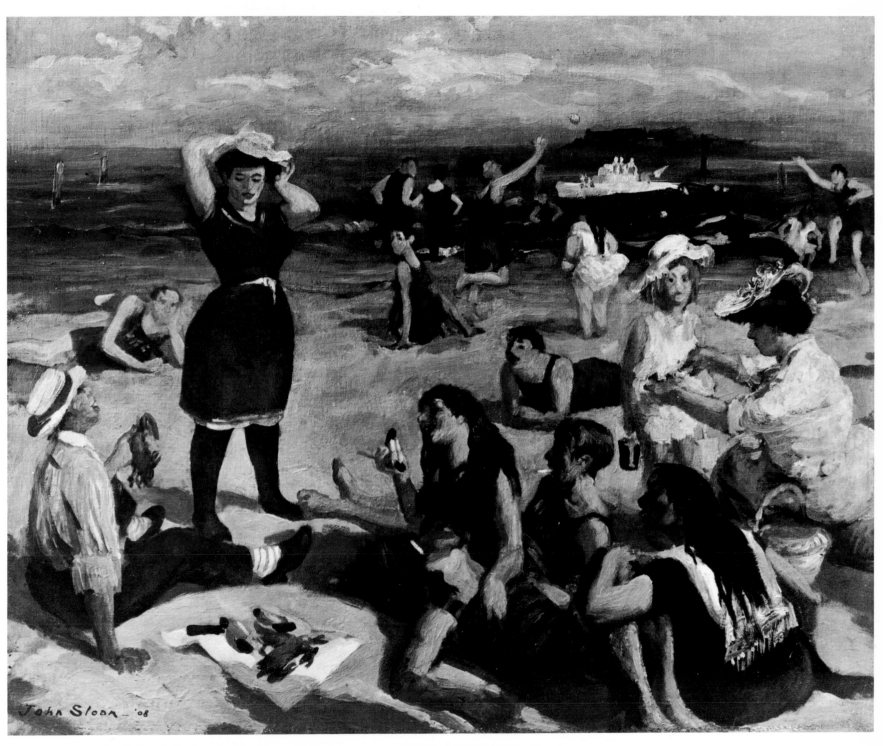

South Beach Bathers *by John Sloan, 1908. Oil on canvas, 25 7/8" x 31 7/8" (65.7 x 81 cm).*
Walker Art Center, Minneapolis, Minnesota.

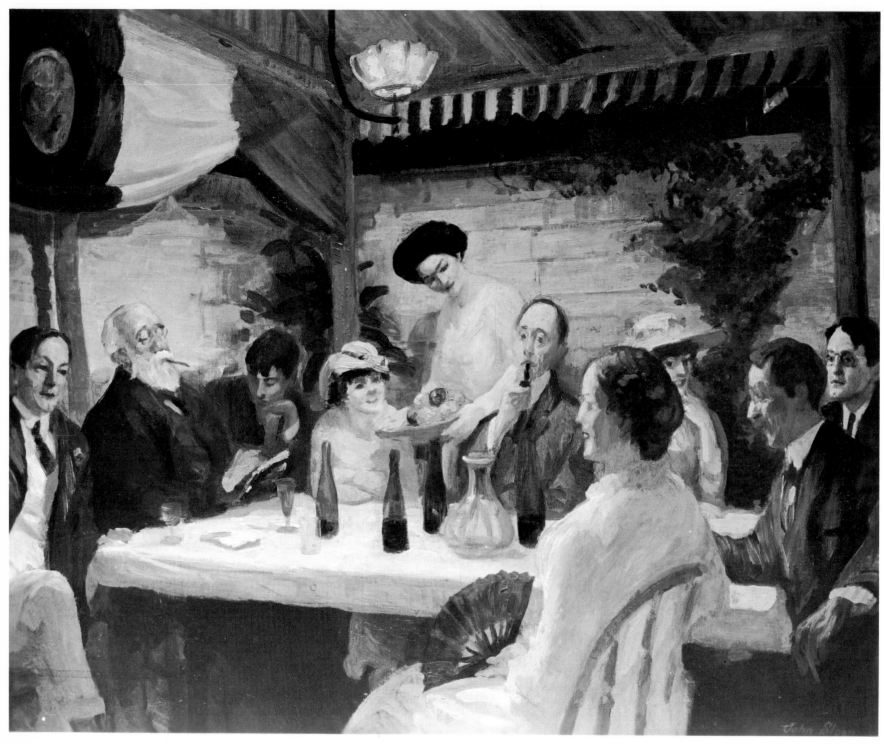

Yeats at Petitpas *by John Sloan, 1910. Oil on canvas, 26 3/8″ x 32 1/4″ (67 x 81.9 cm).*
The Corcoran Gallery of Art, Washington, D.C.

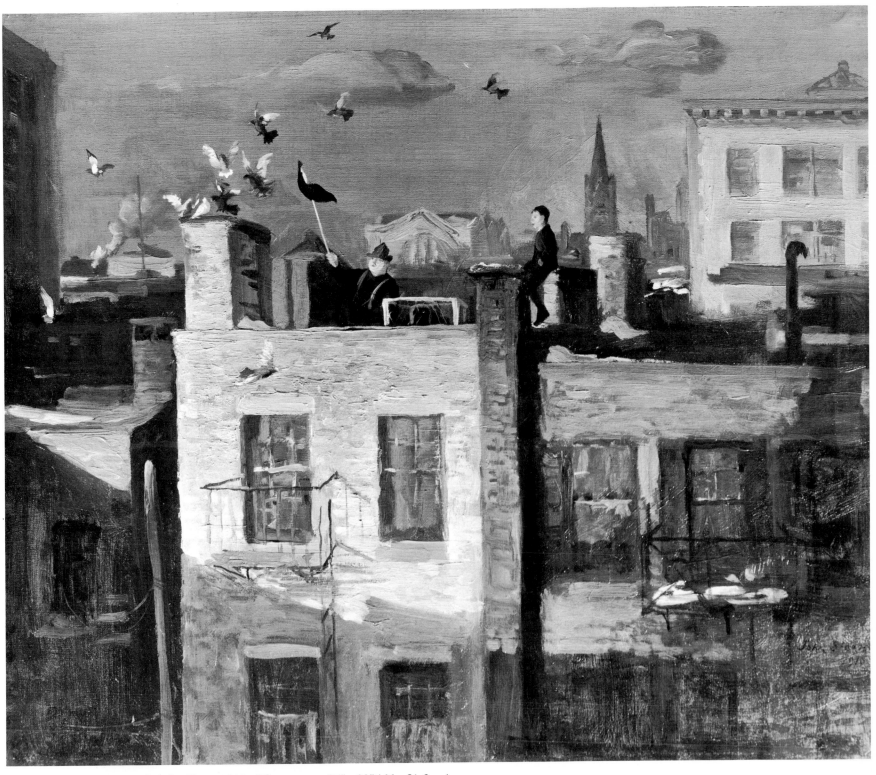

Pigeons *by John Sloan, 1910. Oil on canvas, 26" x 32" (66 x 81.3 cm).*
Museum of Fine Arts, Boston, Massachusetts. Charles Henry Hayden Fund.

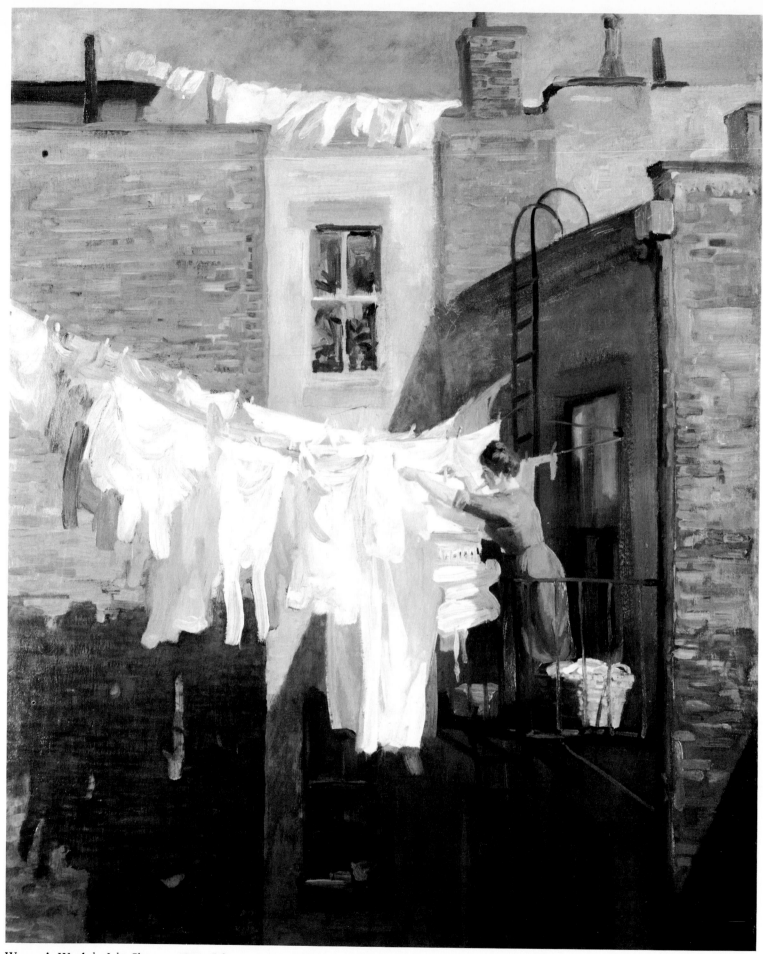

Woman's Work *by John Sloan, c. 1911. Oil on canvas, 31 5/8″ x 25 3/4″ (80.3 x 65.4 cm).*
The Cleveland Museum of Art, Cleveland, Ohio. Gift of Amelia Elizabeth White.

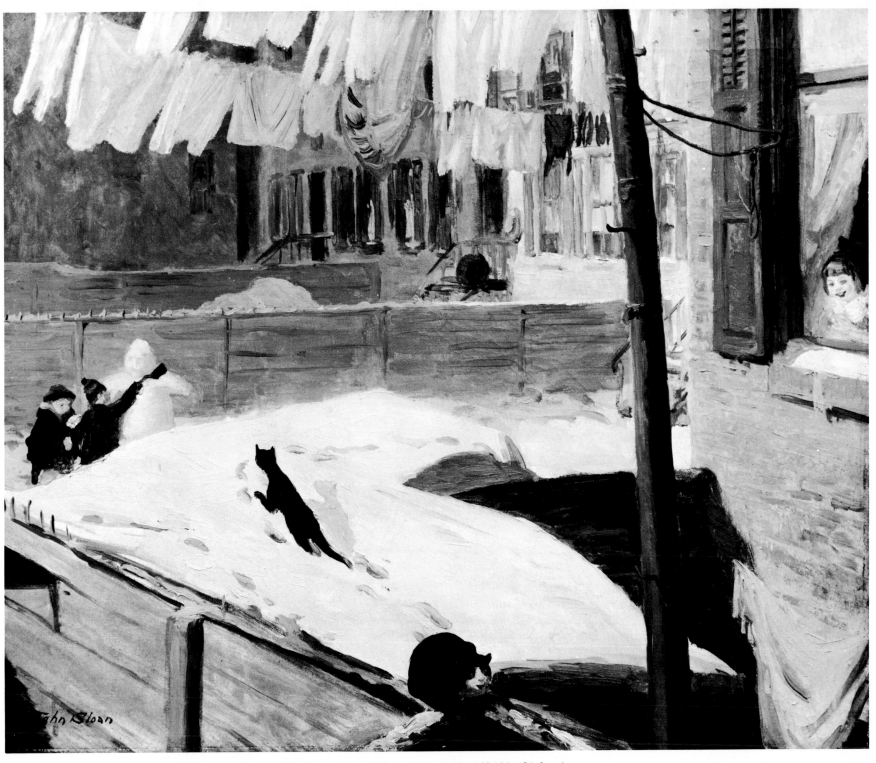

Backyards, Greenwich Village *by John Sloan, 1914. Oil on canvas, 26" x 32" (66 x 81.3 cm).*
Whitney Museum of American Art, New York, New York.

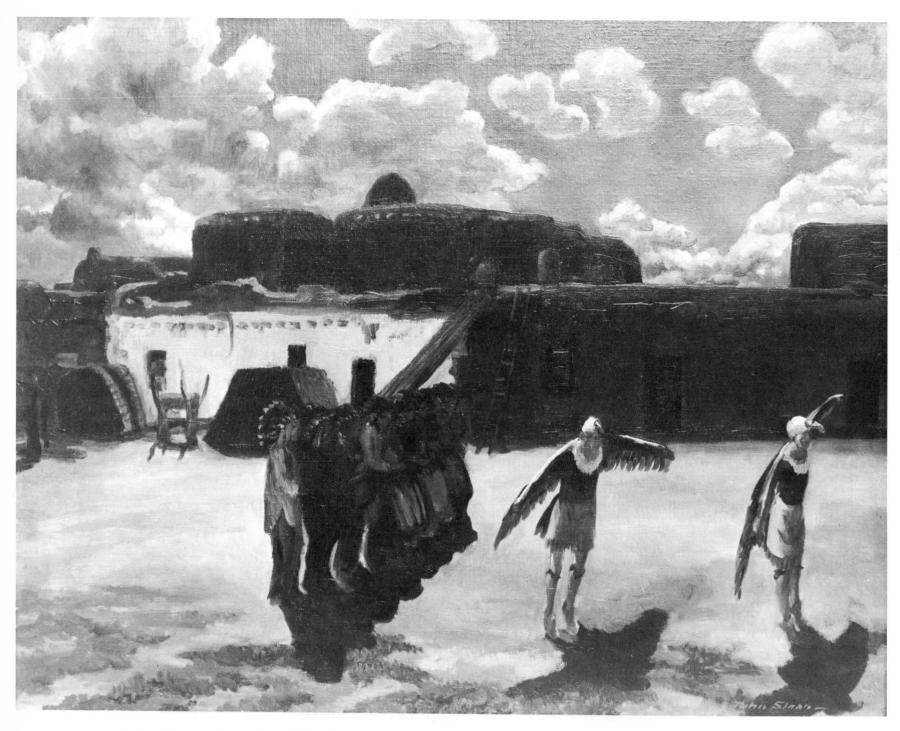

Eagles of Tesuque *by John Sloan, 1921. Oil on canvas, 26" x 34" (66 x 86.4 cm). Colorado Springs Fine Arts Center, Colorado Springs, Colorado. Mrs. A. E. Carlton and Debutante Ball Purchase Funds.*

Eve of St. Francis, Santa Fe *by John Sloan, 1925. Oil on canvas, 30" x 40" (76.2 x 101.6 cm).*
Wichita Art Museum, Wichita, Kansas.

George Bellows
1882 - 1925

People look at Bellows with nostalgia now, but it was a nostalgia he didn't share. Bellows didn't give a damn about the past, his own or anybody else's. The only thing he was interested in was now. Although he grew up in small-town America, he left it as soon as he could. New York was his Paris (page 149); that's all he needed. The only thing he was interested in was painting — that and his family.

When Henri's pupils drifted away or set up as great men on their own account, he acquired new disciples. Not long after Sloan came to New York, he had an argument with Glackens over whether Henri's teaching was hurting Henri's painting. A proud man, Henri was disappointed in his work and in its reception, but it was a great satisfaction to him when wonderful pupils like Bellows, Rockwell Kent, Walt Kuhn, and Edward Hopper came along. If Henri had not happened along, Impressionism and the National Academy would have flourished unchallenged. It was Henri who gave strength and cohesion to the whole realist movement and kept it going far longer in this country than in France. He did not hold back abstract art, which did not yet have a big enough head of steam. For these realists, abstract art was not the enemy; the enemy was the crew who were not their friends in the National Academy.

Bellows called Henri his father in art. It never occurred to Bellows to doubt Henri, for the younger artist died before doubt could set in. Bellows was sure of himself all his life. Plenty of his fellow students, like Eugene Speicher, ended up feeling that the world had played a dirty trick on them. There are men alive today who once had every reason to think they'd be the great painters of the future. They never knew what hit them when realist painting went out.

George Bellows was an all-American boy from Columbus, Ohio, who cranked the ice cream freezer on the back porch and chased the watermelon wagon. There was a handsome double row of trees down the middle of Broad Street in those days, but Bellows only came back from New York to paint portraits of the local gentry. He never painted Columbus, though he made some lithographs of Columbus that are satire and farce.

Bellows loved New York. The Scioto and the Olentangy rivers, which meet in Columbus on their way to the Ohio, were nothing like the North and East River. He roomed with Columbus friends — for the big city is made up of little cells of people who came from Salt Lake City or the same part of Sicily — and went to the Art Students League. He soon became Henri's star pupil and his best friend. Bellows was a natural-born painter who hit his stride early. He was soon painting better than Henri. To Henri's credit, he never seemed to mind; he was proud of his pupil's success. When Bellows got married to a formidable young lady from Montclair who looked down on Columbus, Ohio, he bought a house on Nineteenth Street, close to Henri's studio in Gramercy Park, and the two men saw a lot of each other, walking the streets at night and shooting pool at the Players Club.

Nobody would deny that Bellows was a realist. He painted what was in front of his nose; besides, Bellows didn't have much imagination, and his excursions into mystery were disastrous. Clouds in the summer sky were wonder enough. His wife and daughters were his favorite models, for this most masculine of men was bossed by women all his life. A great ballplayer, he kept up his interest in sports (pages 176 and 178), though he never painted a baseball picture. His portraits of his father, mother, wife, and daughters (pages 174, and 179 to 181) are far more profound and more moving than any figures Henri ever painted. His great New York scenes (pages 150 and 177) and his fight pictures (page 148) are far beyond Henri's limit, yet they owe everything to Henri.

Bellows didn't waste much time thinking; he thought best with brush in hand. He would tell you that he was just putting down what everybody saw, but the miracle was that he could get it down so you could feel it. A little of Eakins' careful training might have helped his drawing (compare, for example, *Stag at Sharkey's,* page 148, to *Taking the Count,* page 69), but Bellows was the prize example of the Henri method: how do you know you can't do it if you don't try?

Sometimes, in the summer, Bellows would knock out two or three pictures a day; he was always trying to catch that first vivid moment. For him, the most natural thing in the world was that he should be the wonder kid of American painting. He hit his stride early and he never stopped — nothing bad happened to Bellows except his early death. He won all the prizes, while a man like Sloan couldn't give his pictures away. It took Sloan forty years to get started,

while Bellows hit a home run first time at bat.

Bellows had a remarkably wide range: he could paint anything, but it's amazing how much he got out of just painting his daughters. He never ran out of material; he *enjoyed* painting. But the harder he tried, the worse he got. Because of Henri, he was strongly affected by the color theories of his day, which certainly didn't help his painting. Bellows had a natural talent for placing forms and colors in pleasing patterns, but the compositional theories he picked up from Henri tripped him up pretty badly. Very often, his drawing is cockeyed, his composition hopeless, his color corny. And he had no imagination at all. But his pictures are wonderful anyhow. It's the sheer vitality of the man, his unembarrassed love of the obvious that makes his paintings so unforgettable. As Henry Miller said about Van Gogh, it's a victory of the man over art.

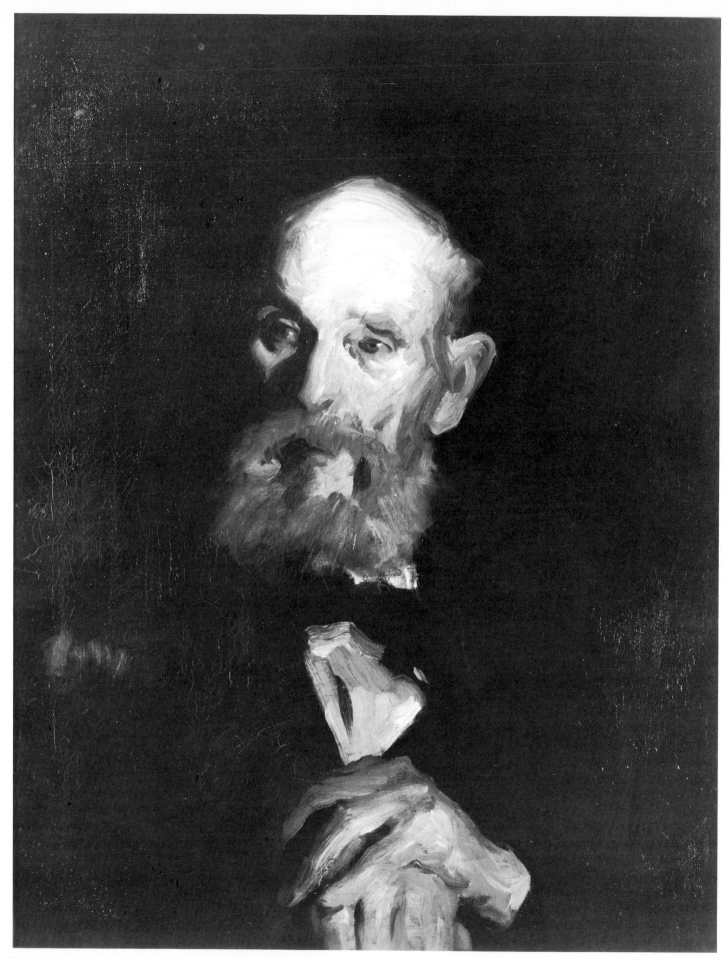

Portrait of My Father *by George Bellows, 1906. Oil on canvas, 28 3/8" x 22" (72 x 55.9 cm).*
The Columbus Gallery of Fine Arts, Columbus, Ohio. Gift of Howard B. Monett.

Forty-Two Kids *by George Bellows, 1907. Oil on canvas, 42 3/8″ x 60 1/4″ (107.6 x 153 cm).*
The Corcoran Gallery of Art, Washington, D.C.

Polo at Lakewood *by George Bellows, 1910. Oil on canvas, 45" x 63" (114.3 x 160 cm).*
The Columbus Gallery of Fine Arts, Columbus, Ohio.

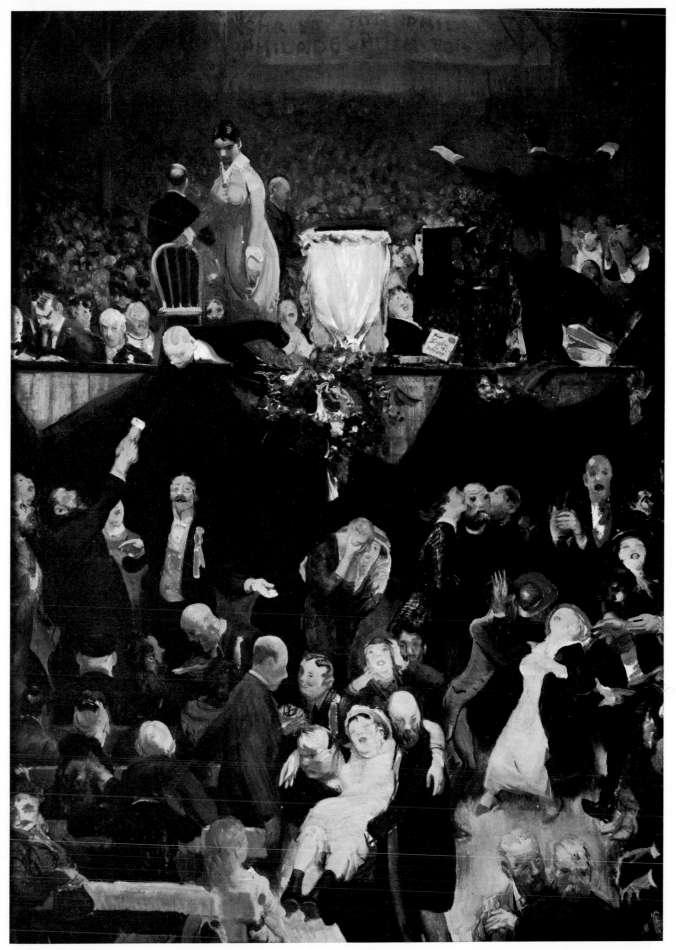

The Sawdust Trail by George Bellows, 1916. Oil on canvas, 63" x 45 1/8" (160 x 114.6 cm).
Layton Art Gallery Collection, Milwaukee Art Center, Milwaukee, Wisconsin.

Golf Course, California *by George Bellows, 1917. Oil on canvas, 30" x 38" (76.2 x 96.5 cm).*
Cincinnati Art Museum, Cincinnati, Ohio. The Edwin and Virginia Irwin Memorial.

Children on the Porch *by George Bellows, 1919. Oil on canvas, 30 1/4″ x 44″ (76.8 x 111.8 cm).*
The Columbus Gallery of Fine Arts, Columbus, Ohio. Howald Fund Purchase.

Anne in White by George Bellows, c. 1920. Oil on canvas, 52 7/8″ x 42 7/8″ (134.3 x 108.9 cm).
Museum of Art, Carnegie Institute, Pittsburgh, Pennsylvania. Patrons Art Fund.

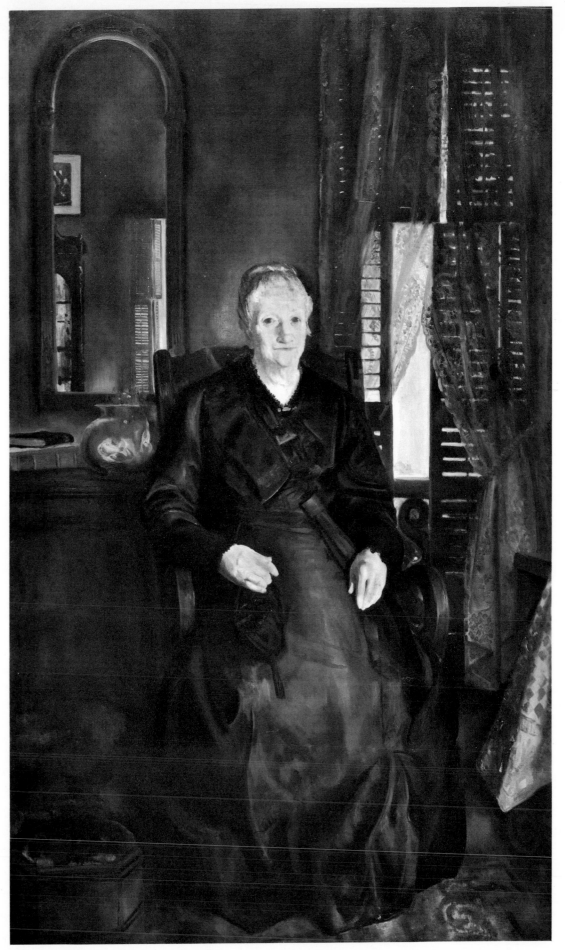

My Mother by George Bellows, 1921. Oil on canvas, 83" x 49" (210.8 x 124.5 cm).
The Art Institute of Chicago, Chicago, Illinois. Wadsworth Memorial Collection.

Rockwell Kent

1882 - 1971

John Sloan thought that Rockwell Kent was a big man who painted big pictures, both in size and spirit. In the early days, Kent used to go to Canada or Alaska for the winter, leaving his silent wife alone in the city, where she pretty much moved in with the Sloans. In later life, Kent wrote very freely about himself in his books, but you don't get to know him very well. He became a kind of public man, like a politician. He made much of the frozen North, but he lived in upstate New York, which is not exactly the Arctic. For this backwoodsman was born in Tarrytown Heights and educated at Horace Mann High School and Columbia University. He studied with several teachers, including Kenneth Hayes Miller, who formed the last generation of realists into the Fourteenth Street School of urban "regionalists."

Ferdinand Howald, the collector from Columbus, who never bought a Bellows, backed Rockwell Kent on his first trip to Alaska, where the artist lived on little Bear Island with his young son. That was his idea of the life, all alone at thirty below (pages 151 to 153). The letters Kent wrote back to Howald were worth the price of the trip. There they were, he and Rockwell, Jr., in the wilderness sure enough, but so cozily housed, so well supplied with almost everything the heart could desire and the body could need, that it seemed they were almost cheating themselves of the experience they went there for. It was wonderfully still and so remote from the world; Kent was enchanted that no one could visit them from the beginning to the end of their stay. Cutting trees,

then sawing them into stove-lengths, alone took hours a day. There was endless work to such an existence, but that was the glory of it. The wind was beyond belief, but Kent loved the life and thrived on it. Then and later, he spent as much time in the Far North as he could, making a career out of getting away from it all. When Kent wrote Sloan that he was planting discontent among the miners of Newfoundland, he wasn't entirely kidding, for his socialism lasted all his life.

Kent's early realistic paintings, which are his best, show a great feeling for bare mountains (pages 186 and 187), icebergs (page 153), and snow-covered trees (page 183), though his fame rests on the tremendously popular illustrations he turned out during the Depression. In those ink drawings for *Moby Dick*, the big, flat, plain compositions became mannered and two-dimensional; he gave up his personal conception of nature and turned to stereotyped and stiff decoration. However, these illustrations made him a great man, and he expected you to know who he was.

But Kent was painting fine pictures, fascinated with nature and with himself, up to the end. The Russians, who have plenty of icebergs of their own, admired Kent's special brand of outdoor realism. He is the only prominent artist who has ever known the Far North from Alaska to Greenland, which is a lot of territory. Kent became isolated from the other artists, but he didn't care. Many a man, and certainly many a boy, discovered the sea and the outdoors through Rockwell Kent.

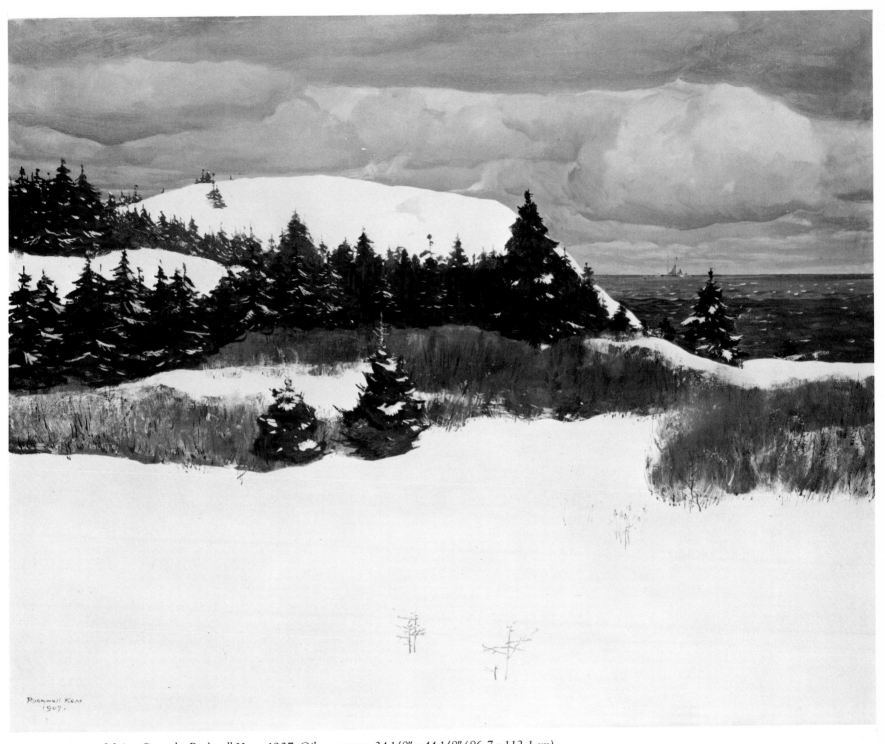

Maine Coast *by Rockwell Kent, 1907. Oil on canvas, 34 1/8" x 44 1/8" (86.7 x 112.1 cm).*
The Cleveland Museum of Art, Cleveland, Ohio. Hinman B. Hurlbut Collection.

Road Roller *by Rockwell Kent, 1909. Oil on canvas, 34" x 44 1/2" (86.4 x 113 cm).*
The Phillips Collection, Washington, D.C.

Shadows of Evening by Rockwell Kent, 1921–23. Oil on canvas, 38" x 44" (96.5 x 111.8 cm).
Whitney Museum of American Art, New York, New York.

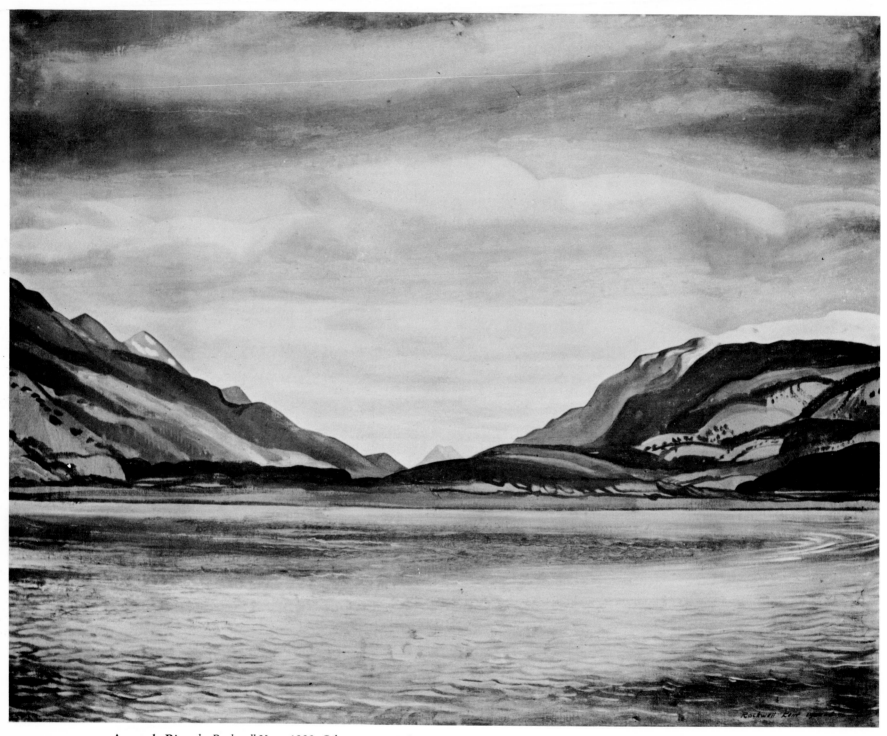

Azapardo River *by Rockwell Kent, 1922. Oil on canvas, 34" x 44" (86.3 x 111.8 cm).*
The Phillips Collection, Washington, D.C.

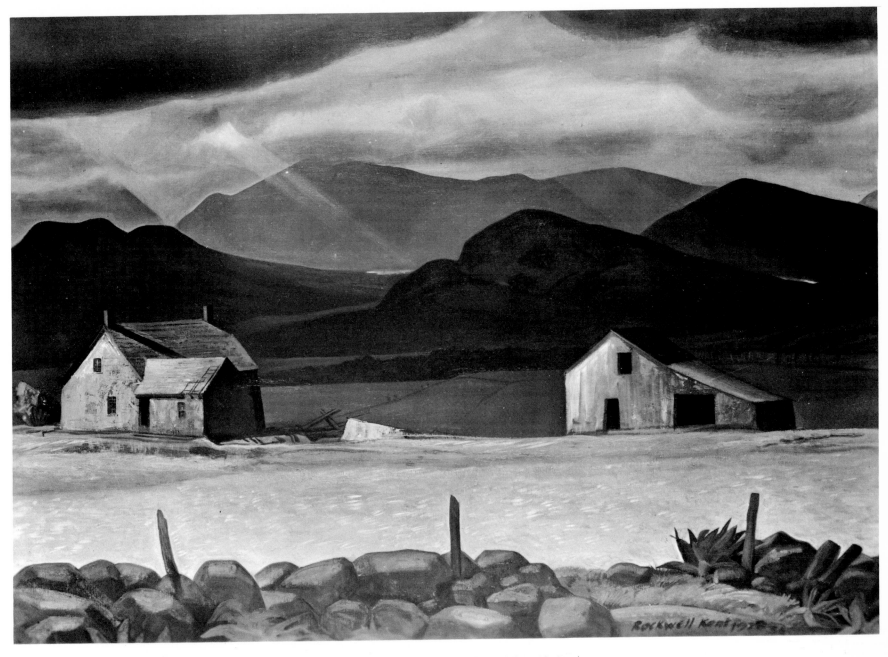

Adirondacks by Rockwell Kent, 1928–30. Oil on canvas, 38 1/2″ x 54 7/8″ (97.8 x 139.4 cm).
The Corcoran Gallery of Art, Washington, D.C.

Walt Kuhn

1880 - 1944

Walt Kuhn didn't give a damn about abstraction, but he was proud of his part in organizing the Armory Show in 1913, which brought modern art to New York. Born in Brooklyn, he shared with Duveneck a German Catholic background. His parents, who kept a sailor's boarding house, backed him and left him some money. Kuhn studied art at night school, but mostly he made his own way. He certainly didn't give anybody credit for teaching him, not even Henri.

As a boy, he was a professional bike rider, and he had his own bicycle shop when he was twenty. On weekends, he worked the county fairs. A couple of years later, he turned up in San Francisco, where he drew cartoons for a local publication called *Wasp*. Despite the time he spent in the West, his work has little Western flavor, except for the burlesque series called "The Pictorial History of the West." In San Francisco, he started signing himself "Walt," perhaps for Walt Whitman, who was a great name in those days. When he went to art school in Paris in the early 1900s he knew all about the circus paintings of Degas and Toulouse-Lautrec, but Cézanne's harsh black outline was the real influence. Never one of the boys, he isn't mentioned much in reminiscences about Paris and Greenwich Village.

In New York, he made his living as a cartoonist for *Life* and *Judge*. In 1913, as secretary of the Armory Show, he selected the work in the European section, along with Arthur B. Davies and Walter Pach, who was also an old pupil of Henri's. With his talent for getting along with important people, Kuhn was adviser to John Quinn from 1912 to 1920. Quinn patronized American realists and Irish romantics until he discovered French painting. From 1930 on, Kuhn was adviser to the dealer Marie Harriman, wife of Averell Harriman. On the side, Kuhn was a professional theater man, directing musical comedy acts for Broadway shows. During the Depression, he decorated three railroad club cars for the Union Pacific.

Kuhn had a booming voice and a loud laugh and he liked to send rich friends little drawings for Christmas. He taught quite a lot and his pupils were devoted to him, for he heightened their sense of reality. With his tremendous presence, he liked to say there was only one champion, and it was clear that he was it.

The circus haunted him all his life, and his paintings catch some of its glare and intensity. His clowns aren't sentimental or pathetic (page 191) — the real clowns are in the audience — and his staring figures don't depend on trick lighting; they depend upon themselves (pages 155 and 156).

Walt Kuhn kept his private life very much to himself. He didn't invite intimacy: if people confided in him, that was their affair. Not much is known about Kuhn; he liked that, and he liked living in separate worlds. He spent half his time doing things that had nothing to do with art. Proud of his ability to get along in the real world, he liked show business as much as painting. His pictures didn't sell well, for the twenties didn't give a damn about painting, and in the thirties, everybody was broke.

Kuhn liked to talk about the Armory Show, where he was mixed up in big events. He did a fine job there, but he never admitted he was digging realism's grave. He didn't have much sympathy with bellyachers; nobody asked you to be an artist. Kuhn didn't court obscurity; he had more of it than he knew what to do with. He always thought he was the best of the bunch, and he was surprised that not everybody agreed with him. He didn't get any less idiosyncratic as he got older. The success of his 1948 show at Durand-Ruel was too much for him: with his paintings selling for record prices, his mind broke and they carried him off to a mental hospital.

Dressing Room *by Walt Kuhn, 1926. Oil on canvas, 44 15/16" x 33 1/16" (114.1 x 84 cm).*
The Brooklyn Museum, Brooklyn, New York. Gift of Friends of the Museum.

Trude *by Walt Kuhn, 1931. Oil on canvas, 68" x 33" (172.7 x 83.8 cm).*
The Santa Barbara Museum of Art, Santa Barbara, California. Gift of Mrs. Walt Kuhn.

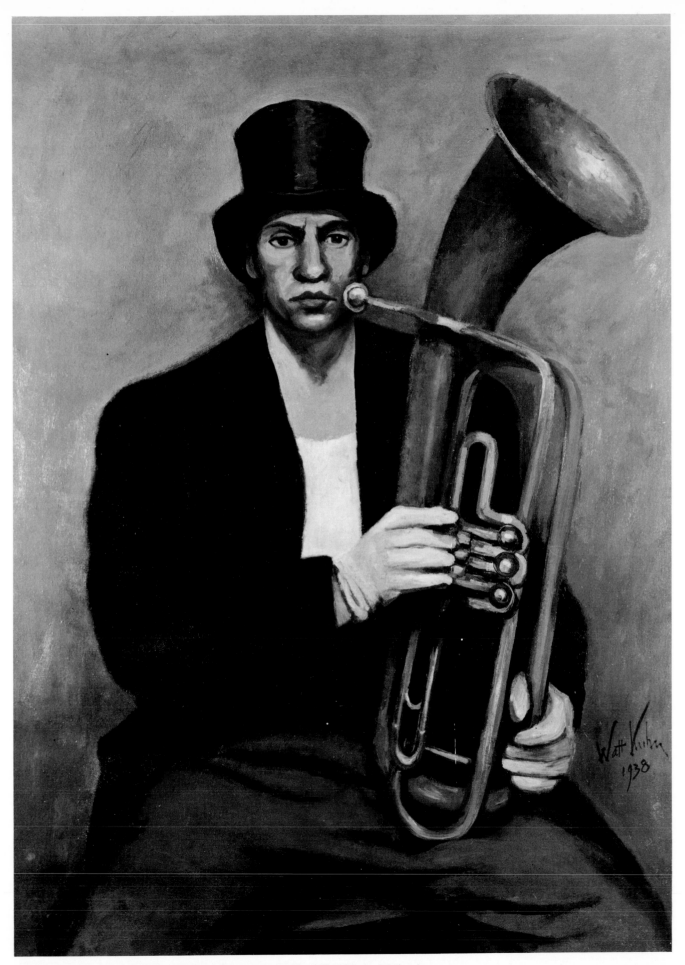

Musical Clown *by Walt Kuhn, 1938. Oil on canvas, 40″ x 38″ (101.6 x 96.5 cm).*
Whitney Museum of American Art, New York, New York.

Green Bananas *by Walt Kuhn, 1946. Oil on canvas, 20 1/4" x 16" (51.4 x 40.6 cm).*
Des Moines Art Center, Des Moines, Iowa. James D. Edmundson Purchase Fund.

Bread with Knife *by Walt Kuhn, 1948. Oil on canvas, 16" x 20" (40.6 x 50.8 cm).*
Wichita Art Museum, Wichita, Kansas.

Edward Hopper

1882 - 1967

Most Americans drive past a Hopper on their way to work (pages 157 and 159). Lonely white houses with no kids around; if they're freshly painted, you know they're lived in. Occasionally you see the old lady or the old man. Hopper's American city is almost that lonely: early light in downtown streets (page 202); Sunday morning in the cheap hotel (page 200). Even his nudes are all alone.

A very literal realist, Hopper had the good fortune to be accepted by the abstract painters, probably because the critics saw dark meanings in his white light. In 1933, when he had his first big show at the Museum of Modern Art, he was a prosperous commercial artist in a herringbone suit. The austere Hopper is a legend now: he was still walking up five flights of stairs and eating cold food out of cans when his prices went through the roof. Hopper didn't say much, so you could read what you wanted into his work. He thought it should speak for itself. He was more surprised when people bought his work than when they didn't. He went right ahead painting what was in front of him, or that's what he thought he did.

After Henri, he studied with Kenneth Hayes Miller, who carried on the Henri tradition by training Reginald Marsh and most of the urban realists of the thirties. What effect did his teacher's unending words of wisdom have on Hopper? Very little. Miller and Henri were brilliant talkers, but Hopper paid no attention. His three long trips to France, where the light was different from anything he had known, made more difference to him. He didn't sell his first oil until the Armory show in 1913, and he didn't paint a whole lot between 1915 and 1924.

He hated his commercial work. Often he'd stand outside the ad agency until he could force himself to go in because he needed the money. As he told Lloyd Goodrich, he didn't want to draw people grimacing and posturing; what he wanted to do was to paint sunlight on the side of a house (pages 197 and 201).

The Whitney Museum crowd appreciated his work from the beginning, and when the Modern Museum took him up, he was made. He built a house on Cape Cod, where he lived frugally with his wife, a Henri student who kept away the world. She posed for every figure he painted. He didn't mix much with other artists at Provincetown, and he never played politics; he just worked away. His aim in painting was to make the most exact transcription possible of his most intimate impressions of nature. He said that the only real influence he ever had was himself. You didn't mind Hopper saying that because it was obviously true. He was just as clear as his paintings. He did not think it was easy to explain painting with words. To hear him talk, you'd think he was the greatest pessimist in the world. But he was amazingly serene. The other artists always asked anxiously, "How's old Hopper doing?" for they knew he was way ahead of them.

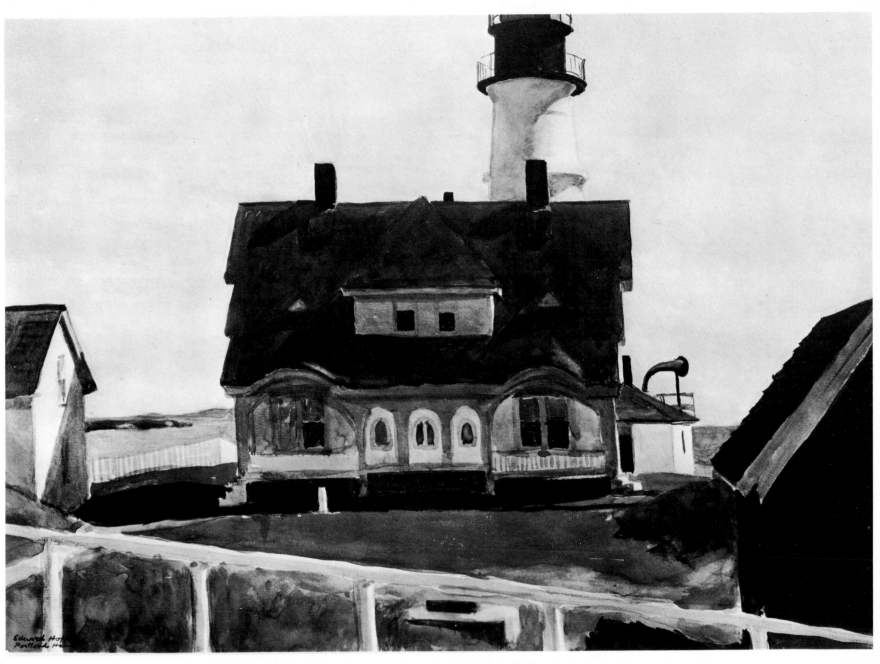

Captain Strout's House *by Edward Hopper, 1927. Watercolor, 14″ x 20″ (35.6 x 50.8 cm).*
Wadsworth Atheneum, Hartford, Connecticut. Ella Gallup Sumner and Mary Catlin Sumner Collection.

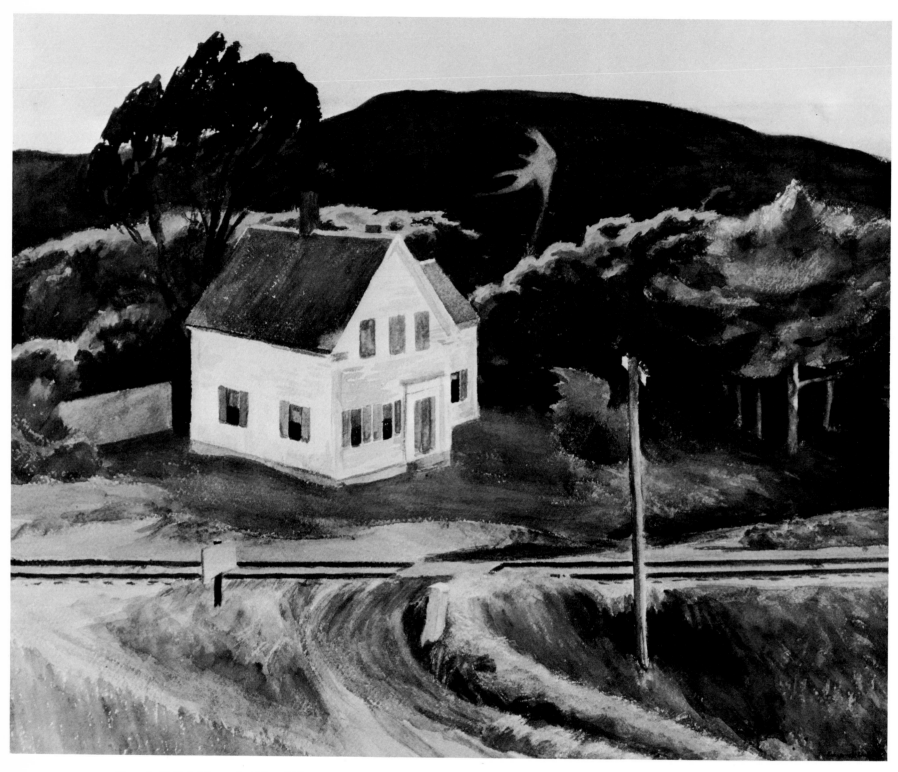

Captain Kelly's House *by Edward Hopper, 1931. Watercolor, 20" x 24 7/8" (50.8 x 63.2 cm).*
Whitney Museum of American Art, New York. Bequest of Josephine N. Hopper.

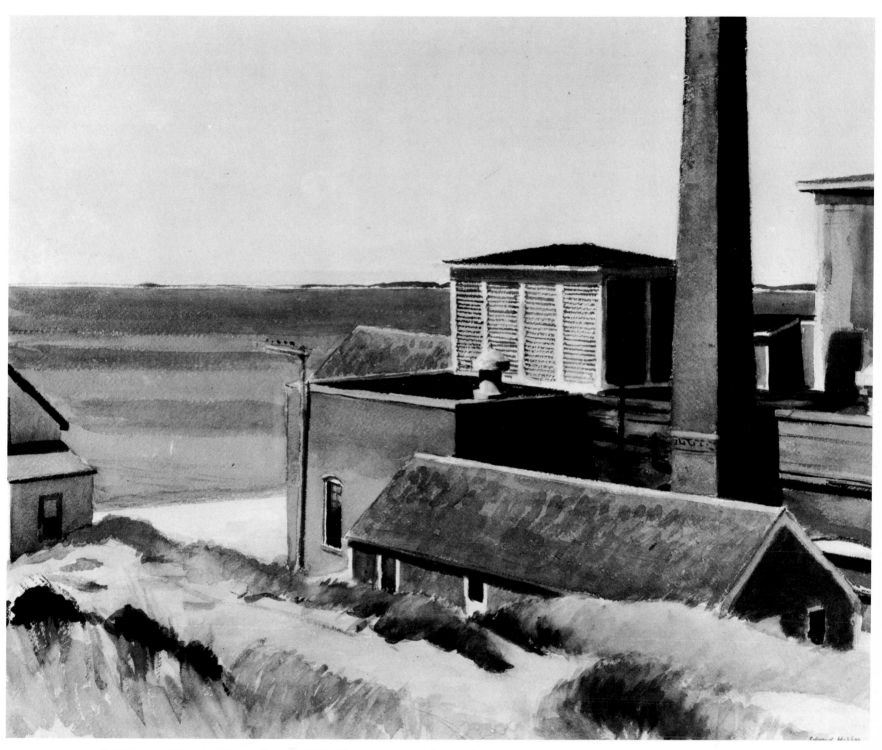

Cold Storage Plant by Edward Hopper, 1933. Watercolor, 19 3/4″ x 24 3/4″ (50.2 x 62.9 cm).
Fogg Art Museum, Harvard University, Cambridge, Massachusetts. Purchase, Louise E. Bettens Fund.

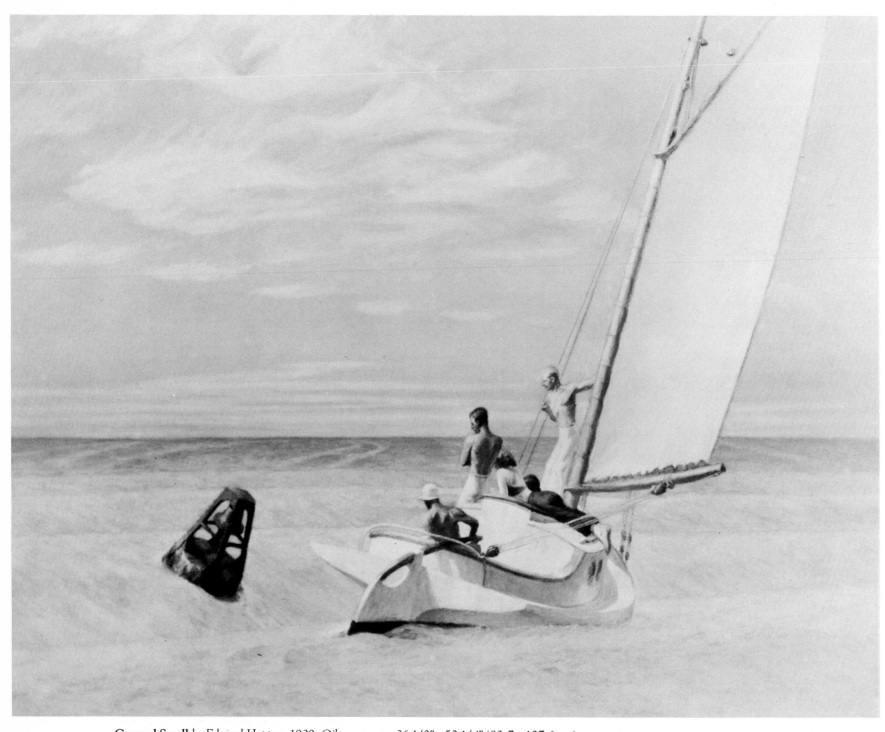

Ground Swell *by Edward Hopper, 1939. Oil on canvas, 36 1/2" x 50 1/4" (92.7 x 127.6 cm).*
The Corcoran Gallery of Art, Washington, D.C.

Shoshone Cliffs *by Edward Hopper, 1941. Watercolor, 20″ x 25″ (50.8 x 63.5 cm).*
The Butler Institute of American Art, Youngstown, Ohio.

Monterrey Cathedral *by Edward Hopper, 1943. Watercolor, 21" x 29" (53.3 x 73.7 cm).*
Philadelphia Museum of Art, Philadelphia, Pennsylvania. Given by Dr. and Mrs. Gustave E. Landt.

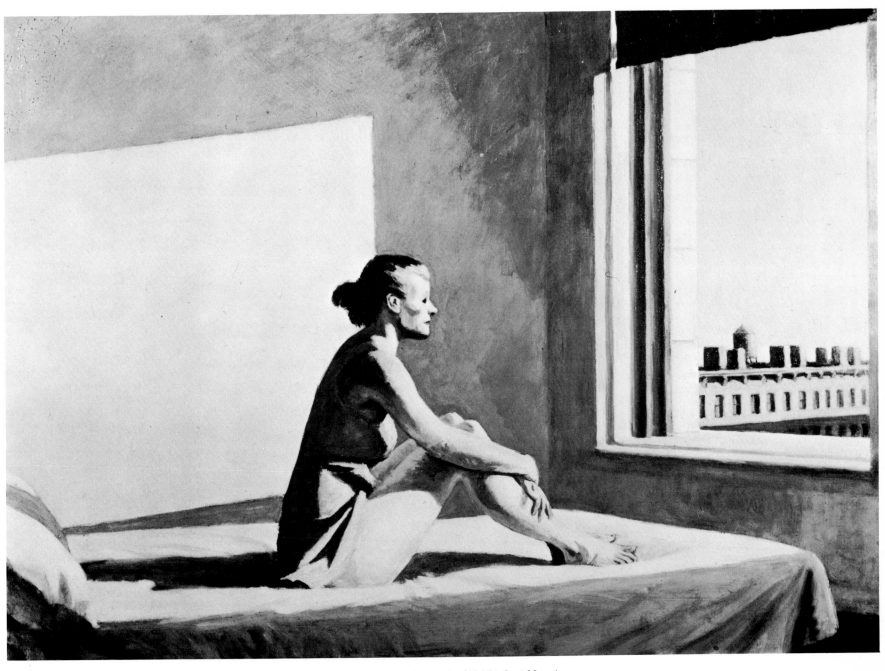

Morning Sun *by Edward Hopper, 1954. Oil on canvas, 28 1/8″ x 40 1/8″ (71.5 x 102 cm).*
The Columbus Gallery of Fine Arts, Columbus, Ohio. Howald Fund Purchase.

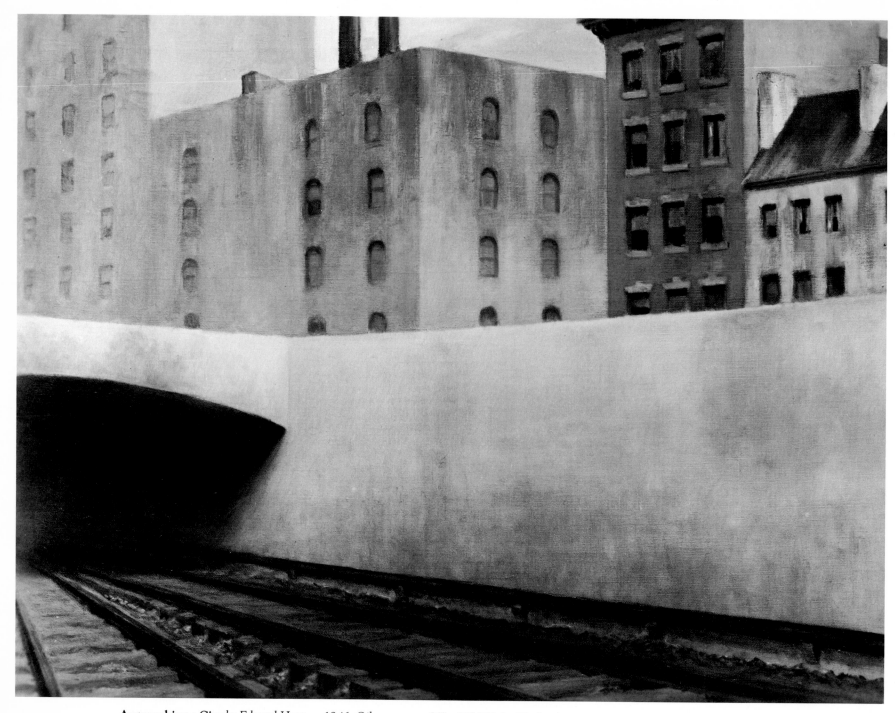

Approaching a City *by Edward Hopper, 1946. Oil on canvas, 27" x 36" (68.6 x 91.4 cm).*
The Phillips Collection, Washington, D.C.

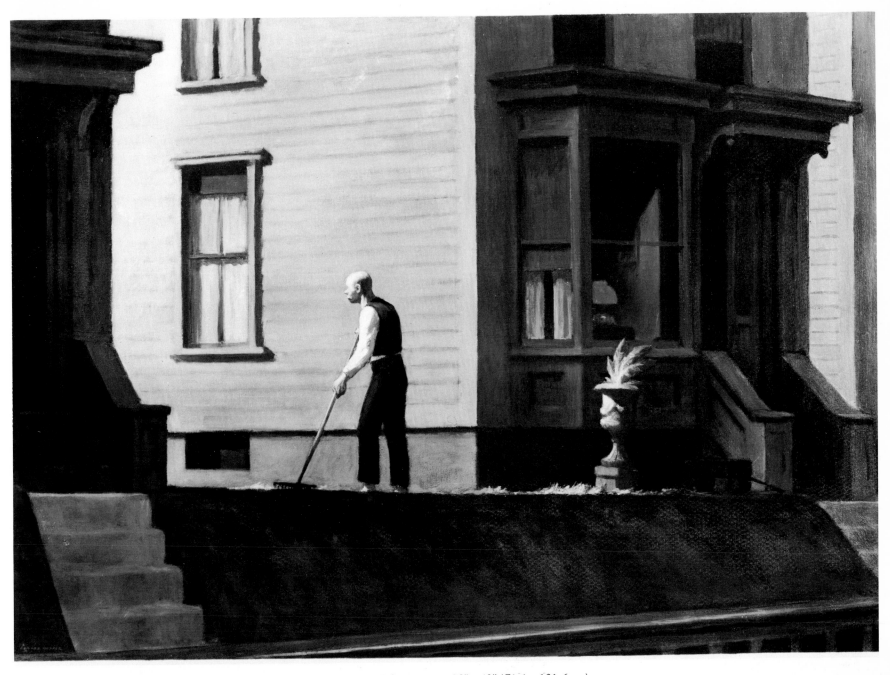

Pennsylvania Coal Town *by Edward Hopper, 1947. Oil on canvas, 28″ x 40″ (71.1 x 101.6 cm).*
The Butler Institute of American Art, Youngstown, Ohio.

Bibliography

General

La Follette, Suzanne. *Art In America.* New York, 1929.

Larkin, Oliver. *Art and Life in America.* New York, 1960.

Novak, Barbara. *American Painting of the Nineteenth Century.* New York, 1969.

Richardson, Edgar P. *Painting in America.* New York, 1965.

Sandler, Irving. *The Triumph of American Painting.* New York, 1970.

Wilmerding, John. *American Art.* Baltimore, 1976.

Winslow Homer

Beam, Philip. *Winslow Homer at Prout's Neck.* Boston, 1968.

Gardner, Albert Ten Eyck. *Winslow Homer, American Artist: His World and His Work.* New York, 1961.

Goodrich, Lloyd. *Winslow Homer.* New York, 1959.

Hoopes, Donelson F. *Winslow Homer Watercolors.* New York, 1969.

Wilmerding, John. *Winslow Homer.* New York, 1972.

James McNeill Whistler

Holden, Donald. *Whistler Landscapes and Seascapes.* New York, 1969.

Pennell, Elizabeth Robbins and Pennell, Joseph. *The Life of James McNeill Whistler.* 2 vols. London and Philadelphia, 1908.

Sutton, Denys. *Nocturne: The Art of James McNeill Whistler.* London, 1963.

Weintraub Stanley. *Whistler: A Biography.* New York 1974.

Mary Cassatt

Breeskin, Adelyn D. *Catalogue Raisonne of the Oils, Pastels, Watercolors and Drawings.* Washington, D.C., 1970.

Bullard, John. *Mary Cassatt.* New York, 1972.

Hale, Nancy. *Mary Cassatt.* New York, 1975.

Sweet, Frederick. *Miss Mary Cassatt, Impressionist from Pennsylvania.* Norman, Oklahoma, 1966.

Thomas Eakins

Goodrich, Lloyd. *Thomas Eakins.* New York, 1933.

Hoopes, Donelson F. *Eakins Watercolors.* New York, 1971.

Porter, Fairfield. *Thomas Eakins.* New York, 1959.

Schendler, Sylvan. *Eakins.* Boston, 1967.

Frank Duveneck

Heerman, Norbert. *Frank Duveneck.* Boston, 1918.

Duveneck, Josephine Whitney. *Frank Duveneck: Painter, Teacher.* San Francisco, 1970.

William Merritt Chase

Roof, Katharine Metcalf. *The Life and Art of William Merritt Chase.* New York, 1917.

John Singer Sargent

Charteris, Evan. *John Singer Sargent.* New York, 1927.

Hoopes, Donelson F. *Sargent Watercolors.* New York, 1970.

Mount, Charles Merrill. *John Singer Sargent: A Biography.* New York, 1955.

Ormond, Richard. *John Singer Sargent: Paintings, Drawings, Watercolors.* New York, 1970.

Robert Henri

Homer, William Inness. *Robert Henri and His Circle.* Ithaca, New York, 1969.

Read, Helen Appleton. *Robert Henri.* New York, 1931.

Young, Mahonri Sharp. *The Eight.* New York, 1973.

William Glackens

Glackens, Ira. *William Glackens and the Ashcan Group.* New York, 1957.

Young, Mahonri Sharp. *The Eight.* New York, 1973.

George Luks

Cary, Elizabeth Luther. *George Luks.* New York, 1931.

Young, Mahonri Sharp. *The Eight.* New York, 1973.

John Sloan

Brooks, Van Wyck. *John Sloan: A Painter's Life.* New York, 1955.

St. John, Bruce, ed. *John Sloan's New York Scene.* New York, 1965.

Scott, David, and Bullard, John. *John Sloan.* Washington, D.C. 1974.

George Bellows

Morgan, Charles H. *George Bellows: Painter of America.* New York, 1965.

Young, Mahonri Sharp. *The Paintings of George Bellows.* New York, 1973.

Rockwell Kent

Armitage, M. *Rockwell Kent,* New York, 1932.

Walt Kuhn

Bird, Paul. *Fifty Paintings by Walt Kuhn.* New York, c. 1940.

Edward Hopper

Goodrich, Lloyd. *Edward Hopper.* New York, 1971.

Index